HOW WE GOT BY

HOW WE GOT BY

111 People Share Stories of Survival, Resilience, & Hope through Hardship

Shaina
Feinberg
&
Julia
Rothman

Andrews McMeel
PUBLISHING®

TABLE OF CONTENTS

INTRODUCTION......6

1 DRAE......9
2 T.L.......11
3 BRIAN......12
4 JUDI......15
5 BIG JOHN......17
6 REN......19
7 BILL......20
8 ETHAN......22
9 OSCAR......23
10 JOAN......24
11 SHIRIN......27
12 AZIZ......29
13 ANN......30
14 ZACH......33
15 TANYA......34
16 NAFÉ......37
17 CHRIS......38
18 WALEED......41
19 CHELDIN......43
20 KUYE......45
21 CHAD V.......46
22 MAGIN......48
23 ERIKA......50
24 RADHIA......53
25 MARY......54
26 FAREEHA......56
27 IRIS......58

28 GRETTA......60
29 DORIS......62
30 BIBA......65
31 ANNIE......66
32 RUTH......68
33 JJ......70
34 DUSTY......72
35 DAVID B.......73
36 DR. B.......76
37 TINA......78
38 JOE......80
39 DALLAS......81
40 ALICE......82
41 SAV......84
42 POOJA......86
43 BETTYE......88
44 NOUFOU......89
45 DHANTÉ......90
46 CHRISTEN......92
47 ASHLEY......95
48 DJ ALI......97
49 SHONALI......99
50 RACHEL......100
51 RŌZE......104
52 JEFF......106
53 LAURA......108
54 ANJA......111
55 JASON......113

56 **GUY**114

57 **DAN**116

58 **OZZIE**117

59 **THAO**118

60 **MICHELLE**119

61 **OLLIE**120

62 **GREGGY**122

63 **ISAAC**124

64 **JOSEPHINE**127

65 **NORAH**128

66 **ALEX**129

67 **CASANOVA**130

68 **MICHAEL**132

69 **YINFAN**133

70 **CAVEH**135

71 **MARINA**136

72 **CHRIS K.**138

73 **BECCA WILLOW**140

74 **MID**141

75 **DAVID P.**142

76 **JONAH**144

77 **BENTON**146

78 **JESSIE**149

79 **ALICE J.**150

80 **NEGIN**152

81 **NAOMI**155

82 **TANTELY**157

83 **CARLA**158

84 **VICTOR**160

85 **REGGIE**162

86 **JULIA**164

87 **TENILLE**167

88 **MIKE**168

89 **KRYSTAL**170

90 **MONIQUE**173

91 **SEENA**174

92 **ULI**176

93 **CHAD B.**178

94 **AYA**181

95 **JAMIE**184

96 **JULIA M.**187

97 **DAVE**191

98 **GOLDIE**193

99 **RAELEN**195

100 **GABE**196

101 **MONTE**199

102 **CARISSA**201

103 **MARIKE**202

104 **EDDIE**207

105 **RIO**209

106 **ANGELA**210

107 **EDAFE**212

108 **ALESSIO**217

109 **DIANE**218

110 **TONE**220

111 **NICK**221

INTRODUCTION

SHAINA: Hey Julia! Should we tell people how we came up with the idea for this book?

JULIA: Yeah!

SHAINA: It was March 2020 and the lockdown had just happened in New York City. I was freaking out. I had to figure out how to homeschool my kid and keep working.

JULIA: Everybody was at home, locked in their houses. We didn't know anything about what was going on. People were scared and alone. It felt like, *Well, how are we going to do a column now?*

SHAINA: Wait, we need to back up and explain that we do a column.

JULIA: Oh, right.

SHAINA: Julia and I do an illustrated column in the business section of the *New York Times* every other week.

JULIA: The unofficial motto is "small business, big personality."

SHAINA: When the lockdown happened, all businesses were either shutting down or going into crisis mode, and everyone was reporting on that. It didn't feel like we could add anything to *that* discussion.

JULIA: It felt like, *What could we possibly do a column about right now?*

SHAINA: In *this* moment!

JULIA: I was living upstate to get away from the city for a while. We were FaceTiming a lot.

SHAINA: You and me. Yeah.

JULIA: And you told me this story about your mom to make me feel better.

SHAINA: Yes! It was a story my mom told me [page 54] about how when she had cancer, she gave herself these little to-do lists in order to get through the days. Because having little things to do that she could accomplish made her feel good, but it was never too much that it would knock her out.

JULIA: When you told me that story it made sense for the column. It was like, *What does everyone need right now?* They don't need a story about a business shutting down. They need something to uplift them. So the idea was to get stories from people about the hardest thing they had lived through and how they got through it. One person was Dan [page 116], who lost his twin brother during 9/11—which was also a very scary time for people. Dan talked about using music to cope with his grief.

SHAINA: We talked to Ruth [page 68], who told us about getting divorced and how having a dog to walk and care for helped her get through that difficult time.

JULIA: We talked to Waleed [page 41] about escaping the Syrian army.

SHAINA: The stories were all very meaningful.

JULIA: We interviewed them all over Zoom. I painted their portraits from photos I took over Zoom.

SHAINA: Those portraits and stories became our column that week.

JULIA: It was one of the most popular columns we ever did. Why do you think that is?

SHAINA: I think people needed some advice on how to deal with the insanity of that time. And I think people really wanted to see other people being resilient. After about a year, we thought, *Well, this would make a good book.*

JULIA: Yeah, more stories like those.

SHAINA: For this book we interviewed III people. Some are people we know. Some are people we got connected to by people we know. Others were just people we met on the street.

JULIA: All of these stories are accompanied by a portrait of the person who told the story. I think the best portraits were ones where I got to meet the person in real life. But often people had to send us pictures. Sometimes the portraits don't look like the people because I can't always get the person's face just right from a photo. But I hope that they all captured the spirit of the person. You know, I think there is a difference between a photograph of a person and an illustration of a person.

SHAINA: Yes, how so?

JULIA: I think there's something warm about a painting of a person. So it makes sense to have paintings alongside these very personal stories.

SHAINA: What is it about listening to people's stories that's important?

JULIA: It's a way of building empathy and learning about people. Not just having preconceived notions about them.

SHAINA: It's so easy to live our lives in these bubbles. But when you zoom out and see that the world is made up of all of these different people who have all of these different kinds of experiences, there's something human about that. Everything that we heard made me feel bonded to people—not just the people who told the stories, it made me feel like I was bonded to all humans.

JULIA: In doing the book, we learned that people don't really get through things. They don't really "get by." So the title doesn't actually work. But we kept it anyway because it's the question we posed. We asked people, "How did you get through this? How did you get by?"

SHAINA: A lot of people said that rather than getting through something, they brought it with them and kept going.

JULIA: That reminds me of when I first started therapy, my therapist gave me this workbook. There were cartoons in the workbook* and this one cartoon really stuck with me. In it, there's a person walking and they come across a sign that says something like "fear" on it. There are three ways a person can deal with it: They can get to the sign, ignore it, and keep walking. Or they can get to the sign and become paralyzed. And then the third way, which is the best way, is that they get to the sign and pull it out of the ground. They can carry it with them and keep moving forward.

SHAINA: Wow.

JULIA: It's basically saying, *It's OK that you have this fear or this struggle. Just carry it with you and keep going.* Don't let it stop you.

SHAINA: That's what this book is about!

**The Mindfulness & Acceptance Workbook for Anxiety by Georg H. Eifert and John P. Forsyth*

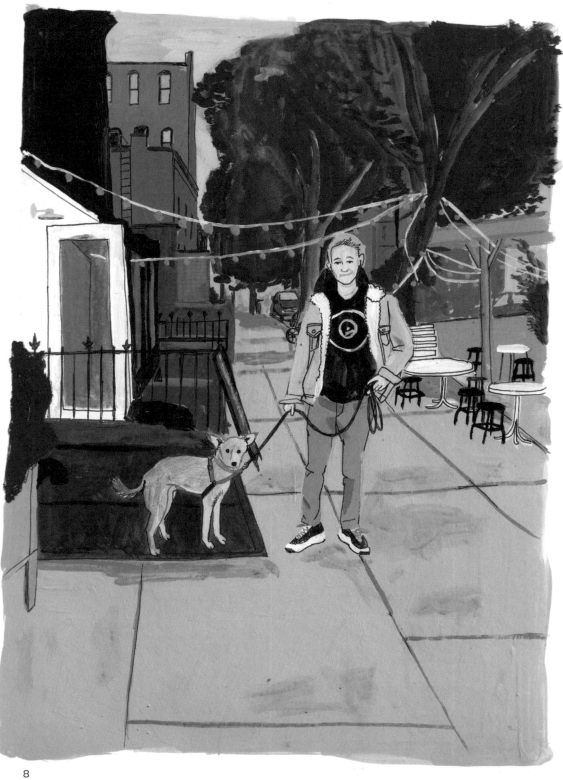

DRAE

I'M THE YOUNGEST OF NINE CHILDREN AND we were very poor. When I came along almost all my siblings were grown up, except I had one brother, Brian, who was severely disabled, so we had to care for him like an infant. So it was like having a younger brother, even though he was older than me.

Until I was three, we lived with my father in the country. We had horses and catfish, and my father was insane. He would run around shooting off a shotgun, and he was abusive. We used to hide in the bushes at night. We had to get out of there, so we fled to San Francisco—me, Brian, my mom, and two other siblings of mine, Jackie and Paul.

When we moved to San Francisco, we lived in shelters and hotels. My mom was a single mom with no college education, though she was quite smart and read a lot, but she would gamble a lot to make ends meet. My mom was a gambling addict. She would go to bingo almost every night.

My brother Paul and my mom would get into these crazy fights where she'd be like, "You have to babysit the kids because I'm going to bingo." And he would say crazy things like, "I'm going to kill them, I'm going to cut them up into pieces." She knew his threats weren't serious, and she didn't have a lot of options if she wanted or needed a break. So she'd leave and he would be babysitting us.

Paul would say things to me like, "Mom is getting murdered." He would scare me on purpose. And Brian couldn't speak. And my mom wouldn't come home until late at night. I was left at the mercy of these people. I was just a kid!

I was so worried and freaked out that something would happen to my mom, and there was nobody I could phone, no one I could talk to, nowhere I could go. I was painted into a corner and my only way out was that I would close my eyes and I would see a little tiny, disembodied God head in my mind. It was a white man, this God head—and I would ask him, *Is my mom OK?* And he would nod yes. And then I would ask him, *Are you just saying yes because I am making you say yes?* And he would nod no. It was really the only way I got comfort.

It's funny, there was a period of time when I was little when there were these Halloween scares. People would say there was poison or razor blades in the candy. So I would be in the corner, holding a mini Snickers bar, and I'd go into my head and ask the God head, *Is this candy safe?* And then he would say yes, and I would eat it!

Any troubling question, I would go into that little headspace and talk to him. I guess it was a version of prayer. It was uncomfortable to have that much anxiety, and this was my way of solving it.

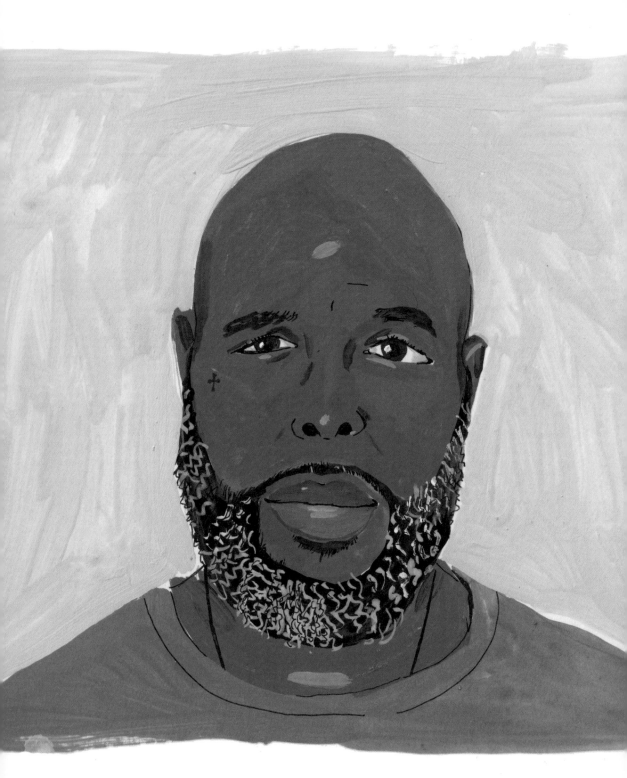

T.L.

When I walk into a room with new people, I still try not to use my regular speaking voice.

MY VOICE—PEOPLE LOVE IT. BUT I AM HESITANT to talk to people because everybody always has a reaction. Everybody says I sound like Barry White or like Barry White on steroids. My voice is super deep.

I've been getting these reactions since kindergarten. I went to Catholic school, and in kindergarten, when we used to say our prayers and Pledge of Allegiance in the morning, kids from the eighth-grade class would come across the hallway to see the kid with the deep voice. Teachers would call my house and I would pick up the phone and they'd think I was my dad. I sounded like a regular grown man before I hit puberty. Once I hit puberty, it got even deeper. Little girls were so mean to me—they said I sounded like a monster. From the time I was five to thirteen, kids were mean sometimes. Then when I was thirteen, girls were like, "That voice is amazing. Here's my number, call me"—which was a stark departure from being told repeatedly that I sounded like a monster.

It made me self-conscious that everybody was always commenting. It got to a point where I didn't want to talk to anybody because I didn't know what the reactions were going to be.

When I walk into a room with new people, I still try not to use my regular speaking voice. I find myself slipping into a higher register. Maybe it's a self-defense mechanism.

I've adjusted some now. It's been a thing I've had to get over multiple times. It's like I'm in recovery. It's an everyday kind of thing. I have to tell myself, *Yo, just speak. It's not that big a deal. This is your voice. This is how you sound, bro.*

I have a speech prepared already for my son because he has a deep voice. I will say, "You cannot allow yourself to get hung up on what other people think. The person upstairs gave you this voice for a reason. Everybody is the way they are for a reason." I wish someone would have told me that when I was younger. How you sound, how you look—you gotta embrace that!

BRIAN

WHEN I WAS TEN YEARS OLD I STARTED playing guitar. There was a guy that gave me lessons. He would come to the house once a week and he'd be like, "Next week we're going to learn 'Blackbird' by the Beatles." And then I would just learn it myself. And he would come back and be like, "OK, unless you want to learn theory, there's not really much I can do for you. I could teach you songs, but you seem to do that well enough yourself."

I learned a lot by ear when I was really young and shied away from theory and the nitty-gritty stuff that wasn't fun to a ten-year-old. I picked up things really quickly, which was kind of a double-edged sword.

The more I played and the more I played with other people, the less I needed help.

And then I blinked, and one day I was playing with a bunch of people in New York who had all gone to Berklee College of Music or they'd studied jazz in high school. I would doubt myself a lot when I was playing with these people. People would ask me, "What do you play?" And I would say, "Technically, I'm playing bass, but I wouldn't consider myself a bass player." When someone would ask me if I was a musician, I wouldn't have a straight answer.

I guess I had imposter syndrome and I felt insecure. I was always second-guessing myself.

The big turning point was when I lost my day job. I had this day job for almost fifteen years. It was flexible and allowed me to play music but not think about it as a career. But when I lost that job, I had to think about music professionally. It freaked me out because I didn't feel like I deserved it, since I hadn't studied it. But I just had to trust myself that I could do it without the security of having a full-time job to fall back on.

I came to realize there's something that I do that people like. Maybe because I play "wrong" or don't have the training that they do, they like me. I'm super busy, and I've learned to stop asking why and just play. Really, you're a musician because you play music not because you study it.

I think if you have the drive to do something, you should just do it and not second-guess yourself so much.

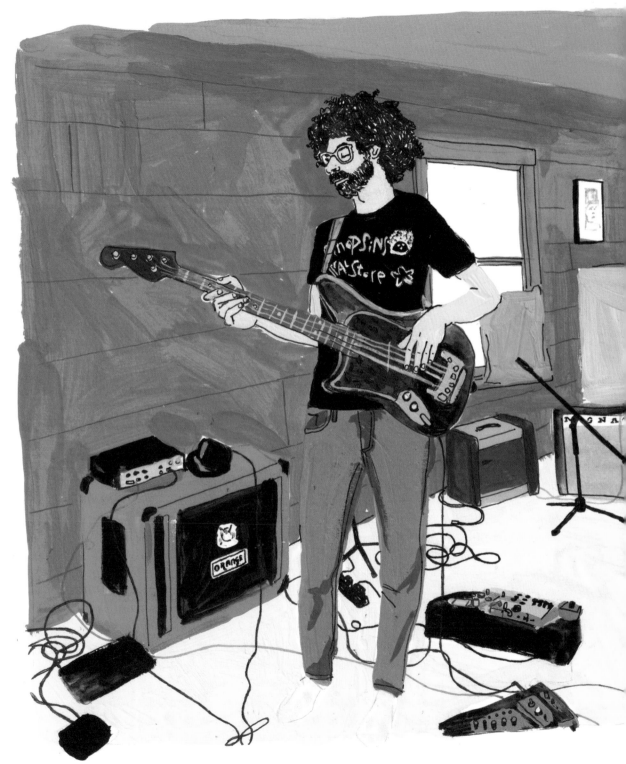

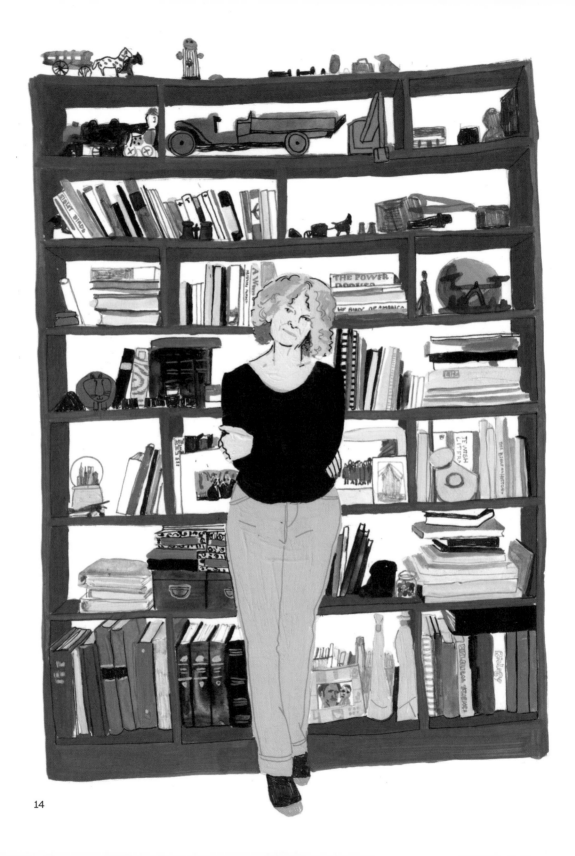

JUDI

I thought people got married and stayed married forever.

I GOT MARRIED WHEN I WAS TWENTY-ONE. I only knew my husband for a very short time before we got married. And I had two boys with him. Then another woman came into his life.

I was very trusting at the time, and we were sleeping over at our friends' house. Winds up, my husband was having an affair with the woman in the couple—a friend of ours.

I felt betrayed. I felt disappointed. I was miserable. That was one of the biggest traumas in my life.

We decided to get divorced. So my then-husband and I told our kids. We said, "Daddy is going to be living someplace else, but you'll go to the same school and have the same grandparents." They were devastated because Daddy had come home every night, but now they'd only see him once a week.

I thought people got married and stayed married forever. But the more I peeked into corners, the more I saw more and more women who were getting divorced.

I think I had a perspective that enabled me to go on. There's this Lewis Carroll quote, something like, "I can't go back to yesterday, because I was a different person then." That's very good advice. I was who I was then. I operated in a world that existed then. Now things had changed. And I'd adjust.

Raising my children—sharing the world with them—that saved my life. I knew I had a purpose. I had to keep them happy and grounded.

And soon after my divorce, I met my current husband, Saul. And together, with my boys and his two boys, we found new interests, new things in common, a new life.

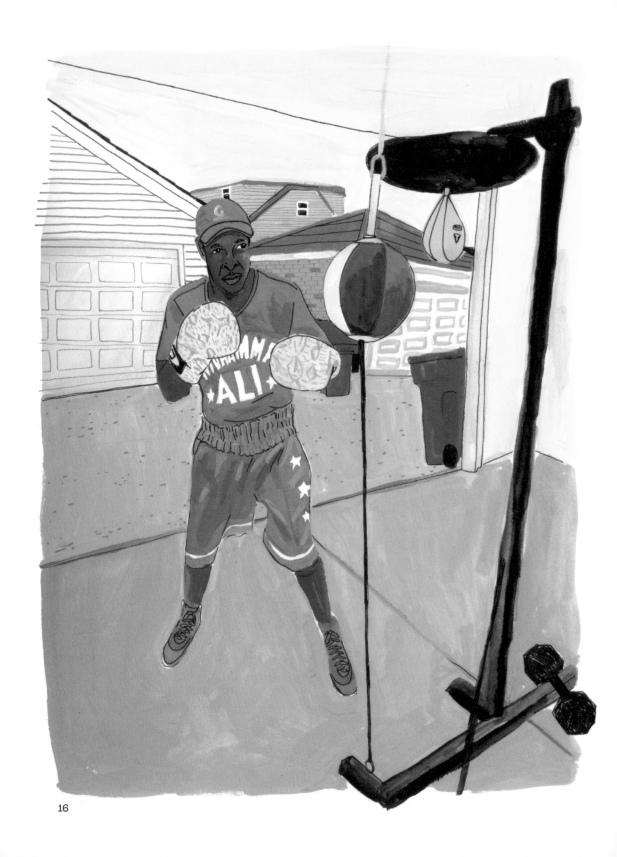

BIG JOHN

It was hard not to fight, but I had to find a way to make myself happy.

I BECAME A BOXER WHEN I WAS TWENTY-ONE. I was watching the 1992 Olympics and I fell in love with boxing. I went to my church and I told my pastor, "Pastor, I asked god to go to the next Olympics." And my pastor looked at me and said, "God said you're going." I really believed god was speaking to me when the pastor said that.

I joined a boxing gym, and I told all of these people there that I was going to go to the Olympics. These guys are national champions, and they said to me, "Have you ever fought?" And I said no, and they looked at each other and said, "You're crazy."

But I trained and trained, and my country, British Guiana, picked eleven of us to send to the next Olympics. And out of the eleven of us, ten lost. I was the only one to qualify.

I went to the 1996 Olympics in Atlanta, Georgia. It was my first time in America. It was amazing to be an ambassador of my country. I had my country's flag and I was proud. It was a dream come true.

After that, I moved to the US and started my boxing career. I was twenty-five, and I started fighting professionally, fighting for money. I boxed professionally for fourteen years.

Then I started training people how to box. I loved sparring with them. This one day I was sparring with someone, and I tried to hit my back on the rope but the rope was too slack, so I flipped over and hit my head on the concrete. I ended up having to go for brain surgery, four times.

I went to the surgeon, and I said to him, "You know what? God has his hands in your hands, and everything is going to be grand." But afterward, the doctor told me I cannot box anymore. That was the roughest part for me. He said I could exercise, but nobody could hit me anymore. I was really disappointed to have to stop sparring. It took away half of my life.

I started teaching more. And I made teaching my life. I'm good at teaching and I enjoy it. It was hard not to fight, but I had to find a way to make myself happy.

My mom used to say, "The stricter the government, the wiser the population." The more strict the government gets, the people become more creative. I love that idea. It's a way of boosting yourself up and becoming more creative with your problems. That's what I did. I got creative.

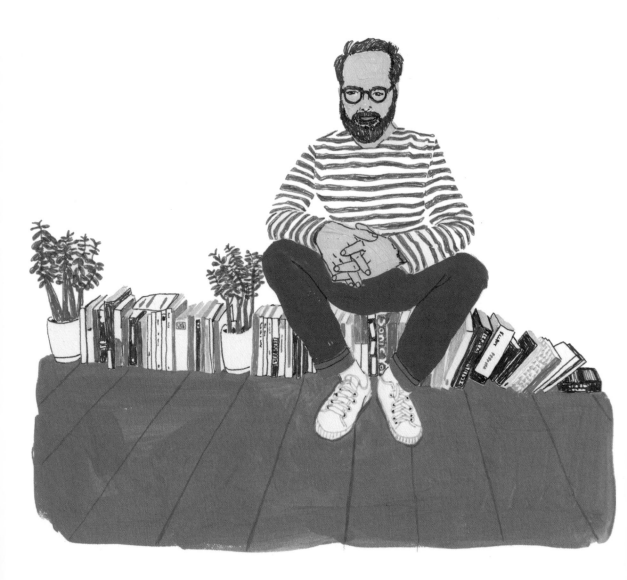

REN

I'M ORIGINALLY FROM RUSSIA. SOME LITTLE city in Russia. I lived there until I was seven. And I showed up in New York on Halloween of 1990. It was like, *Ohhh, we're going to the land of opportunity*, and then we show up and there were skeletons and shaving cream everywhere. I didn't really know what to make of it.

I didn't speak English. They put me into public school—I was in second grade. My memories of it are very vague. I looked weird, I felt weird. I was put into this environment where I didn't fit in, and I felt stupid. I didn't understand social dynamics. Kids would be like, "Oh, did you see the Michael Jackson video?" And I would be like, "I don't know what Michael Jackson is." Some kid was like, "You didn't use hair conditioner for your hair?" And I went home and was like, "Mom, you need to get me hair conditioner." And she said, "What is that?"

I hung out with my brother a lot. We watched TV and played Nintendo, and we would walk around the block a lot.

I met other immigrant kids and they weren't as maladjusted as I was. I think I just come from a really weird family.

Anyway, my parents were in their mid-thirties at the time. They came to this new country, and there was no going back. And there was no safety net. They had to learn English and make money. They were good parents, but emotionally I was left to fend for myself. And I don't think I did so well because as soon as I found drugs I was like, *Let's go.*

I started sneaking cigarettes when I was thirteen. Just the act of sneaking the cigarettes was a high because it was this secret thing. I smoked pot when I was fourteen, and then I probably smoked every day until I was twenty-two. And I basically said yes to every drug that came along.

Then when I was twenty-three I went to rehab. In a way, going to rehab was me asking the world for help. I was like, "I don't know what to do." Rehab was useless, but it was good because it got me to AA, and in AA they told me, "You have to ask for help." It winds up that asking people for help is good because not only do you get help but also it makes other people happy because people like helping.

Now I ask for help all the time. I call my friends to help me think through an issue. I have a bunch of friends now, and we work through stuff all the time.

I think people rely on themselves too much. They think that they have to figure everything out on their own.

BILL

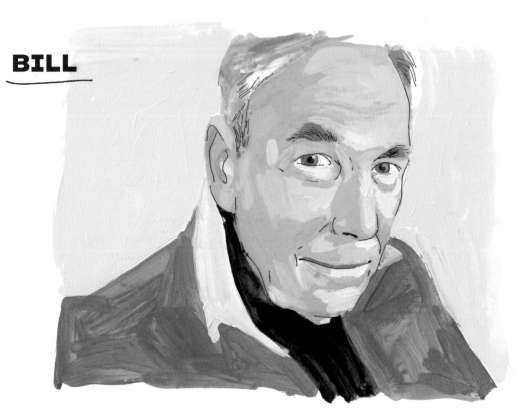

IN LATE MAY 1961, I WAS JUST OUT OF GRADUATE school and I was in New York, and a friend of mine said, "Have you heard about this thing they're putting together called The Freedom Rides?" And I said, "Yeah, I've heard about it." I'd heard Martin Luther King Jr. speak. And my friend said, "Are you interested in doing it?" And I said, "Absolutely."

I was a sheltered, middle-class white kid from New York. I'd gone to YMCA school and a prep school that was full of Asians, Latinos, and Black people. So I'd never encountered much prejudice. I'd encountered a tiny bit of prejudice against Jews, which I didn't understand. So I was pretty sheltered. But when I realized that I wouldn't have been able to travel through Mississippi with my good friend from Oberlin College, Walt Johnson, because he was Black, I said, "Well, this isn't the country I thought it was."

So I went down to the Congress of Racial Equality in lower Manhattan and met the founder of it, Jim Farmer. He was delighted to have any white people who would go because it was mostly Black people who were going on the Freedom Rides. He interviewed me extensively to make sure I was going for the right reasons and that I understood the parameters, which were that this was a completely nonviolent demonstration. We were going to go anonymously to Jackson, Mississippi, by bus and then integrate a lunch counter with Black people and whites sitting at a counter, side-by-side. Jim Farmer told me that we'd probably be arrested. And he didn't know what would happen after that. He said, "It could be really dangerous, I'm not kidding you." So I said, "OK, I'm in."

I went down to Atlanta and had three days of nonviolent training. We talked about nonviolent resistance and how you do it. At

the end of three days, we got on an overnight bus to ride through the night to Jackson, Mississippi, where we'd get out and integrate the lunch counter, and we assumed that we'd be arrested. We'd been told that we could spend up to six months in jail, but that they wanted us to serve at least forty-nine days in jail so that Mississippi would pay for their racist policies. I had no idea what we'd be facing.

So we get on the bus and we're heading south and there's about ten or eleven of us on the bus that are Freedom Riders. Now, it's all supposed to be completely anonymous. We're all supposed to not talk to each other.

At an early stop somewhere in the South, a guy gets on the bus and sits next to me. A big burly guy. I could tell he was drunk. He was mumbling.

The night went on, and a guy in our group—a real jerk—told somebody that we were Freedom Riders. All of a sudden the guy next to me looked at me and he told me he was an ex-Marine and how tough he was, and he said, "You're one of those N-word lovers, right?" I said, "I'm with the Freedom Riders group." He took out a loaded .45 pistol and put it to my head and said, "I'm gonna blow your head off."

Everybody on the bus froze. Fortunately—and I'd never thought this would be fortunate—I had a bunch of alcoholics in my family, including my mother, sadly. So I was used to dealing with alcoholics, especially ones who would get really angry. I knew what the .45 was—I'd been in the Air Force ROTC on the rifle team—so I could have grabbed it and disarmed him, but this was supposed to be nonviolent. I'd given my word. And that was also taking a chance. I was really terrified.

Sure, it might just be bluster, he might just be a drunk. But he kept going on and on and pushing it. Everybody on the bus was terrified. I just kept talking to the guy. Talking and listening. Not arguing. Not contradicting. Slowly, he wound down a little bit. We were very close to each other, so if he did shoot me, he'd be covered in my blood. Eventually he wound down and got very quiet.

About twenty minutes later, we're out in the middle of nowhere, and the bus driver pulls over to an abandoned gas station—it was a completely unscheduled stop—and he says, "Everybody gets out for a bathroom break."

Everybody filed out. And the drunk guy gets out, and he's looking for a bathroom. And I saw state police come and confront him. And the bus driver said to me, "Listen, I don't agree with what you guys are doing, but that was too much." The bus driver had alerted the police and deliberately pulled off the road.

So the drunk guy was arrested—he went off into the Mississippi night. My fellow Freedom Riders looked at me and thought, *Man, we dodged one there.*

The next morning, we got to the lunch counter, and they arrested us. We spent a night in the county jail. Then they took us out of the county jail in the hot Mississippi summer up to Parchman Farm—the most infamous state prison in the country. They put me and the other white guy on death row—he was the guy who had instigated the incident on the bus. After about three weeks, they took us off death row.

One of the things I learned from that whole experience was, I don't know what business I'm going to wind up in or what life is going to throw at me, but I can survive it. And not only will I survive it, I'll thrive. I never really knew what I was made of until that moment. And nothing in my life quite matches up to it.

ETHAN

I'M AN ARTIST. ONE OF THE THINGS I LEARNED early on is you can't be precious with what you're working on. You have to just let it go and see what happens, and if you mess up, try to remember that if you can do it once, you can do it again.

OSCAR

I WAS FEELING SO DEPRESSED. I COME FROM El Salvador and I'm here by myself and it was Christmastime and I got to a point where it was like, *This is not working.* I decided to believe in god, which for me just means being positive. I used to be so negative, waiting for the worst thing to happen. But I learned in school to change my mind and be more positive—to go out and enjoy my day and to read good books. I decided to create a good environment for myself.

JOAN

They brought me into a man's office and I said, "I'm Jewish and I need sixty-five dollars to be able to go back to school next semester."

I HAVE ALL OF THESE LITTLE VIGNETTE moments of survival. The first one I can think of is what I call "the flagpole moment." My father had died when I was seven and my mother sort of split up the family that summer and sent me off to camp. The woman who ran it was a friend of my mother's, and she gave me a scholarship to go to the camp. I went to camp the first summer, and I really liked it.

The second summer I was invited back, and I was at breakfast in the dining hall when all of a sudden—I don't know whether you'd call it a panic attack or what—I just didn't want to be there. I was terrified, I was homesick. I never collapse quietly. I collapse with great agitation.

And I excused myself from the dining hall, and I went out and I stood at the flagpole where we would all gather to salute to begin the day. And I remember I took hold of the flagpole with one hand and I said, *You are not gonna do this, you're gonna have a good time. You like this place. You've had a good time before. You're gonna go back and have a good time.* I was eight years old when I did that.

The day my father died, I was seven. They told us that my father died. I said, "Oh my gosh!" I said to myself, *Well, he goes off to work every day, and I don't see him while he's at work, so this will just be like he's at work all the time.* And then I said to myself, *Oooh, I can go to school*

tomorrow, and I can say I'm half an orphan! I was already milking it.

Years and years later . . . surviving without any money in college. I really had no money at all. And I would go into the dining hall and get ketchup, saltines, and hot water—all of which were free—so I would live off of "tomato soup" and saltines.

I transferred to the University of Texas and it was sixty-five dollars a semester for an out-of-town student. I had no money. I finished my first semester, and of course, I desperately wanted to go back. So I looked in the phonebook and I found a Hillel—a Jewish foundation—and I went to the Hillel in my

jeans that were torn at the knees. I walked in and I said, "I would like to speak to somebody." They brought me into a man's office and I said, "I'm Jewish and I need sixty-five dollars to be able to go back to school next semester." And he looked at me and said, "Will you pay it back?" And I said, "Yes." He opened a drawer and gave it to me. And I did pay it back.

When push comes to shove, I figure out how to survive. When the moment comes, without thinking about it, I find a way to stand up and take the next step. And one of the things I like about myself is that I survive on my humor. I'm just a person who makes lemonade no matter what you give me.

SHIRIN

WHEN I GOT MARRIED TO A YOUNG BOY, I WAS young myself. I was twenty, he was twenty-one. We fell in love, and all I knew was that I was following this person to his country, having no clue whatsoever about Germany. But I knew the temperature and language would be different.

In India, where I'm from, there were people everywhere. You were never alone. I had no clue what I was headed for. But I presumed I knew him and we were in love, so what could go wrong?

We married in India. I was from a very open-minded family, so they didn't restrict me. The only thing my mom said to me was, "The problem with you going so far away is that if you are in trouble you can't just come over and talk about it." That was the only thing she said, and I was like, "Mom, what are you talking about? I'm not going to have trouble!"

I came to Germany without a word of German. It was like being thrown into deep, cold water. But I was like, *Well, there's no way out.* So I studied at home with a dictionary and cassette tapes. We lived in a little town of six-thousand people. I went from a twenty-million-person city in India to a town of six thousand. I had no friends. I had my mother-in-law and her daughter, my sister-in-law who was thirteen. That was it.

My husband was in the police force, and he was working. It was desolate where we lived. Lonely is not the word. I was terribly homesick. I did a lot of crying and making sure I dried up my tears before my husband walked in.

Five months into it, I secretly packed my bag, and I wanted to leave. But a week later I got sick; typical signs of pregnancy, morning sickness. My mother-in-law snatched me and said, "I'm taking you straight to the gyno, and we will check."

My mother-in-law was not happy. The gynecologist said, "Congratulations!" And my mother-in-law took me aside and said, "Are you sure you want this kid?" And I said, "Yes." She said to me, "In Germany, you are allowed to abort if you feel you are not capable."

I felt absolutely alone. Here I was thrilled to be pregnant but also alone.

I rang up my mother and told her I was pregnant and she was thrilled, and hearing her response gave me such courage and a new state of mind.

My husband was happy, but his mother still wanted us not to have the baby. And, in front of me but in German, she was trying to convince him that we should get rid of the baby. She kept repeating, "Kids having kids is not good."

But I kept the kid. I unpacked my bag and said to myself, *I have to remain here.*

I had the kid alone in the hospital. All that pain, all alone and young. After many hours, my son was born. But I felt like, *Well, now we are two helpless people.* I realized I had to be strong for this kid who needs me.

Every day was a challenge. I stayed on in Germany. I learned German. I got after-baby depression. Which is normal. But it felt like the stress was doubled.

I was alone. We had no telephones back then, no Skype to contact people. So I just did a lot of praying. I was taught in India to pray in times of trouble, and it gave me a lot of strength.

The marriage was getting shaky. He was stressed because I was going through a low period. He couldn't really help me. He was very young. And at his job as a policeman he had a partner who was a female. I was so involved with the kid, I didn't realize I was neglecting my husband. We were drifting apart. And it was probably too late when I realized that he just goes to work and then comes home to sleep. I realized there is something really wrong. I asked him, and he told me he wanted to apologize that he had been involved with his female colleague. He was having an affair, and I didn't even realize. He confided in me about it. And I said, "Oh no, you shouldn't have told me this." My trust was shattered. I had no strength whatsoever. It was a difficult phase for me.

When I was unhappy and down, I would get the baby in his buggy and I would walk around. I realized that getting out of the house was better for the soul than sticking at home and being grumpy.

One fine day I was out and about, and a woman said, "Oh, you are the young lady from India. Would you be able to teach me English?" So I started to teach English at home. That was the first step.

I asked my husband for us to go to marriage counseling and my husband said, "You go ahead." I said, "No, it takes two." He said, "I'm not interested." And I realized it was over. It was hopeless. I tried not to give it all up because I had sacrificed so much to be there with him. But there was no love and no hope left, so I took the step to leave him.

I called up my dad and told him I was terribly unhappy, and my father said, "Count your blessings." And he hung up the phone. And I said, *Dammit, I'm going through hell; what blessings?* At that moment, I didn't know what he was talking about. But years and years later, I think to myself all the time every day is a blessing.

I have had such good luck with my kid. The teachers always said my kid was a peacemaker. And I took him to a child psychiatrist because of the divorce. My neighbor said he should see someone. My son was told to draw a tree and he drew a tree with a huge, thick trunk. And the psychiatrist looked at me and said, "You don't need to come again, he is fine. Your child has drawn this trunk, the foundation. That's you. You are the foundation."

It was a very tough divorce. My husband fought to gain custody because in Germany, if he had won custody, I would have had to leave the country and he wouldn't have had to pay me alimony. But he didn't win custody.

Doors began to open up for me one by one. I started to teach English in a little public school for housewives.

And things changed for me step-by-step. And when my kid was ten, I went to a party and met a wonderful person, and I have had him by my side ever since.

Every new day is a new experience. No day repeats itself.

AZIZ

WHEN I WAS FIRST OUT OF COLLEGE I GOT A job as an associate producer. There were probably fifteen of us. All in our early to mid-twenties. I was working on a show for the History Channel at the time. And we were all very enthusiastic and extremely hard-working. We would work until 11 or midnight every day. It was one of those situations where you get very burnt out.

There was this one associate producer named Gora. He was in his early or mid-forties. He was a Hare Krishna. I'm sure he could have been a producer many times over, but he just clocked in at 10, and by 5:30 at the latest, he was out the door. Gora was this wonderful dude, and his real passion was playing sacred music.

All of Gora's shoots went down perfectly. And anytime any of us crazy, floundering twentysomethings had a big shoot, we'd find a little picture of Ganesh at our computer. Gora would put a little postcard of Ganesh on our desks because Ganesh is the remover of all obstacles.

This one day I was totally freaking out about a shoot, and I was like, *I'm going to go and figure out how Gora is doing it.* So I asked him how he managed to keep cool and how he was such a good producer. He looked at me and he smiled and he said, "Well, I just try to see people the way they see themselves." I just kind of shrugged my shoulders and started to walk away. And he was like, "No wait! Aziz! I just told you something extremely deep."

I'm so grateful he gave me this simple, yet very actionable advice. And if he hadn't realized that I wasn't taking it in and doubled down and told me it was deep, I probably wouldn't have noticed it as such good advice.

ANN

I'M SURE THAT IT WAS DEVELOPING THROUGH middle school and high school. But I knew I had this eating obsession going on. And in my freshman year of college, I was obsessed with not gaining the "freshman fifteen." And I got really regimented about running every day. And I got really focused on my food intake. I was strict about what food I would eat. No fried food, very little meat. I was eating a lot of bagels and frozen yogurt. Bagels aren't healthy, but I was like, *There's no fat in these!* That was my thought process. Without realizing it, I was being extremely picky.

My mother was always kind of obsessed with weight and appearances, and I absorbed all of that. So during my freshman year it was getting worse and worse, and my family started to notice. I didn't realize I was depressed and I was having suicidal thoughts. It wasn't just about the food, it was about control. I was obsessively thinking about what I was going to eat and what I had eaten.

I remember being in the car driving and looking out at a field and how beautiful it looked—I was in Kansas at the time—and thinking, *I very rarely ever have thoughts like this because I'm almost always thinking about food.* And I remember thinking, *I don't want to live if I'm always going to be thinking about this.* It felt like torture.

I expressed this to my mom, and almost immediately she put me in therapy. I transferred to a different college that was closer to my mom. I went to a dietician and I went to group therapy, which was horrible. I knew I was bad, but there were girls in group therapy who were worse. You could see their skeletons. It was awful. I thought, *Well, I'm not there yet, and I don't want to get there.*

At one point, the dietician was like, "It's so good, you gained two pounds." And I cried so

hard. I wanted to get better, but I couldn't let go of the control.

That summer, my friend Laura, who I'd grown up with, invited me on a sailing trip to cross Lake Superior with her and two other girls. One of the girls was named Sarah. I had grown up with her too. She was beautiful and a couple years older. I was like, *Wow, to be Sarah.* I idolized her. She had this beautiful Botticellian body. She was very happy in her body and really gorgeous. And I felt so gross in my skin, and I felt like a skeleton. She was this cool, alternative girl. She didn't give a fuck what anybody thought. Sarah had this gorgeous bathing suit she'd gotten in France. It was olive green and she was blossoming out of it. She was in this bathing suit picking raspberries, and I remember thinking, *Oh shit, I want to fill my body out. I want to be full.*

Then we actually crossed Lake Superior. And these women that I crossed with were not talking about calories or fat content. It was so important for me to be around. And we docked in this place in Canada, and there was this old house that had been converted into a pie shop, and we ate the pies from there. And they were made of fresh fruit, and I was enjoying food again.

An eating disorder doesn't just go away. So I was still dealing with it. In my junior year, I went to study abroad in France. They just love food, and there's this ceremony about when you sit down to have a meal.

The first morning there, I sat down to eat breakfast, and I poured myself cereal, and my host mother was like, "What are you eating?" She was like, "I'm going to make you a tartine," and she grabbed a baguette and slathered it in butter, and it was so good. I had always loved food, but in France it was part of enjoying life. And that was major for me.

ZACH

MY MOM WASN'T THE BEST PARENT GROWING UP. She had a lot of kids—there's fourteen of us—and a lot of them she lost to adoption. Including myself. She would just give them up at the hospital, or she'd just leave us somewhere.

My mom left me somewhere, but someone who knew my family found me and said, "I'm going to call his grandma or else this kid will go into the system." And apparently when I was born there were drugs in my system.

So my grandma raised me since I was one year old. But I knew who my birth mom was because she came around like once a month.

There were awkward moments where the teacher would ask, "Who's your mom?" And I didn't know what to tell them—my grandma or my birth mom?

When I got to college, I met people with similar circumstances, so I didn't feel as weird.

After I graduated high school, I asked my mom, "Hey, what happened? Why'd you leave me?" And she said, "I like to live life, and kids were holding me back, and I have no regrets about that because your life turned out for the better."

I was like, "Wow, you have no regrets?" She said she had no regrets because my life turned out for the better. But she didn't make this choice for me so that my life would be better; she made it for herself, and I just so happened to end up with her mom, which is why my life turned out for the better.

I had opportunities. I had friends. I grew up in a house where they made sure I read books and went to the doctor. Made sure I had interests. My grandma bought me a baseball uniform, even though I sucked at baseball.

Now I've got two degrees. I'm married. I work for a big advertising agency. So I feel like I turned out great in spite of my mom.

Compared to my siblings, I did good for myself. Three of my brothers are deceased. Two were killed in drive-bys. One of my siblings was killed at age two by one of my mother's boyfriends.

So it could have been harder for me than it was. In my life, I had a lot of people who invested in me. Healthy people who invested in me. My mom made her choice. It didn't matter that she didn't want me at the time. I'm number seven, so six times before me she said the same thing.

The ten years after we had that conversation—me and my mom—I felt like, *I don't know if I like this person*. It weighed on me.

But I realized I can change the cycle. I'm not going to do that to my kids. And I can raise the bar for us. Just realizing I don't have to follow in her footsteps makes me feel good.

I had been carrying this grudge against my mom and feeling like I was hindered by her choices. But I'm not. And I realized I had to let it go and forgive her. I'm healthy, I'm living my life. It's all about forgiveness.

TANYA

It was this shitty, shitty house, but it was a shelter for people when things went really downhill.

I MOVED TO NEW ORLEANS FROM NEW YORK almost twenty years ago. I had inherited a little bit of money, and I used it to buy a house. The house was twenty-thousand dollars. It was abandoned, burned up, didn't have wiring, and had been regarded for years as "the crack convenience store."

I bought the house with the encouragement of my boyfriend at the time, who was a super-anarchist squatter who refused to rent anything.

It was a privilege to be able to buy a house. But the house I had the money to buy was really awful. We had ash raining down on us all the time because it was all burned up. It was missing a floor, it was missing walls. We were getting what power we had through an extension cord running to a neighbor's house.

My boyfriend had said, "Oh, I'm an old-time squatter. We can fix up this house, and we can live in it, and we'll never have to pay rent." But then he left me.

And then the house got hit by a tornado, and the roof caved in.

Then Hurricane Katrina happened. And after Katrina, there was a second hurricane. New Orleans became completely desolate.

There were overturned buses and dead animals in the street. There was no power. People were setting their properties on fire to collect insurance because everything was so desperate. There were military helicopters overhead, and the National Guard were the only people out.

I remember having this moment where I was watching the house across the street burn, and I thought, *I'm getting out of here.* But then this guy I didn't know came up to me and said, "I don't have anywhere to stay, can I stay in your house?"

Suddenly my house had become better housing because other people's houses were so destroyed, but mine didn't get as much hurricane damage. It was this shitty, shitty house, but it was a shelter for people when things went really downhill. People who had lost their housing started staying with me.

A little while after that, this political collective from California came to help rebuild hurricane-damaged housing, and they stayed in my house and helped me fix it. You never know which way things are going to go. I feel like if you stick around in a bad situation, weird things come up and you never know how you can be helpful or when people might help you.

NAFÉ

I'VE BEEN DOING A LOT OF WORK AROUND what it means to have grown up with a father who is an alcoholic and an addict. I've been working to overcome that and the shame that comes with it and the lingering trauma.

I think it was hidden from me for a really long time because I'm the youngest sibling. And I think my mom and my sister were like, "Awww, Nafé, she is so little and innocent. She can't see any of that." And I didn't remember any of the really hard things from when I was a young child. And they thought, *Well, if she doesn't remember it then we don't have to talk about it and we can just hide what is going on.*

So when I was a teenager—like fourteen—I started spending more time with my dad, and I was like, *Wow, he's drunk a lot.* And there was a clicking moment for me and I was like, *Oh, he drinks more than everybody I know, and he gets* drunk *drunk. My other friends don't put their dads to bed in the evening, but I do.* And that felt shameful because you're not the one who should be taking care of your parents. Your parents are supposed to be taking care of you. I felt like I couldn't tell any of my friends. I had to hide, and if people asked me questions about my dad, I was very vague.

You kind of never know what's going to happen, like how he's going to be the next day. And to not be able to have a real sense of the future and what it holds—that's very scary. You're constantly tense. You're on your toes. It's always unpredictable.

I wasn't addressing the issue at all. And I think I got a bunch of issues from it. I developed a lot of mental illness from it. I thought, *Oh fuck, this is coming from somewhere, and I have to address it and be open about it.* It can't be this weird shame that I carry through my life. I can't keep making it a shameful thing that I am somehow responsible for.

It's very liberating to be open about it and be like, "My dad struggles with this." A big thing for me was being open about it with romantic partners. Because for a really long time I wouldn't talk about it. I would be like, *Don't tell those guys that your dad is an old heroin addict and alcoholic; they won't like you.* But that's not true! It's not my responsibility.

I noticed that it has been easier to work on my own mental health issues because I don't have to worry about the mental well-being of this other person and what they are going to do. I don't have to carry this horrible burden of responsibility. I get to care about my own mental health and my own self. I'm the child here. I'm not the parent.

CHRIS

I STARTED DRINKING WHEN I WAS FOURTEEN. Right away, I knew I wanted to do it again, even though I threw up. We drank this disgusting stuff called hooch—it was just sugar. It was bright orange. We'd drink it on the train tracks.

Drinking was immediately a problem for me because I no longer looked for other activities to do. I would just drink and do drugs. And that would be my activity for the day. I would go to somebody's house right after school and drink or drop acid or smoke weed or do mushrooms or take Ambien. A couple times we got a whole pack of Sudafed and we'd take all of them—and you'd have these weird feelings in your body.

This lasted fifteen years. During that time, I got a DUI, went to jail, lost my license, got banned from Canada. Eventually, I had to do this outpatient rehab program, and they required me to go to AA. But none of it worked. I knew I had a problem by then. I would think about quitting all the time and talk to people about how I was going to quit while I was high on cocaine. In my twenties, I was a comedian, and I was performing live a lot, and I'd sabotage myself all the time. I'd have a show at 8 p.m. and wouldn't wake up until 6 p.m. Or I'd have a meeting with an agent at 10 a.m. and show up reeking of booze and BO. When I was in college, I studied abroad a bunch, and my drinking was a problem in every country I went to.

It got to the point where I realized I wasn't living the life I ever thought I'd be living. The gloss and sheen of this partying lifestyle wore off. I lost a whole bunch of friends during this time. All of these things piled up, and eventually, I quit drinking. I knew I had to stop.

At first, in order to stop, I used this idea I learned in AA—you keep a mental picture of yourself at rock bottom in your back pocket. It's a mental image, so it's not really in your back pocket. But the idea is to recall yourself at your absolute rock bottom and have that image handy. When I would remember myself at rock bottom, it would prevent me from drinking. That really helped me. And I decided to find other things to do—other than drinking. I got into things I used to be into before I started drinking, when I was fourteen.

People say to me all the time, "I wish I could quit." And I say, "You can quit." If you think you have a problem, you do. Throw yourself into doing something else. There are so many other things to do. Learn something new. Learn something easy. Work on running a mile. Or learn a language. Get into making things—like bread. You might gain a few pounds, but people will be more impressed by you making bread than you being drunk. Almost everything else is more rewarding than feeding an addiction.

Now I've been sober for seven years, and those years have been the best part of my life.

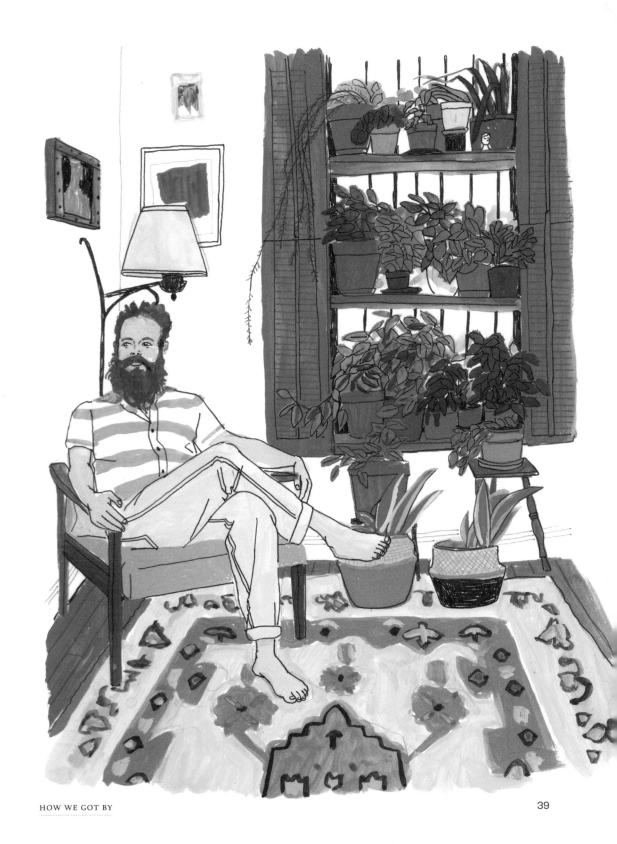

WALEED

I'M FROM A SMALL VILLAGE IN THE MOUNTAINS of Syria. People always assume we are Christian, but we are not. I grew up Muslim, and I memorized the Quran. I am from a huge family—altogether ten siblings. I am number nine.

I ended up in Damascus to get my BA in 2007. I did well in school. Then in 2011, I was drafted into the Syrian army. It was the beginning of the revolution. We did three months of physical training—running, climbing. We were still kids—me and the others in the army; we were maybe twenty years old.

There's no phones; you cannot communicate with the outside world at all. In the early morning, you would wake up and they would play Fairuz songs. She is a Lebanese singer. And a colonel would talk about conspiracies and how we will crush the enemy. When I finished training, they sent me to special forces. I was in the tank unit.

From June 2011 to September 2012, there are so many details that I don't remember. There are so many details that my brain pushed down. I know for sure that I didn't participate in the violence, but I know I was in the background of the violence. I wasn't the bullet that was shot out of the gun, but I was the next bullet that would have been shot out of the gun. I knew eventually I would be called on to be violent. I kept hearing about people who were fearing for their lives, people who were running away from the army, people who would get shot in the back for refusing orders. It was scary.

Eventually our unit was sent to one of the small towns in the south because people there had started to take up weapons, they had started to revolt. We had no idea what was going to happen. I was terrified and surrounded by hyper-masculine guys who were willing to take orders. But I had been trained politically in school to refuse violence—to reserve violence as the last trick in the book. There are so many things you can do before violence. And I didn't want to fuel it more. I didn't want to be the log of wood added to that fire.

They would send people from the special forces to the small villages for small clashes. So this one day, we were surrounding this small village, and we got the order, "If anything moves, shoot it down." I was like, *That's it! I am being greased to be the ball in the cannon.* This one evening, I heard a tank shot. So I went to check on it, and the soldiers were laughing. I saw that they had shot a guy and his cow. I went to my commander, and I said, "They shot a cow; they are supposed to shoot terrorists!" He just dismissed me.

I was trying to decide, should I take my AK-47 and shoot everyone? Or should I run? If I ran, there was a chance I would be killed. But if I shot the other soldiers, I would not be serving anyone. So I told someone I was going to take a piss in the woods, and then I just ran. I cruised.

I was wearing military boots, so I had to hide them. And people in Syria, they hang their clothes outside. So I took some clothes off a line and put them on to hide my clothes and boots. There are military checkpoints all over, and if they knew I had escaped the army, that would be the end for me.

I hitchhiked and begged people to drive me. I had a little money, but not much. I was able

to find a safe house in the mountains. At night, from that house, I could see all of Damascus. I would watch the news twenty-four hours a day until one day, after a couple of months, I got bored and I guess I got too comfortable and I decided to walk around the area. There was a military checkpoint, and they captured me. They took me to jail.

It was horrible. It was one of the lowest moments of my life.

After a month of my parents not hearing from me, they thought, *OK, he is killed, we need to find the body.* They started bribing officials to find my body. My family is very poor, so it was a lot of money for them. One military official said, "We know where he is." And my parents asked how could they get my body. And the official said, "Well, he's alive, so if you pay a little more money, we can get him out." So my mother sold her wedding jewelry—a necklace, earrings, some bracelets. I remember the jewelry from my childhood. She also sold a freezer. She later said that the freezer was more important to her than the jewelry.

I was in jail for three months and twenty days. I was very skinny at the time—you could see my ribs; I was getting skinnier and skinnier.

That day when my family paid the money, it was the first time that the people in the jail called my name in like a month. They took me and eight other people to a bus; they put bags on our heads. I thought, *This is it, I'm being sent to my death. I will be shot.* We drove and drove. And when they removed the bag from my head, I was on the border of Lebanon. It was early September, and the mountains were very dry. There was a phone in a Lebanese village nearby, and they told me to go and that I could use the phone. I called my parents, and they sent me a passport and seven-hundred dollars—it was everything they could give.

From there I went to Beirut and then to Istanbul. My body and my mind were refusing what had happened to me. It was hard to imagine what I had lived through. I was constantly thinking, *What's next, what's next?* There was no living in the moment. I was in Turkey and people were enjoying the sun and the weather, but I could not enjoy anything. Everybody was having fun and they were alive! But for some reason, I felt like I had to go back to Syria. I had what they call "survivor's guilt." I just felt like I had to get back to Syria and finish the job. But I don't even know what job I was finishing! I did wind up getting work helping journalists. I would do translations or go back and forth to Syria getting information for them.

After Turkey, I came to the United States. For me, I don't believe in post-traumatic stress disorder because for me, there is no "post." I have Syria in the background of my mind all the time. It should be called current traumatic stress disorder.

If I have anything to offer it is don't treat this time as a bus stop, don't treat it like you are just going somewhere else. Use this time as best you can. We know this is temporary, but we don't know how long it will last. In my mind, when I was in the army and on the run and then in Turkey, I thought I was doing the right thing to think, *This is temporary, I don't need to enjoy this.* But now I see that you have to enjoy these times rather than just let it go by.

I have been in the United States since September 2013. I am in school here, and I am in love. I am trying to enjoy my moments. You know what is something I often enjoy? The quiet moments in a movie. Or when you walk down a carpeted hallway and you can hear the sound of the carpet under your feet. It is those moments that I am just trying to be in.

CHELDIN

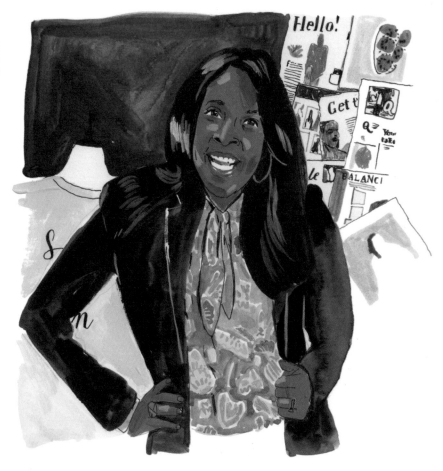

I WAS GUILTY OF OVERPROMISING. THAT WAS MY thing. I've always wanted to be an entrepreneur and a CEO. And in my youth, I believed that ambition was enough. That you didn't need a plan. That if you wanted it deeply enough and if you manifested it enough, it would work. I'm not saying that manifestation doesn't work. I do believe that it does. But it has to be matched with a plan. And what I was guilty of is that my enthusiasm outran my capabilities—that really hindered a lot of my relationships.

So I would be like, "Oh my gosh, we're gonna do this, we're gonna make this happen." And people would buy into that energy because that's a beautiful energy to have. But if you don't have a plan to match that energy, you are doing a disservice to those you share your energy with. And that was such a hard thing for me to realize. I was always letting people down.

I am still overly enthusiastic about everything, but I had to learn to check myself. I have to count to three. I say, *One, two, three.* Then I say to myself, *Do you have a plan, Cheldin? Do you have the resources? Can you really get this done?* If I don't have all three of those things, I calm myself down. I go eat a bowl of ice cream or go dancing. I do something fun that shakes off the enthusiasm.

When I have a plan to match my enthusiasm? Forget it! Amazing things happen! But one without the other? Nothing happens.

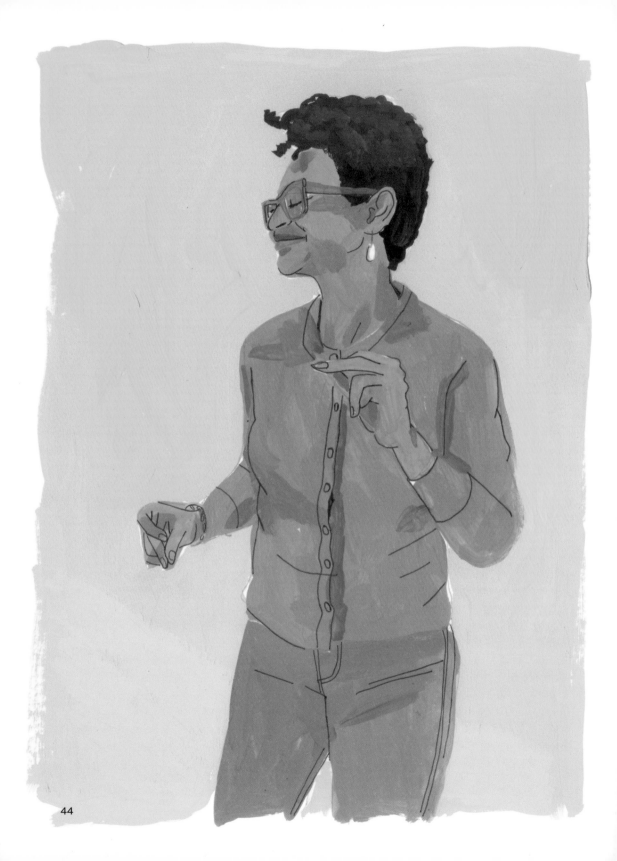

KUYE

MY DAD AND I WERE VERY CLOSE. I'M FROM Brooklyn. My dad's from Brooklyn. We're Bed-Stuy folks. He grew up in a brownstone, and I spent a lot of time in that same brownstone with his siblings—my uncles and aunts—and my grandparents. We were a big, close family.

He taught gym at PS 57 in Bed-Stuy, and he had summers off, so we were at the beach every day in the summer.

Then when I was twelve I moved away, and that was hard because he and I were really close. But my mom had met someone else and got remarried, and so I moved to another state. I didn't come back to New York until I was about twenty-seven. So of course my dad and I were in touch all those years, but I didn't see him every day like I used to. When I came back, I only saw him on holidays—because life is busy.

Then he got sick. He was sick for about ten years. He had kidney failure and was on dialysis. It's a really tough treatment to go through. He aged a lot in that time. It was hard to see someone who was so vibrant and athletic age so quickly. And he kept getting sicker and sicker. In my mind I saw it, but I didn't see it—like, I didn't think he would ever die.

He would do dialysis three times a week. He would drive himself there, go through the treatment, drive himself home, take a nap. Then he'd get up and cook or make wine—he grew grapes in the backyard. He was still doing the things he always did. And we talked every day. I just was never prepared for him actually dying.

So when he died that was really hard. But what was even harder was what happened after; my stepmother and I had a falling out. This is someone I had known since I was about fourteen. And after my dad died, I asked my stepmother for the will. I said, "When are we going to see the will?" She finally gave me the will—at my birthday dinner. It felt sinister. I was like, *Why is she sliding this across the table to me here?* I wasn't going to read it there, so I took it home and read it.

Basically, I was written completely out of the will. I know that's not what he wanted, but he was so sick, and very shortly before he died, the will changed. It just felt very ugly. It felt like losing him twice. And to this day, she's still very mean to the family that's left, and she's fighting to get my grandparents' house—the brownstone I had spent so much time in.

It was a really, really dark time. But early on, I made the decision not to lean into dark places like anger and revenge and spending a lot of time hating her. I was like, *Alright, I just need to heal.* And so I did a lot of things that made me feel free. I do a lot of dancing. I put on all kinds of music, and I dance. It gets me out of my mind and out of my emotions, and there's a feeling of freedom with it. To this day, I still wrestle with what happened. But wherever I am, if I start to get into a dark place, I just dance.

CHAD V.

I WENT AWAY TO COLLEGE IN 2007. IN MY senior year, I decided to move off campus. I was in a little complex that was across the street from the school, so I would still be close to campus and hear everything that was going on at school.

So everything was going smooth at first. My grades were good. Had no problems with the locals in the area. Then Christmas break came. In college, Christmas break is long—you're gone basically the whole month of December and come back after the new year. While I was gone, I got a call from a friend who lived in the complex, and they said that somebody had broken into a lot of the apartments. I found out somebody had kicked in my door, and me and my roommate had gotten everything stolen. We had TVs, electronics, PlayStations, shoes, clothes. They basically went shopping at our apartment. I had to rush back to Atlanta and salvage whatever I had left.

I was like, *OK, bad things happen, but I gotta still do what I need to do to make it through my senior year.* But I felt violated and unsafe because you didn't know who did it or where it came from or if people were watching you. It felt strategic. They knew we were college students, they knew we'd be gone for this certain amount of time. You're kinda sleeping with one eye open because you don't know if this person was gonna kick in the door and do it

again. And every time I'd go to class I'd bring my laptop with me.

My roommate was shook about it because they got him way worse than me. He had a sixty-inch TV they took out of there. And that also makes you think, if somebody walked out with a big TV like that, somebody must've noticed it.

The first week back from Christmas break, I lived at the apartment by myself because my roommate didn't feel comfortable. Eventually my roommate started feeling comfortable, and he came back. I don't know if the locals saw his truck or something, but about a week or two after he came back, we came home and we saw our door was cracked open again and they had gone back into our apartment. I was like, *OK, this is the second time they're getting us, but it's not gonna happen a third time.*

This was my last semester, so I had to figure out what I was gonna do. Luckily, one of my close friends allowed me to sleep on his couch for the whole semester. It was an uncomfortable situation, but my parents didn't raise me to be a quitter. I was upset of course, but instead of sitting there and crying I had to adjust and get the job done. I still had to graduate. The teachers aren't going to be like, "Oh, he got robbed, give him an A." You gotta keep pushing. You gotta do what you gotta do. So I had to adjust and push through the uncomfortability.

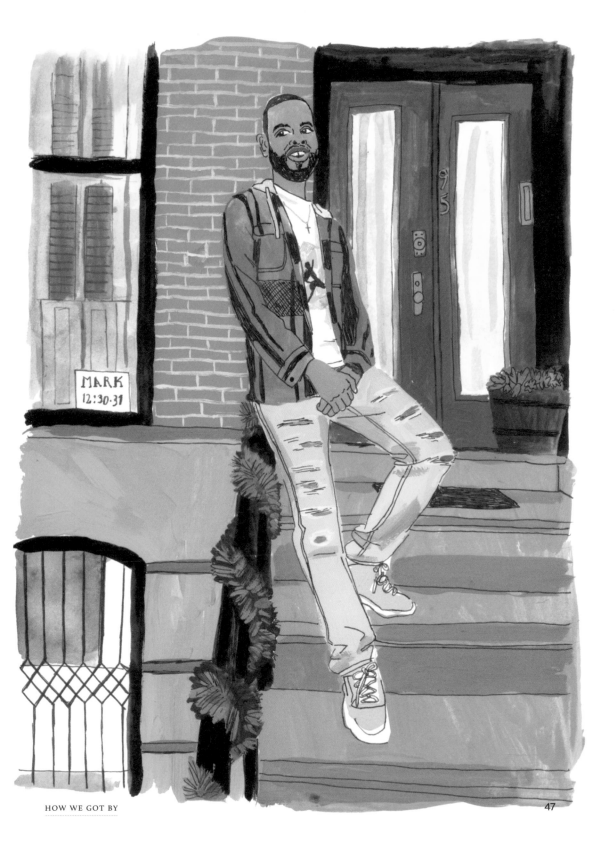

MARK
12:30·31

MAGIN

IN JULY 2020, I HAD A BLOOD CLOT. IT WAS actually a hemorrhagic ovarian cyst, and apparently they are pretty common, but doctors don't really know why they happen. Basically, something had been growing slowly in my body for years, and I didn't know about it. A cyst had burst on my ovaries and started to bleed and create a blood clot. I noticed there was some discomfort, but I was ignoring it.

And then my husband and I were having a rare moment of intimacy—which is always such a special occasion for a married couple with a child—and all of a sudden I was in excruciating pain. It felt like contractions. At first I thought it was something wonky with our sex. Then I thought maybe it was something I ate. I took painkillers. But I was having trouble walking and moving. It was late—like midnight. And I waited an hour or so, hoping it would subside. But it was just getting worse.

We went to the hospital, and there was no one in the emergency room. They started doing all of the routine checks and monitoring me. Everything went really fast. It was go, go, go.

I was in so much pain, I had a hard time even knowing what was happening. Finally they got me in for an ultrasound, and I was laying on the table, and the technician was scanning my uterus area. And I was watching her. I was tired and was really delirious, but I saw her chest start to heave. Her breathing changed. Her face didn't change, but you could tell she was seeing something. She asked, "Are you tired?" And I was like, "I guess." She went to talk to a doctor, and they came back and they were like, "You have internal bleeding." Everyone was very kind, but I felt like a piece of meat.

A surgeon came in and said, "We need to perform emergency surgery right away to clear out the blood in your body." I was moved upstairs for the surgery. I was rolled in on a bed. It's totally from a movie: I'm in a hallway and there's lights and people's faces over you. A person is prepping all of this stuff—all the trays of tools. Finally, the surgeon came in who is this older man, and he said, "You've been feeling like something is wrong for a while, so why didn't you do anything?" It was sort of like he was accusing me. I was like, "I'm sorry, I'm in so much pain right now, can you be nice to me?" And then they lifted my body and put me on a table and put the mask on my face, and I was out.

I woke up hours later. Apparently there was a liter and a half of blood in my body. And they had to blow air in to suck it all out. I spent another day and a half in the hospital because I had lost so much blood that they had to give me a blood transfusion. It was insane. I remember looking up and there was this stick where the blood bags were hanging off. One of the bags of blood was really red like ketchup and the other was darker, like BBQ sauce.

I think something in my body was like, *Don't remember this*. It was an out-of-body experience. There's this attitude of *just get through this, just keep moving.*

It's so weird, but when I was a kid I did a lot of regional theater. And I was in *Macbeth* when I was seven or eight. I was one of the Macduff children, and I was in a scene where Macbeth murders these two kids. And the director had set it so that the whole set was all white. It was very minimalist, we were all dressed in white. So somebody murders me, and I'm wearing a white dress with a bag of fake blood under my dress. It was a Ziploc baggie of blood, and it was strapped to me. And this actor slices my belly, and you'd hear the whole audience gasp because it's so insane. And there was all of this blood and I would fall to the ground and drag myself across the whole stage leaving this line of blood. It was really dramatic.

I wasn't making this connection when I was laying on the table full of blood, but now it feels like I knew this was going to happen. Like I had been practicing it. Although when it happened for real, I didn't drag myself across the floor.

ERIKA

A lot of my identity has been for my parents. Everything I do is for them, so that they feel like their sacrifices are worth it.

MY WHOLE LIFE MY SISTER AND I HAD TO BE good. We always had to get good grades in school and just always be good. My parents were undocumented, so it felt like any kind of trouble could be bad for them. It always felt like you can't risk anything. It always felt like we could get deported.

We felt a lot of pressure to be good because when we turned twenty-one, we'd be able to sponsor our parents so that they could get citizenship and be able to do all kinds of things but especially so that they could travel again.

My mom wanted to be able to see her mom back in Colombia again. We were working and being good so that my mom could travel and didn't have to feel like a prisoner in this country.

My sister and I *could* travel. So we went to visit my grandma one summer and then worked the whole next summer so we could go again. My mom was living vicariously through us.

My mom would always talk about it, and she'd say as soon as she received her green card, she'd leave for Colombia to see her mom the next day.

And then my grandmother passed away before we were twenty-one, and it felt like, *What have we been fighting for?* It's like this big build-up to this one moment, and then it couldn't happen anymore. My mom would never get to see her mom again.

I remember when it happened I felt like I didn't want to call my mom. I didn't know what I could say to her. It was this thing we'd been working toward, and what more could I do now? I just kept my feelings inside.

A lot of my identity has been for my parents. Everything I do is for them, so that they feel like their sacrifices are worth it. And that's a lot to carry around.

Now that I'm older I realized that it's helpful to talk about this. You know how people say there's no stupid questions? Well, there's no stupid feelings. All of them are valid. For me, it's been helpful to just be like, *It's OK to have my feelings.*

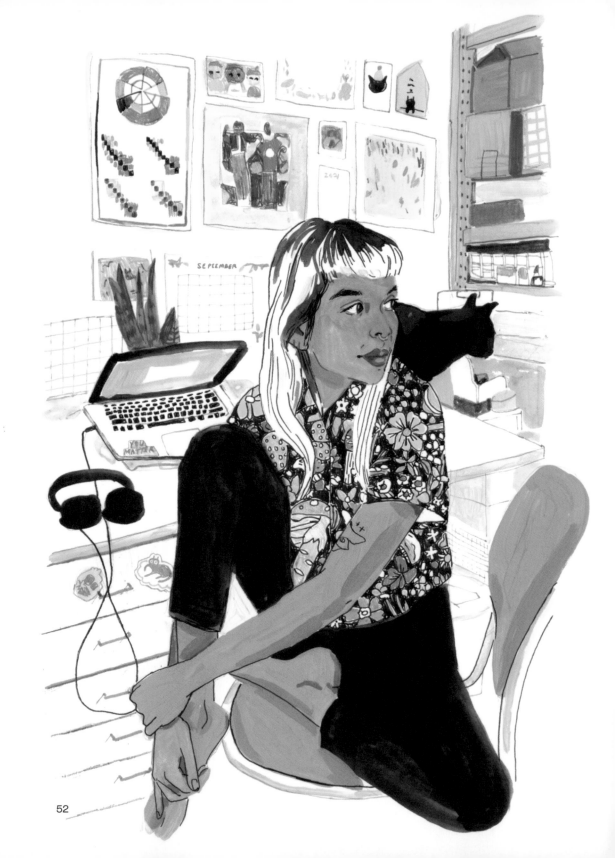

RADHIA

I WAS A REALLY SHY KID. I COULDN'T articulate what I needed. I always had a fear of being scolded or being incorrect. It felt like every time I opened my mouth, every word I spoke had to be perfect.

Also, my parents were not so great at talking about feelings, so that made it harder for me to express how I felt or whenever I needed something. This made me have a really hard time communicating and participating in class. Whenever I'd randomly be called on for participation in school, it made me feel like I'd rather die in my seat.

And it was just really hard making friends. There were times when I would retreat into myself because that's where I felt safest. I went to some middle school dances, but I never went to a high school prom or anything big. Because anxiety!

I remember being embarrassed when I thought I'd said something stupid. The back of my neck would get incredibly hot. I would get really flushed, and I'd immediately dart to the bathroom. It was this nauseous feeling. I would

physically get sick. I didn't realize this when I was younger, but I was having a panic attack. I was like, *Why am I having a hard time breathing the moment I'm done speaking?*

Once I started acknowledging it, that's when I was able to start managing it. I thought about *why* I was so scared of speaking to other people and what I felt comfortable talking about instead. I realized I could articulate myself better when I talked about things I enjoyed or things I was interested in. I hated the feeling of *wishing* that I had said something but not doing so. Whenever I'd see someone really cute, I'd be like, "Damn, I could have been like, 'I like your hair,' or 'I like your style.'"

I realized as I got older that in order for me to develop as a person, I needed to communicate better. I needed to voice my needs and my wants.

I still have a lot of trouble socializing with other people. I'm still working through it. But I realize if I can openly speak to other people, I can build a connection with them.

MARY

Making lists and laughing made me feel good. It was better than sitting around feeling sorry for myself.

WHEN I WAS SIXTY-THREE, I WAS SITTING, eating my lunch, and I crossed my arms under me, and I felt this lump. It was underneath my right breast. I said, "Uh oh, this doesn't feel good."

Eventually I found out I had breast cancer. They did at least four lumpectomies to remove the lump, but they could never get clear margins, so then they said I had to get a mastectomy. I said, "Fine, what are you gonna do?"

I had the mastectomy. And I had a little time to heal. Then they started me on chemo. I was naive about what was going to happen with chemo. I knew I would lose my hair. But I didn't know I would get severe headaches. And I got really tired too. And the chemo got worse and worse. I became a basket case. I really couldn't do much of anything. Food didn't appeal to me. It was hard.

After a while, they stopped the chemo because I was developing neuropathy in my feet. I was still feeling very tired most of the time. And you can't really go out and do too much. But I would make a list of things that were things that I *could* do. Small, little chores. That way, every day I felt like I was getting something done, but I wasn't wearing myself out.

In the evenings I would turn on Comedy Central and I would watch *South Park*. I got hooked on it. It made me laugh. I would do that religiously.

Making lists and laughing made me feel good. It was better than sitting around feeling sorry for myself.

It takes a long time to recover, but I did recover. I don't watch *South Park* anymore, but I still love it. I think it saved my life!

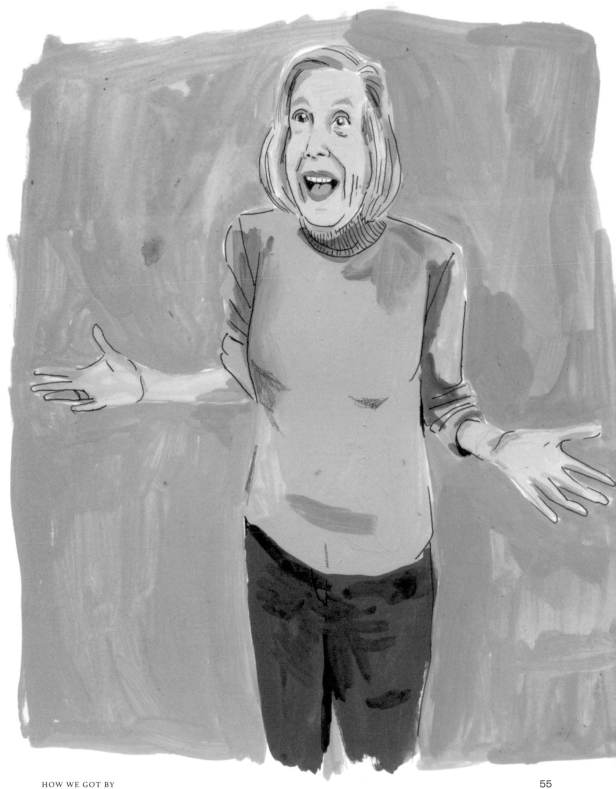

FAREEHA

I STARTED 2019 OFF BY HAVING TO GO TO THE emergency room because I was having an allergic reaction to a room I was subletting. Apparently there was a ton of dust in the room. Like *a lot* of dust. And I started breaking out in hives. But I wasn't sure why. And I was feeling like shit.

I decided to walk over to Urgent Care and see what was going on. Once I got there the nurse was like, "You're having anaphylactic shock, and I'm going to stab you with an epi pen." It hurt so bad. Once you get stabbed with an epi pen, you have to go to the emergency room so they can watch you. So I went to the ER, and they were like, "Just let us know if you can't breathe." And that made me freak out.

It was really lonely and isolating in the ER. And I didn't know who to call. I had spent the last few years just focusing on my career and not on my relationships. My relationships were not in a good place. I had the mindset that if I just succeeded professionally, I would eventually get back to my friendships.

I felt like such a loser growing up, and I just wanted to prove myself to everyone by being successful. But it was this crazy thing to prioritize that over mental health and relationships.

Having to be at the hospital at that time was so isolating. It was hard to ask for help. It was really lonely. But it made me think about how I had been so isolated for so long.

I learned from that experience. I was like, *Wow, my priorities are so out of whack.* I think I came out of that reflecting on my life and realizing that career is not more important than relationships.

Now, for example, I have to go for this procedure where they put you under, and I asked my best friend to pick me up. And that felt monumental. It feels like I've worked on my relationships so that I don't have to feel alone anymore.

And for an immigrant Pakistani-American kid from Virginia, not feeling so alone in the world anymore feels like a huge triumph.

IRIS

I CAME TO AMERICA WITH MY MOM WHEN I was sixteen or seventeen. I came from Belize to a big, new world. It was a little scary. I didn't know what to expect. I saw all the lights of the airport and all the planes. And the house where I was staying was not the same as where I came from. It was all different. And I had no friends. I was very sad for four months. I wanted to go home.

Then my mom and I went to an agency to look for a job, and we saw people like us. I met people like me from the islands—from Jamaica, Trinidad, Haiti. And we all shared stories. It felt good to meet people like me. We exchanged numbers, and I started to have friends. It made my life easier because I saw people like me going through the same thing as me.

Now I love New York. You can do whatever you want to do in America. If someone was coming to America from Belize today, I would say, "Don't expect what you hear from people in Belize." They say, "Oh, in America you can get this and that." You can, but you have to work for it. I worked for it, and I'm still working for it. I ain't giving up. I am a business-woman now. I own my own bra shop. I was always saying I want to be a CEO of something. And it happened.

I worked for it, and I'm still working for it. I ain't giving up.

GRETTA

THERE WAS A PERIOD OF MY LIFE—BACK IN the '80s—when my best friend was dying of AIDS, and my mother was in and out of hospitals, and my daughter was in and out of hospitals and was told that she had this very dire condition and probably wouldn't live until she was ten.

I was spending my life in hospitals and in despair and anxiety and trying to take care of everyone and do everything I could. I was feeling overwhelmed and alone in it.

I had been doing a lot of meditating, but it felt like, *Well, this isn't helping at all.* And I felt really angry at the universe because I had been trying to be so good, and not only did I not know how to deal with all of this but it also felt like, *What is the meaning of all of this? Am I being punished?* There were all of these emotional and psychological things going on that left me feeling at the end of my tether. I didn't know how I was going to get through it.

There was this one day when I was in the hospital, and I called up this meditation center that I belonged to and they had these women, these expert meditators who were spiritually more mature than me. I called them and said, "I don't know what to do. I'm really falling apart. Can you tell me what to do?" I told them, "I feel like I want a drink, but that doesn't feel like a good idea." And the woman I was talking to said, "Yeah, probably not a good idea to start drinking." And so I said, "What do I do?"

The woman paused. And she said, "So you're in the hospital? What is something there that feels good? What is something that doesn't feel terrible?" I felt like a smart-ass, and I said, "Well, the lemonade is really good in the cafeteria because it's real lemonade and they have one of those nifty machines that squeezes the lemons." And she went, "Well, that's it. The lemonade." She said, "I want you to just focus on the lemonade. Just really be with the lemonade and feel the goodness of it. Taste it. Feel its cool. Allow it to be in your body, refreshing you. Then you're going to find other things, like the lemonade, to focus on."

I did focus on the lemonade. And then I thought, *OK, what else can I do?* There was this little garden outside the hospital and I thought, *I'm going to get my daughter to this garden.* And my daughter had so many IVs—there were three IVs feeding her and giving her medicines and keeping her alive. So I said to the nurses, "How can I get my daughter to the garden?" And the nurses said, "I don't know." But then they got it down from three IV stands to one IV stand that they could attach to the wheelchair, and if I promised to be back in a half hour, they said I could take her.

I wheeled her out to the garden. And I told her about the lemonade, and I gave her a jade stone to focus on because she couldn't have lemonade. And for that half hour we were just in that garden, and all the other things—the past stuff and the future stuff and the what-is-going-to-happen stuff—was not there. We were just in the garden.

My daughter remembers this as a really important moment. We felt this sense of whatever happened we could always find a lemonade or a garden or a jade stone and be with what was in the moment.

Life happens and I get caught up in the this and the that and my worries and fear. But because I have this place that I can remember, I can bring myself back to this interior garden or the lemonade.

Sometimes I have to remind myself, *Remember the lemonade. Focus on something that is right here that feels good.*

DORIS

OUR SON ARI WAS BORN IN 1986, AND HE suddenly got ill with a metabolic imbalance. So within a twenty-four-hour period, he was brain dead. He was sixteen to seventeen months old. When they did the autopsy, they found nothing wrong with him. He was perfectly healthy.

Ari was our first kid. He died in '88, and Gabriel—our next child—was born in '89, exactly eleven Hebrew months after his brother died. So you say Kaddish for thirteen months, and my due date with Gabriel happened to be on the last day of saying Kaddish for Ari. So at Gabriel's bris we said their two souls were crossing. We said that Ari had told Gabriel that he had broken us in as parents.

We didn't want an empty house, so eighteen months later Naomi was born, and then Margot two years later, and then that was enough. We stopped there.

There was this sense of, *Can it hit twice?* And I do believe it could. So I always walk around feeling like, *Shit could happen anytime, I just hope it doesn't happen to me.*

When I think back about how I managed during that time, I have no idea. Because if someone told me this story, I would think I could never live through it. And yet, here I am.

We were part of a community, and Ari was attending a daycare, and when he died, the news went up and down our community that this healthy kid had died. The pediatricians knew it, and families with kids around the same age knew it. Some of the people we didn't know very well, and when we'd walk down the street, they would cross the street. They couldn't look at us. It was too upsetting and made them too worried about their own kids.

I didn't have any kind of belief system. I was furious, just furious. It's been thirty-four years. I'm not mad anymore. I'm just sad.

My experience of grief is that, at first, there's no breathing space. It's just there in everything you do. But time starts creating space. So between those moments of feeling horrible, time gives you some relief. But it never goes away. His birthday and the day he died are always difficult. And the thing about grief is that when you experience it, it's like it's just happened. Grief has the ability to throw you back in the moment, and you never know when it's going to hit.

We were looking for groups to join after Ari died, but our situation didn't fall into any specific category. He didn't have cancer, he wasn't sick for a long time. So we wound up going to the SIDS group. And that was helpful.

For us, it was this big hole, and we had nothing we could blame. It was just the way the world comes together sometimes.

One memory that's so clear in my head is, the next morning, I was in the bathtub and the sun came up, and I was just furious that the sun would come up and act normal when my life was gone. And over a long time, I came to really appreciate the seasons because it was something predictable. Like the sun rising and going down, it was soothing because I knew it was going to happen. Whereas, if my child is going to die again—another one—that's not predictable. So I wound up taking solace in nature.

My middle child, Naomi, had a daughter a year ago, and she named her Ari Keshett after the brother she never knew.

BIBA

I HAVE A HISTORY OF LEADING TWO LIVES. THE way I was raised, the way my parents are, there were a lot of shoulds—"You should be this way. You should behave this way. This is how you should present yourself. This is the kind of person you should be. This is what you should want for your life."

But I wanted more extreme or visceral experiences. I had learned how to compartmentalize so that I could have the things that I wanted, but then have this more outward-facing life. I had learned how to hide, I guess.

When I got married, I thought I was over all of that. I was like, *I'm better!*

I would have considered myself happily married. I thought that I had figured it out and had done it right. I had just had my second child when I met somebody and had an affair.

While it was happening, I almost felt outside of myself. I was like, *What's happening right now? How is this happening?*

It was more than this random affair that happens, and then it's over and you try to fix your marriage. It lasted a long time. I tried to end it and work on my marriage. But I kept going back to it. It wasn't over.

My ex wanted to get through it. He was like, "I'm able to get through this; I don't want to get a divorce."

But after everything that happened, I don't know how you get past it. I don't think we could have stayed together.

I wound up deciding to get a divorce.

We get along. I consider him a friend. I love talking to him. We co-parent really well. I appreciate the fact that he is able to do that with me, and sometimes it makes me wonder why we couldn't have stayed together. There is a connection and an understanding. But there was just something missing.

As soon as it came out that I was having an affair, I went into therapy. And that was really helpful. I am learning to say to myself, *This is a decision that I made, and I am going to face it.* Like, I'm going to stand up for my decisions.

I am also learning to be comfortable with being uncomfortable, to be honest with someone and tell them, "Yes, I had an affair; what do we do about it?" You have to know you're going to feel horrible, and you have to just own your decision and talk about it. That's a hard thing to do.

I have regrets for sure. But I feel like I couldn't avoid the pull of it, the life change. And I'm still with the person I had an affair with.

ANNIE

I think most people in the world don't give things a shot because they're worried it's going to be lousy.

MY DAD WAS A SUPER PROLIFIC ARTIST, AND he adhered to the idea of do, do, do, and eventually something's going to work. He was not afraid to just try things, and in the '70s he came up with this piece of advice: "Dare to be lousy." At the time, there was this catchphrase, something like, "Dare to be great." And he came up with the opposite of it.

For a long time, I had it written on a Post-it Note by my desk to remind myself that sometimes you just need to try and do and dare in order to succeed.

So . . . I was a journalist for ten or so years, and then around 2008 I realized I needed to do something else with my life. I didn't think I could pivot within journalism in a way that would be fulfilling for me.

I had always loved dogs, and I spent a lot of time at the dog park with my dog. I thought, *Well, I'm not going to be able to do anything work-wise unless I'm really excited about it.* So I would go to the dog park and make lists of things I liked and then would think about how I could possibly make money doing those things.

And at some point I was like, *You know what I really like doing? Sitting at the dog park and writing in a notebook and talking to people and watching dogs and hanging out with my dog and learning about dogs. This is actually the thing I like doing!*

Someone at the dog park said that his father had just retired and become a dog trainer after going to this six-month vocational school. So I applied to the school he went to and got in, and I put it all on my credit card. I thought, *I'll figure it out.* The program introduced me not only to how to train dogs but also to the field of behavioral science, which is something that made so much sense to me. It seems crazy to me now, but I hadn't even known that behavior was a legitimate area of scientific study. Its applications for training dogs made so much

sense to me. It became clear to me that this is what I want to be doing with my life.

What wasn't clear to me when I got out of this program was how I would make a living at this. There was no one locally who I could apprentice with. There was nobody doing things the way I thought I would want to be doing them. I lucked into meeting this woman who was in a similar moment in her life. She was leaving one career to try to become a dog trainer, and we had complimentary skills. So I said, "I think we should do this together."

At some point it dawned on me that we needed to have a space. Most dog trainers in New York City don't have a space. They work out of a dog daycare or people's homes. I thought, *If we had our own space, I think I could figure out how to make a living at this*. So we ended up turning my living room into a dog training school. It was this very cute Montessori school-type feeling. Like a one-room classroom.

And it worked. We were able to create this environment that people wanted to be in. We had a unique approach by focusing on creating a space that people wanted to be in. Today, we're located in a two-story store-front in the East Village. We have a dozen employees and have helped literally thousands of dogs and their owners.

I think my impulse was to use my dad's "Dare to be lousy" and just go for it. What's the worst that's going to happen? Something doesn't work? At least you gave it a shot.

I think most people in the world don't give things a shot because they're worried it's going to be lousy. But failure is just something to learn from.

The only way to get better at something is to keep doing the thing. If you're too timid to dare to do something that might be lousy, I think it's hard to ever do anything great.

RUTH

I MET MY EX IN DC. THE WAY WE MET IS THAT I was teaching at a charter school, and he would come in and read with our kids every week, which I thought was so sweet.

We got married in 2011, and then on our one-year anniversary he said, "I'm just not in love with you. I feel like this is not the right fit." He felt very awful about it.

What ensued was months of us trying to figure out what was going on. I think being blindsided from the get-go put me in a weird headspace, and our dynamic was never quite equal. I was like, "I'll do anything! Is this over for you?" He was just like, "Yeah." I think it was hard for him because he knew he was hurting me.

That just launched me into a depression.

At the time, I was working for the local Y. In my mind, I don't remember underperforming at my job. I remember getting up in the morning and thinking, *OK Ruthie, you just have to put all of your energy into keeping your job going.*

But eventually I got blindsided again, and my boss, who just didn't like me, fired me on the spot. There was a staff meeting, and she said, "Actually, Ruth, before you go to the meeting, can you come to my office?" And she

And I remember thinking, I just need one constant in my life. One thread that hasn't changed.

fired me. And I had to go collect my stuff and leave. And I remember standing on the street—it was classic—I had my box of stuff with, like, my plant in it.

At that moment, I was like, *This is rock bottom, right?* This feeling of being blindsided by everything. I felt like, *Whatever, man, I don't have energy for any of this.*

I also realized I could not afford the apartment I had once shared with my ex, so I had to move.

All within a month or so, it was the end of a marriage, the end of a job, and a new home. And I remember thinking, I just need one constant in my life. One thread that hasn't changed.

It was really my dog, Feta, and my cat, Georgie, that were this one through line. Animals being animals no matter what it is, they just need the same things and want the same things day in and day out. They really got me through.

Having a strict routine helped. Every morning I would do morning pages from *The Artist's Way*. It was just sit down and write whatever you're feeling. And walking my dog, Feta. One of the sweetest memories from that time was walking Feta every night at sunset and sitting with him and watching the sun slowly set.

Those were the only moments I wasn't collapsed in tears or trying to figure out my life.

For some reason, I had no energy to do anything but draw little animals. I ended up doing one drawing a day, and it turned into a series called *Portraits of the Unsure*. I would write a caption that represented something I was feeling and draw an animal doing something with a little bit of humor in it. Because I realized I needed some humor to get through this time.

I signed up for this children's book conference. I went, but I was so depressed and had done very little research on how the industry worked. I was completely lost. But I was like, *Maybe I should give this a shot.* I decided to sign up for the same conference the following year, and I said, *I'm going to do everything I can between now and then to learn about the industry and to build a portfolio.* So I did that. I spent a year drawing and building a portfolio, and then the next year, I went to the conference and met friends and won a portfolio showcase. I got an agent and got a two-book deal. And the rest is history!

And now I've published books, and I also wound up getting remarried to a great guy.

It almost feels like a cheesy movie where I found love and a new career. But it's true!

JJ

I WAS BORN WITH SOMETHING THAT I THINK is called radial aplasia. I have a small, L-shaped arm with three fingers.

The doctor tried to straighten it out when I was little. And they did a lot of tests on me when I was a kid to figure out why I had it. I got poked and prodded a lot.

When I was a kid, kids came up to me all the time, and they would say, "Where's your arm? What happened to your arm?"

I was annoyed by it because it happened so much, so I had this defense mechanism where I'd tell people these elaborate stories like, "I put it in a washing machine, and it chopped off two fingers," and "I put it in the dryer, and it shrunk." I would also tell them, "Oh, I left it over there behind that tree," and then they'd go search for it.

Once, I was at the public pool, and a kid asked me about it, and I told him that somebody broke into my house and shot it off. Normally, I would tell people these stories and then they'd leave me alone, and I'd never hear from them again. But this kid at the public pool told his mom and cried about it, and his mom told my mom, so then my mom had a talk with me about why I was telling these stories.

When I got a little older, I played baseball, and I was very much a celebrity because everybody would be like, "There's that kid who plays baseball with one arm." When I went to college, people would come up to me and say,

"I think I played you in little league." I was memorable to them.

College was scary because it was thousands of new people who I had to prove myself to. It was a new place where everybody's feeling each other out. But I wound up being fine. And then halfway through college, this one-legged kid shows up, and not only was he one-legged, but he was a hunk, and he had lost his leg playing ice hockey. So he's like a bad-ass one-legged hunk, and he took my thunder.

I think part of my personality is that I'm obsessed with putting people at ease. I'm used to people being uncomfortable around me because of my arm, and I'm like, "You don't have to be uncomfortable around me." I like to bring it up first or make a joke to a kid and let them have fun with it.

Teens on the street now are always like, "Thank you for your service." Which is so sweet but so sad because I'm such a coward and would never volunteer for something where I could be harmed. So I never know what to say. And I get this weird respect from unhoused people. They'll be asking for money and then see my arm and be like, "Oh, never mind! I'm so sorry!"

Now when kids ask me about it, their parents are embarrassed. But I'm like, "No. It's OK." It's a very understandable question. And kids are so sweet. They're like, "Is it gonna grow? It looks like a T-rex arm." Now at the playground all the kids know me, and it's like I'm famous!

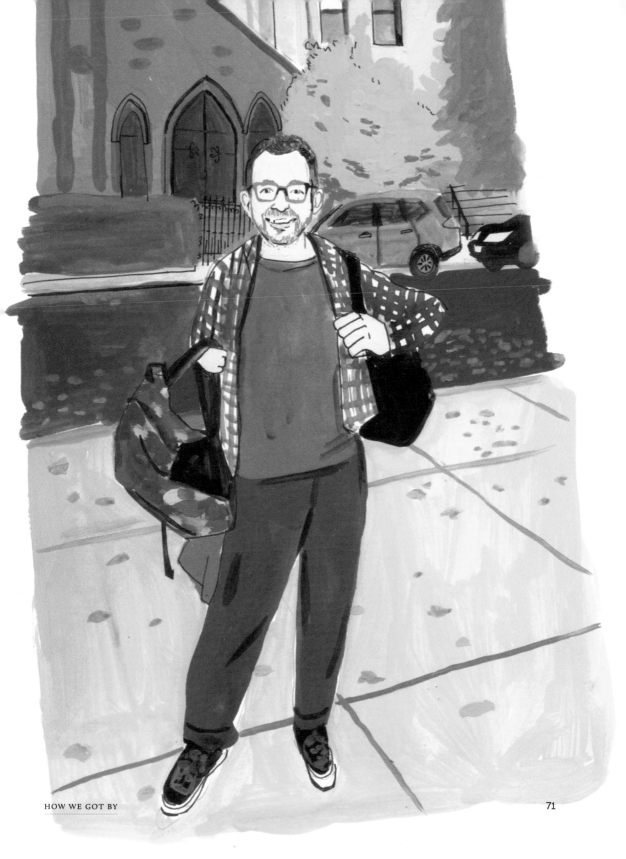

DUSTY AND

WHEN MY KID DIED, I WASN'T THERE TO protect him. I am his mom, and I was not there. I felt really guilty about it at first. He didn't have a flashing light on his bike, and I didn't know that. What if he'd just had a flashing light, maybe the driver would have seen him? The fact that all of his friends had to lose him—again, that felt like my fault. Sometimes I focused on things I didn't have control over, things I don't have control over now. I still have guilt about it.

I've worked through this with my therapist, who reminds me, "You know you don't have this much power in the universe, right? It's an accident that happened."

After he died, I didn't want to enjoy myself. At his memorial, I whispered in someone's ear, "I'll never feel joy again." I meant it, the light was gone. When I was able to feel a little better, I didn't want to. Any little thing that made me happy or made me laugh, I had so much guilt over it. I felt bad about enjoying myself. How could I have fun when my kid was dead? It didn't feel right. Early on, someone asked me out to a concert and I went, but I did not allow myself to enjoy it. I felt so bad about having fun. It was very hard to navigate being a grieving mother and figuring out the world.

I've read a lot of Thích Nhất Hạnh, and he says that humans make themselves suffer, they want to sit in suffering, but we don't have to do that. We can recognize the pain but not dwell in the suffering. We don't have to sit in it.

I've had to work really hard to overcome this, and I'm still working on it. My therapist told me that the more joy I have in my heart, the closer I'll be to my son. Because feeling joy would make my spirit open, and more love could come through from him. I wrote on my bathroom mirror, "The more joy I can feel, the closer to Judah I can be."

I think it's important not to run from any of the sadness, the heaviness—it's part of the journey to just ride the wave of it. You have to allow the emotions, good and bad. These feelings are the purest form of grief—it's vital to sit with them, let the moment move through you.

I've spent a lot of time learning to let the feelings go through me but also to not let them take over. Whenever a big wave of grief has ended, after I ride the wave, I have learned to do some form of self-care: journaling, a bath, a walk, a cup of tea, or maybe reading a book. It takes a lot of practice.

Guilt is normal; it is a part of the process, but it's not the only part. Guilt is not part of the healing because it halts your process. After all this time, the guilt is still there for me. But I visit it less often. I torture myself less. It's good to work through the guilt.

DAVID B.

FOUR YEARS AGO, MY SON PASSED AWAY. AT the time, he was living in Nashville and getting his life started on his own and doing well. It was Christmas, and while part of our family was up here in New York, he was back in Nashville and was supposed to spend the holidays with some family there, but he never showed up.

Days went by. We had people searching and looking for him. He was someone who wasn't

into phones and social media. We had no luck finding him. We had people doing your traditional search—looking for him at his work, driving out to gas stations, friends' houses.

Everything caught our interest. In the midst of it all, there was a news story—very vague and short—about a bicycle fatality, but it was far from where he lived in Nashville, so we initially discounted it. Soon we were getting more

I had been completely turned off, shut down and numb for that entire year, and how I could see in color.

desperate, so my wife followed up on it, leaving messages on answering machines and with various police agencies. Christmas Day passed as we went though the motions of the day still knotted with worry and no sign of him.

It was the day after Christmas; at 7:30 in the morning, we got a call from the city coroner. That day shattered everything.

You know you have the linearity of your life and the struggles that come with it, and when something comes along that absolutely breaks that, you simply don't know what to do. You're in shock and sorrow. From that day forward, all the normalcy that you're accustomed to is uprooted. You're just like, *Why is this even reality? What do I do next?* There's this hollowness, panic, and grief.

If you asked me today, "What did you do for the next year?" I really don't know. It was just sorrow and chaos. My wife and I were in repeated bouts of uncontrollable sadness on a daily basis. Most of the first year, I have absolutely no memory of.

From a personal and very practical standpoint, it's similar to losing a limb. You're still there, you're alive, but you have to figure out what to do. It's absolutely permanent; there is zero changing it. You have this gigantic missing part of you. You can't just get over it and move on. You have to learn to shift your approach from how you used to live, sort of like physical therapy: slowly, incrementally.

I remember initially I had a lot of anxiety about getting together with people because I felt I'd have to tell them that my son died in this tragic accident, as if they'd know just by looking at me or they already heard about it so it's going to come up in conversation. Even if they had no idea about any of it, those topics

always come up. Eventually, I'd have to talk about and relive those moments and feelings to people, in public. The amount of anxiety in the first twelve months was huge. Like, if I'm with my coworkers, will I just break down? What I eventually found most helpful was to talk about it openly, frankly. When asked I'd just say, "I have two kids, one lives in Nashville, the other passed away." Just put it out there. The next few sentences or paragraphs that we talk about, you just get through it. And I've gotten more comfortable with it now as a reality.

And I realized that I had to find a way to cope, I had to figure out how to live the remaining days of my life. I'm learning to navigate the ripples after the big event because some days it's easier and some days it's crippling.

A particularly strong and positive thing I eventually did was I started going backpacking. Actually, right after it happened, I went on a trip with college friends, but I honestly can't really remember much of any of that trip except for I guess it was positive. However, after about a year and going through that first winter without him, I was like, *I have to start doing something to bring joy externally to me.* Something that wouldn't cause me physical harm, or addiction. And so it was back to the idea of backpacking, and once I decided to do it, it took me easily three weeks or so to get everything packed in the living room of our apartment and step out the door.

My most vivid memory of that weekend— what showed me that I had really been in a bad way before this—was this: I was out camping, and that morning I woke up, stumbled out of the tent to fetch my food cache, and I saw the sunrise. And it was this intense colorful sunrise—deep reds, oranges, purples. It was undercast in the valley, and there was fog. This was unbelievably shocking to me. I was crying thinking, *This happens every day.*

Here I had been sitting in my apartment for months, dark clouds, not even realizing that this scene happens every morning somewhere. It might sound simple, but it was amazing in that moment. All I knew was I wanted to experience that same moment again. It was like something in me had been turned on, like someone had flipped breakers on in me. I had been completely turned off, shut down and numb for that entire year, and now I could see in color. So I went back the next week, and I saw a different kind of sunrise and experienced sounds and smells, and things were starting to happen. I could actually feel good about things around me, and not just continue thinking, *Everything is crap, worthless; so . . . what next?*

There's plenty of opportunity to remember my son's death; that horrible reality is still there permanently. Meanwhile, I'm still here walking the earth. And while I'm left here standing alive on the ground rather than feeling perpetually worthless, and to find my own personal feeling of place and purpose, I found peace in nature. I like to think spending time alone in the elements has helped me come to grips with this new reality in my life by feeling personally connected with natural surroundings and understanding how they work. And I see Judah there too—a deer that visits in the morning shuffling through nearby leaves, a fox that follows along the trail within eyesight, two rainbows in a single day, or the sun piercing over the horizon morning or evening—to say hello from the other side.

DR. B.

I've been kicked, had things thrown at my head. You would be surprised how much this happens to doctors in hospitals.

I'M AN OB-GYN AND WHEN YOU'RE A DOCTOR on call—and you're the head doctor—you cover the whole hospital. I've been the head doctor for fifteen years now. It can be challenging because you don't know the patients and they don't know you. There are a lot of patients who just come to the hospital when they are in labor, and whoever is on call is the one taking care of them while they give birth. And we are just a strange face to them.

I also cover the emergency room. So whoever comes in, I deal with them. Whether they've had an incomplete abortion and they're bleeding, or they have a cyst or an ectopic pregnancy or torsions, I deal with it all.

Many days, going to work makes me feel like I'm walking in sand on the beach. It's just regular walking, but you feel exhausted after you're done.

Everybody looks to me. If I lose it, my whole team loses it. And then no one can think properly. Believe me, sometimes I can hear my heart beating in my ears. Pounding. And I feel like I'm going to have a heart attack within the next five minutes. When people are in labor, things happen within the blink of an eye, and you really have like, five minutes to get this baby out before something bad happens. So from the minute I see that something needs to happen—I call for an emergency C-section, call anesthesia, call the operating room, tell the patient, consent the patient, the baby is out—I have five minutes, nothing more. You want to panic and run like a dog following your own tail. But you can't. You have to stay calm.

Very often, I see resistance and mistrust from the patients. I tell them something that

needs to be done, and they say they don't want to do it because they have a cousin who said they shouldn't do it. Their cousin isn't a doctor! Sometimes, patients come in with many pages of birth plans that they've notarized, and they say, "If you do anything different it is punishable by law." And you find out that they got this information from a doula on Instagram! Often this creates complications later on.

I've been kicked, had things thrown at my head. You would be surprised how much this happens to doctors in hospitals.

Before, I was taking it very personally. But I had a mentor who was the head of our gyn-oncology team. He was an amazing human being. I've never seen anybody as nice as him. He taught me a lot, not only medically but also on how to approach people. He would say, "Don't take it to heart. They don't know any better, that's why they are here." He would say, "They don't mean anything they say. Just give them the care they're supposed to get. Don't get upset when they roll their eyes at you. You are here to help them." Sometimes they just don't know any better how to express themselves. That helped me a lot. Just treat them the way you want your family members to be treated.

So now when I ask patients, "Do you have any medical problems?" And they say, "It's in the computer." I say, "Yeah, but I want to ask you." I say, "Have you had any surgeries?" And they say, "Can't you read?" So then I say, "Is something bothering you? Is there something bothering you that I can help with?" Then the ice is melted, and we can communicate much better.

TINA

I GREW UP IN THE IDYLLIC SWISS COUNTRY-side with unhappily married parents—great, kind humans, trapped in a terrible marriage, witnessed by two girls, one of whom was me. My mom left my dad shortly after I went off to college. Back in those days, you stuck things out.

Fast-forward and I get married to a really great man. We got married very quickly and had our daughter very quickly. Our relationship high came crashing down when we realized Ella was one of those always crying, non-sleeping babies. We met our first bump in the road.

Sadly, the way we showed up together in crisis was not compatible. While my husband tried to be there for me, I felt alone early on in the marriage.

My childhood was a boot camp for having a high threshold for emotional pain, so I stayed in our marriage for ten years. What we're used to is what we're comfortable in. I just didn't know any better.

The eternal optimist in me always believed our relationship would magically get better. Maybe once our kids were older. But it never did.

When my daughter was nine, I realized I recreated the same emotional desert landscape I grew up in. As a kid, I had never seen how a healthy, happy couple interacts. And here I was, recreating the same pattern for my children.

Modeling is everything. You can talk and explain all you want, but what you actually do is how they learn. Kids watch you. They copy your behavior, your patterns.

My husband and I eventually hit rock bottom, and we finally decided to do couples therapy. In parallel, I tried to do work on myself, but we were not getting anywhere. It was all a little too late.

And then, one October morning, I woke up with a calm sense of clarity that our marriage had ended. There is no bigger gift than clarity. It was a magical moment where I just knew I had to move forward.

My friends know I have a low tolerance for complaining. A personal rule of mine is that if you find yourself complaining about something repeatedly, either do something about it or let it go. And here I was for years complaining about my marriage and how unhappy I was. Finally I was doing something about it.

That morning, my husband and I walked the kids to school. And afterward, I calmly told him, "I can't do it anymore." And he calmly said, "OK," and asked, "Are you going to keep my name?" And I said, "Yeah, I love your name!" He was hurt, but he was so calm. We very quickly came to an agreement on how to co-parent and what our schedules should be.

When I realized we were separating, I said, *I'm not buying into the dramatic, fighting storyline*. I asked my friends, "Do you know anyone who has a good divorce story?" And then I did what I call my positive divorce case study. I went for coffee with six people who had positive divorces. I asked them questions on what worked well for them, what they wish they'd known. I took notes. Surrounding myself with people who have the mindset that you can have a good divorce set me up for so much success. I kept holding on to the idea that it can be good.

There were moments where it was really hard, and we were angry with each other. But I kept looking at that goal of *we can be friends*.

Now we are really good friends. We go on ski vacations together as a family. We laugh. He's a really good man. We have a good time together. And we're still family. We always will be.

JOE

I'M A RECOVERING DRUG ADDICT. I WAS USING for sixteen years. There was an aha moment for me—I'm a suicide survivor as well—and I was sitting there in the emergency room with my wrists sewed up, realizing I had to make the change. And I wanted to make the change for myself for the first time ever.

Now I help people in addiction. I tell them, "You gotta believe in yourself, and do it for yourself." You gotta see it and want it. You can't do it for somebody else's happiness. You gotta do it for your own happiness.

DALLAS

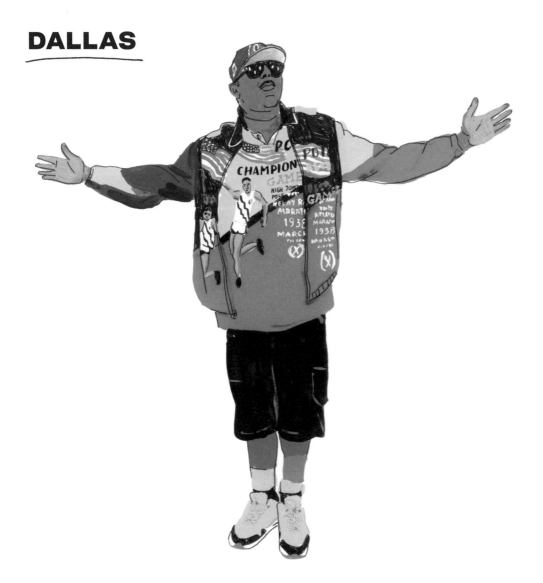

THERE'RE A TON OF THINGS THAT AREN'T IN our direct control, but what we can control is our perception of ourselves. And I do that by framing my own narrative. Whenever I am out of money, I don't call myself broke. I just say, "I'm dealing with temporary recurring fiscal deficits." They're temporary because they don't last. They're recurring because they repeat. They're fiscal deficits because they're me having a lack of money. But I won't call myself broke because I'm always working. And broken things don't work. Sometimes people think if they don't have money, they don't have value. But we're constantly working— working on ourselves, working at our jobs, working to be happy. So I'll never again give myself license to say I'm broke just because I'm short on cash.

ALICE

FOR ABOUT TEN YEARS WHILE I WAS A nomadic snowboarder, I was paying the bills by being a sushi chef in fancy ski town restaurants.

I never set out to be a sushi chef. I was just kind of in the right place at the right time.

I had a friend show me how to make sushi in college, but that was really just an excuse to do sake bombs. After college, I moved to Mammoth Lakes, California, because I loved snowboarding, I loved the mountains, and that was where I wanted to be. I was staying on a friend's couch, so I thanked them by making them my version of sushi. One of the roommates was like, "We're opening a sushi restaurant, and I'm one of the managers there; you should come work with us." And I was like, "No, that sounds serious, that's not me." And they were like, "We're desperate. Come to the restaurant and we'll train you." So I went.

We were busy right away. I worked and worked and made sushi. I felt fortunate because I was being trained by these chefs who taught me these great technical skills and respect for sushi without the traditional hazing and hierarchy. I learned the concept of economy of motion. Everything is very intentional. No wasted movements. I was learning an artform. It was a beautiful tradition that I really loved learning.

When you're a sushi chef, you're front of the house and back of the house. You're like a bartender. You're there to entertain as well as make food. It was very performative.

It was such a unique talent that I could go to any ski town and walk into a sushi bar and say, "I would like a job here," because every ski town has a sushi bar . . . or five.

It immediately became apparent that it was a crazy thing to be a female sushi chef. And to add to the confusion, I'm Chinese, not Japanese. So many who walked into the restaurant started speaking to me in Japanese. Or they'd do their version of, "I know your culture." And I'd have to be like, "I'm Chinese."

I always had people saying, "Do you mind if I take a picture of you? My sushi chef at home would freak out if I told them that I met a female sushi chef!"

Sometimes I'd hear the reasons why there shouldn't be female sushi chefs: like, women's hands are too hot when they are menstruating and they would kill the fish, or their nose isn't sensitive enough so they can't tell if the fish is fresh. And much more.

It made me think of all the other stereotypes people have to put up with. My parents are very practical, and growing up, they were like, "People are always going to see you as Chinese. No one is ever going to see you as something beyond that." But instead of letting it get to me, I decided to let it make me feel really special.

Like anything, if you've been told you're not supposed to do it, find the renegade in the field. That person will be so excited to train you. There's not anything that any of us are not supposed to do. We all can do anything.

SAV

I'M TRANSMASCULINE AND NONBINARY. I USE they/he pronouns. I started to dress more masculine when I was an undergrad. My first year at undergrad, I was in this small liberal arts college within Michigan State University. That was the first time I had heard about gender-neutral pronouns, and I couldn't stop thinking about it. I thought, *That's weird that I can't stop thinking about it.* But I was like, *Well, that doesn't mean anything that I can't stop thinking about it.*

I started to dress more masculine, and I started to get misgendered—I was still using she/her pronouns at the time and identifying as a woman—and I remember getting misgendered as a man and getting really frustrated. I was like, *Why can't I be what a woman can be too?*

A couple years later, after I graduated, I started using they/them pronouns, and I came out as nonbinary.

I first started talking about transitioning and asking my doctor about it four years ago. I had multiple doctors I went to and told them I'm interested in this, and they were like, "You need to get these letters and see a therapist and

Once all of the social pressure was stripped away, I was able to make the decision for myself.

get a diagnosis." And so I tried to do all of it, and it never worked. The whole system of trying to get hormones was hard.

It wasn't until quarantine that I made the decision to do it. I was like, *OK, I want to do this.* I think it was easier to do it in quarantine. When you're just alone in your house, it's so much easier to see yourself transitioning and being OK with it because you don't have all of these outside factors that you're considering and all of these people you're going to see. You're not like, *Oh, what's this person going to think when my voice starts cracking or when I start growing a beard or when my body starts changing?* It really made me realize how much of myself I had been holding back because of all of these outside factors—like, how my family or friends would react or people on Instagram would react, as stupid as that is. Once all of the social pressure was stripped away, I was able to make the decision for myself.

The three years I was going back and forth about it, that was really hard. I was always googling about it, and I would read things like, "You're going to have access to less emotions; you're going to cry less; your orgasms are going to be different." All this stuff is going to change. It's scary. There's a lot of things that can happen, and you don't know how you're going to feel.

But now that I made the decision, it's amazing. It's the best decision I've ever made. If you're thinking about it that much, you should probably just do it.

A thing that held me back for a long time is that my parents are both musicians and I'm a musician and my sibling is a musician, so I've been playing music and singing my whole life. And I knew my voice would change. I know I still can sing, but with a lower voice, it's different. You have a different range. And so I'm still figuring out how to sing again. But it's also exciting to have a new range and be able to make new types of music because of it. Sometimes I'll reach for a note, and it's not there anymore, and it's really frustrating, and I'll be like, *I'll never be able to sing again.* But when I think back to learning to sing in the first place, there were notes I couldn't hit then. So it's like I'm learning to sing all over again.

POOJA

I WAS BORN WITH CURLY HAIR TO A MOTHER with very shiny, straight hair. When I was a child, she would brush the curls and kinks out of my hair with a fine tooth comb and braid the remaining frizz. In an effort to try to tame my hair, she was transforming my unruly curls to static frizz, which made the contrast of our different hair textures even more apparent to me.

When it was time to put me in school, she opted to skip the painful morning routine of me crying under the hands of a fine tooth comb and thought the easiest thing to do was to cut all of my hair off and give me a "boy cut." Which was traumatic. I'll never forget that first day of second grade at a new school—the girls told me I couldn't come into the girls' bathroom because I looked like a boy. I spent the rest of elementary school and middle school wearing my hair in a slicked-back ponytail. I was trying to have the least offensive hair possible. I routinely ran to the bathroom between classes to slick down my frizz with water.

In about seventh or eighth grade, I started straightening my hair because everyone I thought was beautiful either had straight hair or was straightening their hair. There were times in high school that I would be without a hair straightener—when my family and I went to India. Those were the rare times I was forced to wear my hair naturally and not escape from my own *personal thorny bushel*, as an aunt once called it. Outside of the occasions where I was separated from my hot tools and an electric adapter, I never wore my hair curly in public because it always felt like a rare cosmic event for it to behave.

So I chose a beauty regimen of control and consistency over unruly and unpredictable and doubled down on keratin treatments and straightened my hair pretty consistently from eighth grade until I was twenty-nine years old. Straightening my hair felt like I was making myself acceptable. There were a lot of times in my life that I didn't like looking at myself in the mirror. And I wasn't happy with my appearance. And it felt like by straightening my hair, I was doing my part to blend in and go unnoticed.

Now I'm in a very different time in my life than I was before. I found the right hairdresser, hair products, and the confidence to be myself. So I decided I would try this radical act of wearing my hair natural and embracing my curls. I've realized not all beauty standards are one-size-fits-all. You gotta find what works for you, for who you are. And I'm trying to not worry so much about whether my appearance is acceptable to the general public.

BETTYE

I'M FROM SEMI-JIM CROW DAYS. I WAS BORN in 1941. I came from tobacco fields and cotton fields. There was no electricity. You had to burn kerosene lamps. There was no gas stoves or refrigerators. I came from that. I struggled back in the day, but I made it. I made it through praying. I pray every day.

I also love every day. I love all people. I don't have to know them to love them. What's going to make this world a better place is love. It makes me feel good. I have Graves' disease, but I don't let this Graves' disease stop me. Whatever I struggle with, love makes me feel well.

NOUFOU

EVERY SINGLE DAY YOU HAVE TO LIVE YOUR life like it's the last day. You have to be excited. You don't know what comes tomorrow. You're here now, but in the next hour, you could pass away. Don't be mad, don't be sad. The sadness can come, but try to push that sadness away. Live your life laughing, jumping, dancing. I live my life like this.

When I was a child, I felt a weakness in me. I could not walk even two blocks. I got very tired. I went to the doctor, and the doctor told me I had to get heart surgery or I would die. So I had heart surgery. You have to celebrate every day because you don't know tomorrow.

DHANTÉ

Something so harmless turned into this thing I obsessed over.

I'M AN ARTIST, AND I STARTED THIS PROJECT where I took this journal and I wrote on the outside of it "I'll be back in two months from now." I had some friends of mine write in it first, and then I would take the journal out to the park and leave it on a bench, and people walking by would check it out and write in it.

The first couple of days, people would just do drawings or write a few sentences. But as time went on, the responses got longer and more personal.

I would go out a lot with the journal. But then it got to the point where it felt like a power trip. It became my identity for a bit. Something so harmless turned into this thing I obsessed over. It was like, *I have to do this.* I felt like, *The people need me.* It became *I need to do this* instead of *I want to do this.*

When I felt like this—like it was so important—and I'd go out with the journal, no one would write in it. No one would pay any attention to it.

I told my friend about this, and she was like, "You have to take a step back and re-evaluate why you're doing this." So I took some time off from doing it. Because I had been doing it every single day.

Once I took a step back from it, I was able to have a healthier relationship with it. Sometimes we overthink or overanalyze. That's when you have to take a step back and take a sec.

CHRISTEN

I WAS BORN IN THE '70S BUT I GREW UP IN A '50s household because I was the youngest of eight kids with a big age gap. I grew up Catholic, not allowed to talk about sex. I remember being ridiculed when I tried to discover sex as a child. One of the neighbors had a sex book for kids, and I wanted to look at the book, and my mom and sister made me go home and laughed at me: "Ha-ha-ha, Chrissy wanted to look at that book!" It felt shaming to me. That's the kind of background I come from.

When I was in eighth grade, my mother was diagnosed with Parkinson's disease. By that time, it was just my older sister, who was closest in age, and me at home, and we didn't get along. Our mom was becoming very ill, and we both had to take care of her, and I was very resentful about it.

Then I was raped the summer after my mom's diagnosis. The rape was violent, and I didn't tell anyone about it. I was young, and I didn't have the tools of communication.

There were some dark years—in eighth and ninth grade—I was starting to drink and smoke and stay out all night long. All of these things had happened to me, and I was supposed to help take care of my mother at the same time. My mother sometimes thought that I was her mother. Right at a time when I needed mothering, I was pretending to be my mother's mother.

Also, I was lying and barely passing school. But I liked this art class I was taking in high school. And that's where I discovered feminist art.

I always say that feminist art saved my life. I had been raped and harassed and all of these things that I wasn't allowed to talk about. But when I found feminist visual art, I truly felt seen for the first time.

So the first time I found feminist art was through an art teacher at my high school. We had to do a collage, and she had all of these art magazines, and I cut out all the naked women, and it turned out to be work from feminist artists like Ana Mendieta and Mary Beth Edelson. Now I make my own feminist art, and it still saves my life every day.

I'd like to add that my (now former) partner transitioned fairly recently. Then my older child, who was assigned male at birth, transitioned to female and my younger child, who was assigned female at birth, transitioned to nonbinary. So now I'm trying to break feminist art apart so it can be all-inclusive—bodily autonomy is everything.

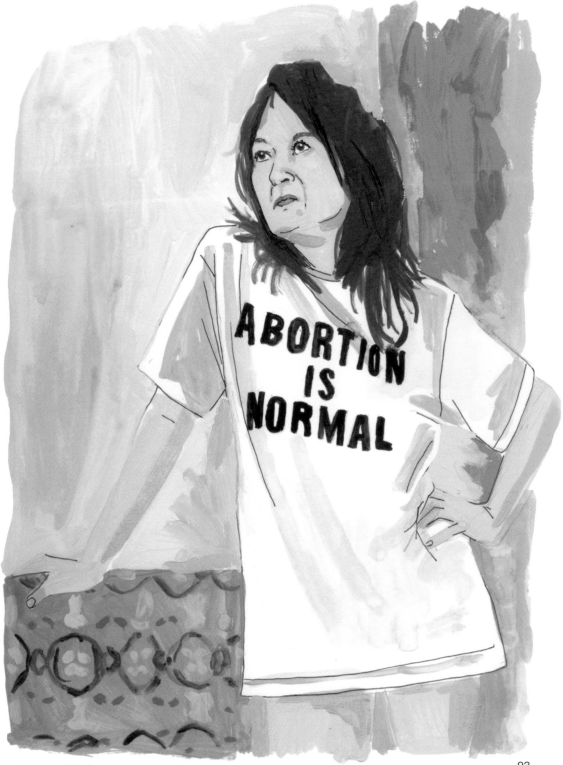

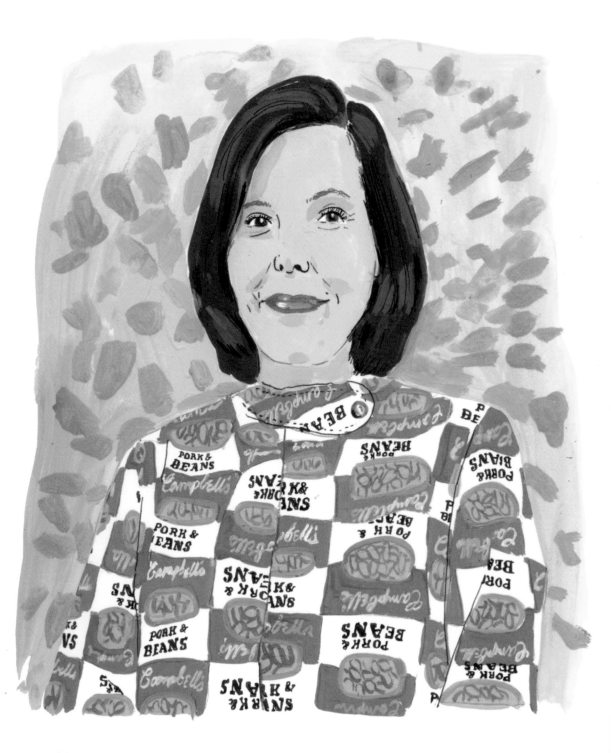

ASHLEY

IN A LOT OF PLACES, WHEN A KID GETS PAST ten or eleven, they're just deemed unadoptable. They're no longer little and cute, so they don't even bother listing them for adoption anymore. It's just assumed they're going to live out the rest of their childhood in the orphanage until they age out and get put on the streets with nothing and no one. It's a pretty bleak future.

So there's this program, Kidsave, that brings about forty kids between the ages of ten and fourteen for five weeks in the summer and puts them with hosts all around the United States. The hosts commit to finding the kids a family. Some hosts are looking to eventually adopt, but some just introduce them to people in their community who might be open to taking on a new family member.

A friend of mine, Lea, helped start this program many years ago, and when she told me about it, I remember thinking, *That's nice, I could maybe host a kid sometime in the future.*

Then, last May, I was down in Miami because my mom was having surgery. I am an only child and an only grandchild, and I was sitting in the hospital waiting room thinking big, sad thoughts about life and family and how when my parents pass away, I will become a family of one.

Right then, Lea called to tell me that a few of the hosts had fallen through at the last minute and asked if I would just take a look at the few kids online that had already been told that they were coming but still needed a place to stay and see if I felt a connection with anyone. She said, "Oh, you're so resourceful and you know so many people, and this would be so much fun for you, and after all, it's only for five weeks!"

Any other time, I probably would've gotten off the phone and forgotten all about it, but I happened to be sitting with my laptop in the hospital waiting room. So I took a quick look, and I saw this one kid's picture, "David" (for security reasons, they give them all pseudonyms that start with the same initial as their real names), and I was like, *I feel like I know this kid . . . have I seen him somewhere before?* I thought, *This little guy? I could take this guy for five weeks. I mean, it's just five weeks!*

And as soon as I'd made that decision, it was a mad dash to get everything together before the deadline, which was only a week away. I got reference letters and fingerprints and did fifteen hours of online training in two days. I got my birth certificate and my divorce certificate. I raced back up to New York to give them a tour of my apartment. And then the very next day, they said, "Thank you so, so much for all of your efforts, but there is a two-parent family that has come forward and is willing to take David, and we really do give preference to two-parent families." It felt like a punch in the gut, but I was like, *Cool, cool—let me have some perspective here. The whole point was to try to find this kid a family. I was just gonna be a five-week visit—this family might be his chance to actually get adopted. I've gotta let it go.*

I went to bed that night and then woke up at three in the morning and wrote an impassioned letter about why I was a much better fit for this little guy than that two-parent family in the suburbs. When I woke up, there was a whole mess of emails in my inbox telling me

that they were so moved by my letter and had never had anyone advocate quite so passionately for a child, and after conferring with the powers that be in Colombia, they had all decided that they were going to place David with me after all.

In his very short dossier, they had said that David was unexpressive and had a low IQ. All I had to work with was a couple of paragraphs about him that said he was *sweet and shy* and two current pictures (the initial picture I'd seen of him online was from three years earlier, when he was nine). So I would stare at these two pictures and try to eke out as much information as I could from them. He had on red Converse sneakers and striped socks. And I was like, *You don't pick that combo out of the clothing pile unless you have a personality*. And I would look at his hands in the picture and say, *Those hands look very relaxed and confident* or *Ooh! He's got a friendship bracelet! He must be good at making friends!* Mostly I thought, *There is so much going on behind this kid's eyes. I just don't think he has a low IQ.*

Anyway, a few days before he came, they set up a Zoom call so we would recognize each other at the airport. I got on the call with him, and he would not even glance up at the camera. He was just staring at the ground saying, *Sí, señora,* to every single thing I asked him in a low, monotone voice. I was like, *Oh no, I just completely made up a whole story in my head about who this kid is, and it is clearly way off base. Oof. It's going to be a long summer, and oh god—I've talked such a big game that Kidsave must assume that I'm definitely planning to adopt him (especially since I snatched him away from that other family in the suburbs), and I'm gonna have to work really hard to find him a family during the five weeks he is here with me just so I'm not stuck adopting him out of guilt.*

Four days later, he arrived at JFK, and when he came through the customs door with the cluster of kids in Kidsave T-shirts, he immediately broke off from the group and made a beeline for me and went straight in for a hug. I burst into tears. It was clear right away that he was exactly the kid I'd imagined him to be.

He got into JFK at 6 a.m., and by 7:30, I'd already sent a note to the adoption agency saying, "Okay—send over the paperwork, this is definitely my kid!"

It felt like I'd always known him and was just somehow finding him again. We fell into a natural relationship really quickly—even though he doesn't speak a lick of English and I speak very limited Spanish.

We had a great five weeks together, and then he had to go back. No matter whether you're keeping them or not, all of the kids from the program have to go back at the end of the summer. Within an hour of dropping him off at the airport, I dove right into the stacks and stacks of paperwork.

That was really how I got through the time waiting to get him back: just keeping myself busy under piles of paperwork. It was something I could hold on to that felt like progress. If I was just sitting around thinking about him back at the orphanage waiting for me to come get him, I think I would crumble.

I've been pretty matter-of-fact about the whole thing, but recently I put a couple of pictures of him up in my house. I'd never had pictures of family in my house before, and it got me pretty good.

Now I'm just trying to get my Spanish skills up before he comes. And make room in my closets and research therapists and schools and parenting techniques. The very best thing I've read so far is, "Be the adult you want your child to become."

DJ ALI

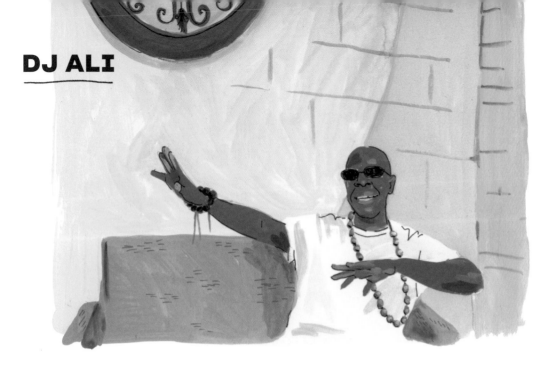

IN 1991, I TOOK A HANDFUL OF XANAX AND tried not to wake up. I was separating from the woman I was with at the time, and I was trying to take the pills and not wake up anymore. But I did wake up.

When I woke up two days later, I had this vision of me standing up on a stage. I was higher than everyone else. I could see thousands of people in front of me. I couldn't hear anything. I didn't know what I was doing. But I know that I was there and all of these people were intently paying attention to me.

Toward the end of the vision, I heard the Beatles song "Here Comes the Sun." Since that day in 1991, every day when I wake up I say, *Here comes the sun*. It's my mantra to make me choose happy right from the moment when I wake up and to remember that nothing that's happening right now would ever get me back to that point that I was at when I took those pills.

It was still a struggle to be happy though, even after that vision. But that whole experience got me thinking about myself as a kid. When I was a kid, there ain't nothing that nobody could say to me that could get me down.

Then one day a little bit after that, I was walking down Thirty-Fourth Street. It's crowded there. There were thousands of people on the street. I was walking down the street, not feeling too happy, but I was thinking, *Well, I'm still here*. And I saw this little girl walking, holding her mom's hand, and she was just saying, "Yay, yay."

I had one of those moments where everything but her disappeared. I had a thought that changed my life. I said, *When did I forget that? When did I forget to be happy just because?* From that moment on, I choose happy.

Yes, I live in the world, I see things that happen. But I choose to focus on solutions, rather than problems. And that little girl was the key for me. Little kids are just happy just because. And I was on a mission to go back to that. And I have.

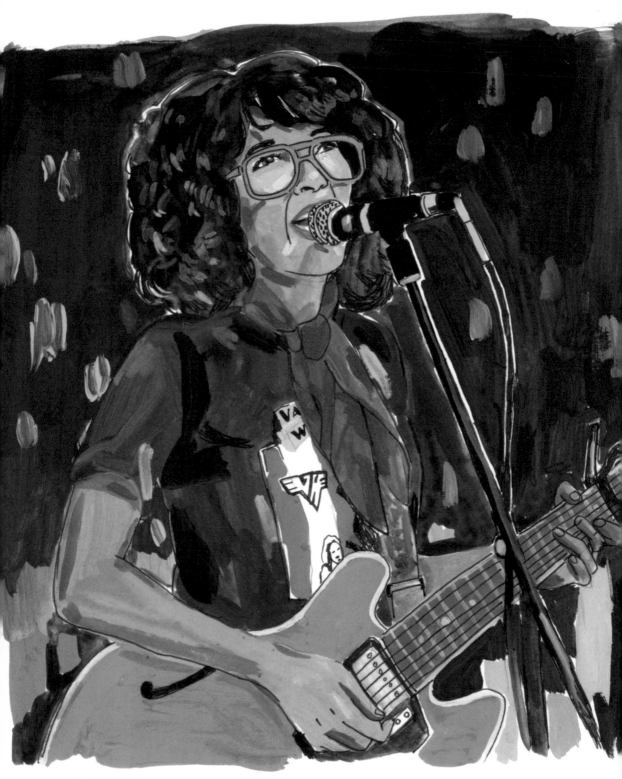

SHONALI

Being a success in America is defined by money. And if you're a true artist, that's not how you're defining it.

I LOST A FRIEND. IT WAS UNEXPECTED. HE WAS an artist. Just this creative joy of a person. I'd known him for twenty years. And his loss made me reflect on myself as an artist, which is an ongoing struggle. The struggle of making money and being an artist and how you figure out how to deal with it on an ongoing basis. Being a success in America is defined by money. And if you're a true artist, that's not how you're defining it.

My friend's name was Sam Jayne. He was a brilliant musician. He passed away in his car the night before he was moving out of the city. His death was attributed to a heart condition.

No matter where he was at financially, he was always infectious with laughter and friendship and support. He was always like, "What do you want to do? What do you want

to create?" And he was always creating. It was inspiring! He made us feel like our art mattered, our voice mattered.

When Sam died, I sent out this email to my friends about how we need to support each other and how the magic is creating something *because* you want to create something. I got so many responses from friends who said, "Wow, thank you. I needed to hear this!" They felt like unless they were making money they weren't a success.

A year after Sam passed away, we did a tribute for him. It was the most beautiful memorial for a human that I've ever been to. There were sixteen acts. We performed four hours of his music. We started saying "I love you" to each other. It was this beautiful community.

It's so easy to get caught up in where you're supposed to be. But the real magic is creating.

RACHEL

MY SISTER, LISA, WAS A WEIRD PET PERSON. She had a ton of lizards and snakes as pets. When I was in middle school, she came and showed the whole seventh grade all of these lizards. And she liked having these cockatiels as pet birds. The cockatiels are bigger than a parakeet but smaller than a parrot. And they are usually some combo of gray and white and yellow. And they have these little orange spots on their cheeks. They are good pets because they're small and they are super-social and you can teach them to talk and they will whistle back at you and they love people.

My sister lived with my dad for a long time in this house in a subdivision in Ohio—which is where I'm from, but I live in New York now. Anyway, when my sister finally moved out, she thought my dad was going to be lonely living on his own. So she got him a cockatiel as a gift to keep him company. She's gray, and doesn't have the patches on her cheeks, and looks like him somehow; she's elegant and slender. My dad named her Sidney.

My dad and this bird, Sidney, had a very nice relationship. My dad would spend a lot of time at his computer, and Sidney's cage was next to it, and they were friends. I do think this bird kept my dad company.

At some point, Lisa got a new cockatiel of her own and named him Mel. And Mel lived with my sister, a few houses down from my dad in the subdivision.

So my dad drops dead suddenly in May of 2019. And there's this problem of what to do with Sidney, who had become very bonded with my dad. My sister came to this conclusion that it would be traumatic for Sid to move down the street. And we had my dad's house, and it wasn't going anywhere because it was full of his stuff. So my sister decided that Mel should go live with Sidney in my dad's old house. So the birds become roommates in this birdcage in my dad's office in his house that he no longer lives in because he is dead. And my sister would turn on the radio for the birds, so they listened to NPR around the clock.

These two birds lived together in this empty house with semi-regular visits from Lisa and her daughter and my brother.

All this time, Lisa had cancer. It's genetic cancer; she had the BRCA gene. She survived breast cancer in her thirties. But the cancer came back, and it's very aggressive. She managed to fight it for a long time, but then she got really sick in the summer of 2020. She went to the hospital, and she thought she was going to get to go home, but every time she thinks she can go home, some new thing happens. At that point, she was sadly falling apart.

In early September, they tell us that Lisa is going into palliative care, and my mom flies from Las Vegas to spend time with her in the hospital. They tell us that Lisa is not getting

And it's so sad to be on the hospice floor because you don't have to wear a mask because nobody's getting better.

better, they're not going to be able to treat the cancer anymore, and she is going to run out the clock. Which is really sad because my sister was not old and she had a daughter who was about to turn twenty. She had a son very young, and he has kids, so she also has grandchildren.

My mom is in Columbus, Ohio, with Lisa when Lisa realizes she is not getting better, and the fight goes out of her. My mom calls me and says, "Lisa is really sick, you should come and see her." It's during the semester when I am teaching. And it's during COVID, before vaccines, and COVID is really scary. And if I fly on an airplane, the rules at the time were that I would have to quarantine, which meant my kids would have had to quarantine and couldn't go to school.

So I research the rules—I'm a lawyer, so research is my thing. And if I don't stay in Ohio more than twenty-four hours, I don't have to quarantine. So I tell my mom I'm going to drive there, but I can't stay more than twenty-four hours before I have to drive back. So on a Tuesday, I teach my class that ends at 3 o'clock, and then I drive to Ohio by myself at night, and it takes nine hours, and I listen to a billion podcasts.

I had told my mom, "I think I'm going to have to take the birds" because since my sister got really sick, the birds have been neglected. On top of everything else that was happening, I hated the idea of these birds suffering and being alone and scared. So I knew I would be going to say goodbye to Lisa, and I would take the birds.

I drive all the way to Columbus. I get a room in the Motor Lodge hotel and sleep over. And in the morning, I go to Einstein Brothers. My mom makes me bring her two giant coffees and the most disgusting bagel. She

asks for an asiago cheese bagel with jalapeño cream cheese. I was like, "Really, this is what you want?"

Anyway, I go to the hospital. And my poor sister looks terrible. And it's so sad to be on the hospice floor because you don't have to wear a mask because nobody's getting better. It's really grim. I had never seen a dying person before. My sister was still there but not really there. They don't want them to suffer so she's on all of this morphine. You can tell that she's dreaming. Her face would make faces that I recognized from having a conversation with her. And sometimes it would seem like she was listening to us. But she couldn't talk. She was just there breathing.

I sat with my mom, and we gossiped about nonsense for eight hours. I put in a work day of sitting there with my mom and my sister. In the end, my mom didn't even eat the gross bagel. Which was maybe a blessing.

I'm like, *The clock is ticking, I have to go back!* It was Wednesday, and I had to teach on Thursday. So I say to my mom, "I'm going to go get the birds." I kissed Lisa goodbye. It was the saddest goodbye. My mom and I go to my dad's house to get the birds. When I get there, the birds have a cage the size of a room, which wouldn't fit in my car. And the birds hadn't been handled by people in a long time, so they bit me really hard. I thought I could put them in a box, but I Googled it, and birds don't like a box.

So I go with my mom to a big suburban pet store to buy a birdcage to take in my car so I can take them home. And then I have to assemble it, and it's in a million pieces. I'm in the parking lot of a suburban pet store in Ohio, and I'm trying to build this cage. My mom is, of course, zero help. I asked her to throw the box

away, and she couldn't even carry the empty box. She was so not helpful, but it was funny. I finally get this thing assembled and drive back to my dad's house to get the birds.

These birds don't know me, they've been in a cage together for a year, and everyone they know and love is dead, so they bite the shit out of my hands. I finally get them in the cage and into my car, and I'm like, "Alright birds, we're driving straight through to New York City." We drove for nine hours, and they shrieked and screamed the whole time.

When I arrive at home, it's the middle of the night, and I couldn't find a parking spot, so I park two blocks away, and I am walking down the street with these shrieking birds.

They've lived with us ever since. And now they are nice to me. They whistle and sing, and you can pet them and talk to them.

Trying to remember my dad and my sister is really hard. They were such imperfect people. They were hard to deal with and so weird. It's not the kind of happy memory you might have. And they also died in such unexpected ways. So having these birds that were really bonded to them so closely, it's this amazing way to feel close to them. The birds have so much of my dad and my sister in them. Like Sidney whistles a song that my dad taught her. And makes the sound of my dad's computer. And Mel says these things that my sister taught him. He says, "Pretty pretty pretty bird bird bird." It's the closest thing that I can have to the nice parts of my sister and my dad. It's so nice to have them in my house to remember them. It feels like for these people who were so important to me and died so suddenly, taking care of these birds that they loved is the best way to say, *You were a part of my life, and you mattered.*

RŌZE

I WAS BORN WITH A HEART MURMUR, SO I HAD TO have open-heart surgery as a newborn and again when I was in junior high. It's something that I have to live with my whole life.

I always have to cut back a little, to make sure I'm not overdoing it. I always tell myself, *Just go beat by beat.* To some degree, I was constrained with some physical activities, so I had to be aware with how much I could push myself.

I wasn't able to play too many sports as a kid. When I did play sports, I would run out of breath earlier than my peers. But I still needed to eat. So I got interested in food.

My dad was a fisherman, and he was gone six months out of the year. My dad always wanted us to know about our culture, and the way he did that was through food. Cooking was big in my family, and it was something that united us.

Although being a chef can be very challenging, I felt like cooking wasn't the most strenuous activity, so I could do it without getting worn out. I would make dishes and then enjoy the flavors. I made a lot of rice—since that was a top staple to my culture growing up. (Actually, I screwed up rice so many times!) But cooking was an activity I could do and feel like I was accomplishing something. And now I'm a chef!

You're starting to see more diversity in the food world now. But it's certainly more white dominant. If I am the only African-American in a setting, I just say to myself, *I am going to represent and open some paths for anyone who is trying to step into this lane.* It's about showing people that there is an opportunity for someone like me. The biggest challenge is that you can feel intimidated if you don't see someone like you. So if I am the only one, I want to crank it out and really perform!

I always know the heart condition is there. But I try not to let it control me. Yes, I have to be cautious, but I also like to be trailblazing.

JEFF

WHEN I WAS A KID, I STARTED DOING THIS TIC where I'd roll my neck. I was doing it so much that my neck was starting to get sore. So I told my mom my neck is sore, and she was like, "OK, I'll set up a doctor's appointment."

I thought we were going to go to an orthopedic doctor, but instead we went to a neurological doctor. He asked me all of these questions that you'd get for a psychological evaluation, and I'm like, *What the fuck does this have to do with my neck?* Then the doctor's like, "I think you have OCD and Tourette's."

I was washing my hands a lot and coughing and having behavioral stuff in school. I remember being in class and making this clucking noise over and over, and my teacher was like, "Jeff, stop making that noise." And I had to! So one last time I was like, "Cluck."

Part of that is being a kid, but part of it is Tourette's. It's a tic! I gotta do it! A tic is like an itch. You can hold off from scratching an itch, but only for so long before it comes out in one form or another.

All throughout high school, I was on a cocktail of medications to treat my OCD and Tourette's. I'd get all of these weird side effects. One made me wake up in a cold sweat, another made me drowsy.

Growing up, I was very much afraid that I was going to barf at the dinner table. At my own dinner table, at other people's dinner tables. I just kept getting the image of barfing all over the table. I never did barf all over a table, and I knew, for the most part, that I probably wasn't going to. But this is where OCD and Tourette's kind of intermingle. The thought of barfing keeps jamming itself into your head, and that's the OCD part, and the Tourette's part of me is like, *What's the worst thing you could do right now?* It's kind of torturous because your brain wants you to do these socially unacceptable things. And when your brain keeps presenting you with this image of barfing all over the table, there's a part of you that's like, *I'm barfing all over the table,* and the other part of you is like, *Hopefully I won't barf all over the table.*

The anxiety is always there. And you're like, *Is everyone aware of these tortured thoughts I'm having?* It's such a big part of your experience that it feels like people must know.

I have mental coprolalia, where I think bad words but don't verbalize them. I have echolalia. I like to imitate dog barks and cars honking. With Tourette's, you have less impulse control.

I used to worry a lot about yelling out in a movie theater. A cognitive behavioral technique I use is that I don't suppress the thoughts because if you do, then they come back stronger. So if I'm afraid I'm gonna yell in the movie theater, I'll think, *Maybe I'll yell, then I'll barf, then I'll fart, then I'll get up and say, "fuck you everybody."* I'll exaggerate it in my mind and make it absurd in my mind. And then I'll think, *Oh, I probably won't do that,* and that takes the edge off.

It's so similar to comedy. Comedy is sort of doing and saying the things you're not supposed to do and say socially.

Something you hear a lot from people with Tourette's is that they integrate it into their personality. Like if you have a tic, you find a way to make it part of your personality. If I could somehow get rid of the Tourette's magically, it would be like taking away a huge part of my personality. They are so interconnected. For me, humor is the only fucking way that I survive. If I couldn't make jokes or make people laugh or make myself laugh, I would be miserable. There's a part of my brain that just has to make jokes. And I wouldn't want to get rid of that.

LAURA

I GREW UP IN THIS ITALIAN FAMILY WHERE you're either too fat or guilted for not eating everything. My entire childhood was spent in this calculated place where I was trying to appease everyone by eating or not eating to be perfect.

When I was twelve, my mother pulled me into a dressing room and she said, "Laura, you gotta lose weight or you're never gonna find love." And I was like, *Oh, I didn't know I was fat or that this was a problem.*

From there on, it was this constant of diet, exercise, binge, purge. All the way up until I was twenty-six.

My hair was thin, my teeth were destroyed, my skin was bad. I thought it was just being an adolescent, but it was because I had an eating disorder. And I kind of thought I was supposed to be engaging in that behavior because everyone around me was thin or trying to be thin or on a diet. And I was a chubby kid, and I was like, *I don't know how to get out of this body, and I'll do anything to get out of it.*

I had grown up in the Bronx, but my parents got a divorce when I was a kid. I lived in the Bronx with my grandparents, but at twelve I moved to Virginia to live with my mom and my stepdad. I was very fish-out-of-water. I remember being like, *What the fuck is this place?*

So I was in this small town with my mom, who I don't know that well because I hadn't really lived with her before. She was married to a guy who was only four years older than me. True story! I felt really sad and insecure. I was trying really hard to find control over my life.

And so much of my life was spent staring at these magazines of girls I didn't look like.

I put myself on all of these diets. I'd stop eating during parts of the day or refuse dinner. My mom never saw it as a problem. She thought I was taking control of my health. I felt like that was the way for me to be OK.

When I was seventeen, I got *Seventeen* magazine, and there was a story about a girl whose sister had died of bulimia. And I remember thinking, *This is how I do this.* Unfortunately, this weird tale of "Don't do this" was like, "Do this." I thought I would just not get caught. And if I lost weight, no one would care because that is what they wanted me to do anyway. It became something I did once every few days.

I graduated college in 2009 and moved to the Bronx with my grandparents. The eating disorder got even worse because I was alone a lot more. And I kept thinking, *Oh, maybe I'm not getting a job because I'm fat.*

I researched how to get weight-loss pills from doctors. So I would go to doctors and tell

them I wasn't getting my period. They would prescribe me the legal version of fen-phen, and I lost forty pounds in a week and basically had a mental breakdown.

Every time I lost weight, everyone around me was congratulatory. It felt like, *This is what girls do. This is just my life.*

The turning point was when I was around twenty-six. I didn't have a career lined up, I was just trying to figure it all out. So I found a part-time job at the Pleasure Chest, which is a sex shop in the West Village. So I'm there working one day, and this woman comes in and she's wearing a shirt that says "Fat, So?" And this woman was bigger than me, she was plus-sized. You could see the entire shape of her stomach. She had all of these tattoos, and the side of her head was shaved. And I could not stop looking at her. I had never seen anyone as beautiful as her. My mind was blown that this person existed. She was so confident. I was like, *Am I in love with you, or do I want to be you?*

She came up to the counter. And I was like, "I like your skirt, where did you get it?" And she was like, "Oh, I got it at this plus-sized clothing boutique." I thought, *Can you even say plus-sized out loud?* It was like this deep shame in me that we're all supposed to hide it and not let anyone know. And she was just like, "It's a store, you should go."

That weekend, I went to the store. And the store was like heaven. There was a chalk drawing on the outside of a fat woman. Every dressing room was dedicated to a famous fat person. There were posters of fat queer people and fat nonbinary bodies. I had never seen anything like this. I was so shy, so I didn't ask for help. I picked out this skirt that was way too big on me because I had complete dysmorphia. I just had no idea how clothes fit me.

I go to buy the skirt, and the cashier was like, "Oh, you should come to our drink-and-draw. It'd be really cool if you came." So I go to the drink-and-draw. I didn't fully understand that it would be nude figure drawing. But this person comes out and is wearing a white robe, and they take it off, and I was like, *This person is existing in a fat body, and they love it enough to show it off to other people!*

I thought, *If I don't stop this I'm going to die.* I'm going to be like that girl's sister in *Seventeen* magazine. I was in so much pain and so hungry all the time. And I thought, *This is how you're going to end your life? Just because you're not thin?*

The next day, I was like, *I need to find some help, and I have to figure out how to get through this.* It took me around two years. I had to relearn how to eat, so I went to a sliding-scale nutritionist. I was twenty-six years old, relearning how to eat. It took me about a year to nail down. I would go every once in a while to Anorexic and Bulimia Anonymous meetings.

I wanted to know, *If I'm not going to be thin, it will be OK.* That was my starting point. So much of my recovery and stopping hating my body came from searching on the internet for pictures of plus-sized women. At the time, a lot of it was porn. But I was like, *I'll take it!* Anything that helps me be OK with my body.

I found my way through all of this by not being so insular. I found people who I could emulate. I've been on this recovery now for seven or eight years. There are days that I hate my body and that's OK. And there are days that I love this temple that I'm in. I get to be this person that people tell you not to be, and I can love it! I can be a girl on the street that some other girl can see and be like, *Wow, I don't have to hate myself.*

ANJA

I GOT PREGNANT WITH MY DAUGHTER, Matilda, when I was twenty-eight years old. At seven-and-a-half months pregnant, I became a solo parent very unexpectedly. Pretty much overnight. I gave birth alone. And since Matilda was born, I've raised her alone. Then six years ago, her father passed away. Being a solo parent is one of the biggest challenges in my life.

It was also a financially devastating event. I was pregnant and very broke and about to support a baby entirely by myself. That was terrifying. At first, I just had to focus on getting the very basic things done because my back was against the wall. I didn't have a lot of time to stress out. I thought, *I just have to get through today, and after I get through today, I have to get through the next. And then the next.* I kept telling myself that as Matilda got older, hopefully the farther out I'd be able to see and to plan.

The thing that it taught me was the idea of patience and trust in myself that I'd be able to handle whatever would come down the road. And it felt like a seemingly infinite number of bad things could happen because this thing that happened was *so bad*. It's hard to stay positive when you're in the middle of what feels like the worst thing. But you really just have to stay focused on what's directly ahead of you. And once you get into the rhythm of that, you can focus a little bit further, and then you get the rhythm of that and then focus a little bit further.

It's been interesting grief counseling an eight-year-old, especially because we're not religious. I can't just be like, "He's with Hashem" or "You'll see him in heaven." One of the things I've been trying to build for Matilda is that this isn't something you move through, it's something you move *with*. I think that might be true of everything in your life, not just grief. Things happen all the time, and when things happen, instead of being something that you conquer and leave behind you, you take it with you and build it into your life.

JASON

I WAS A SKINNY KID. I DIDN'T FEEL BAD ABOUT it but I didn't feel good about it. My father used to call me "bag of bones."

My younger brother, Conrad, was not skinny. He was husky. He was built like a tank. And he was tall for his age. So compared to him—and I was often compared to him—I seemed like a little nothing.

We went to the same high school. And I was a nerd, a weirdo who didn't play any sports. My brother was an athlete and became super popular as soon as he got there. And he was like, "Why doesn't anybody know who you are?" I was like, "I mind my business." So then all the popular kids started knowing who I was because of Conrad, but they called me Conrad Jr., even though I was the older brother.

It bothered me that I wasn't an athlete, so my junior year I decided to go out for the football team. I was like, *I'mma play football.* I didn't know the rules. I had never even watched a full game of football. But I went out for football! Not even for JV. I went out for varsity!

So I'm really confused, and I don't even know why I'm doing it. All I wanted to do was play defense, and I wanted to hit a quarterback. I don't know why. I was like, *I'm gonna be on the football team and hit a quarterback.* That was going to be the key to my popularity.

The tryouts start before school starts, so it's summertime. It's August, it's hot. I don't know what the fuck I'm doing. I have all of this heavy equipment on. And I get hit for the first time,

and it's like a car accident—things go crazy, you wind up on the ground looking at the sky. And it hurts.

But I keep going for many days, and I still don't know what I'm doing. I can't throw the ball. I can't catch the ball. I can run kinda fast but not compared to the athletes. I have no business there, but I'm gonna stick it out.

One day we're doing a little scrimmage thing—and there was one rule, which was that in practice you never hit your quarterback. And that was the one thing I wanted to do. So at one point, I see the quarterback, and something kicks in and I tackle him. I'm sure it was a terrible tackle. But he's on the ground smiling and laughing because he knew what would happen next. The coach comes over and calls me all sorts of "dummy" and "motherfucker" and "stupid." He was like, "What the fuck? You don't touch the quarterback!" I don't know how many laps I had to do around the field that day, but that was the end of my football career. I was so ashamed, I didn't go back.

I think I realized, *Oh, I shouldn't be here. I don't even know the rules, and it hurts. This isn't for me.*

But after that, I started wrestling. I liked it—there were no balls, it was tactile. I wasn't good at it, but I enjoyed it. I loved practicing. I was terrible at meets. But it was fun to be part of the team. I liked the camaraderie. It felt like you didn't have to be nice, but because of that everybody *was* nice. It was more my speed.

GUY

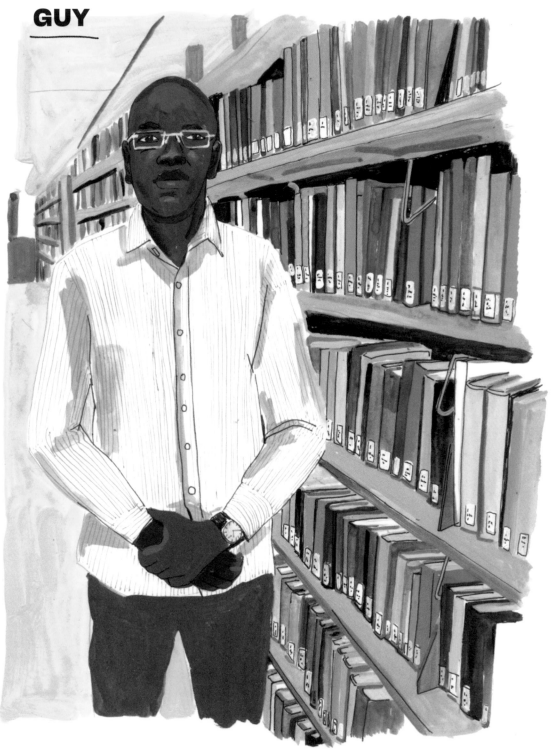

I CAME TO THE UNITED STATES ON DECEMBER 17, 2012, at 10:35 p.m. That is when I hit the ground at O'Hare Airport. The reason I came was that I was seeking safety, and I came as an F1 student. I never thought that I was going to make it to the US, but I made it.

I flew to the US from Israel, but before Israel, I came from Sudan. From Darfur, to be specific.

The government was killing people just because they looked different. They are dark, like myself. The lighter skin is considered superior to the rest of the people in Darfur. There were attacks that I had read about, and then eventually, it happened to my village. And it happened at our house where I used to live. And I became one of the victims—being shot and tortured and forced to leave.

In late April of 2003, I was separated from my family, and we've never seen each other again. I was seeking safety and wound up meeting with people from the UK, Sweden, and Denmark. I was able to obtain their help and stay with them. They asked where I was running—I had a bleeding leg at the time—I told them that my village was attacked and was burning down, and I told them that I was attacked by a gang. I said, "I don't know if anyone survived." They asked me to go with them back to the village. They hid me in a car, and we drove back to the burning village. We passed through, and there was nothing left. All we saw was ashes and dead bodies. I was very young at the time.

Until I left Sudan, I stayed with these people who helped me—eventually they became like family. I moved with them to Khartoum. It was very challenging. Because of my race, I was targeted by the national security officials, and I was arrested multiple times. I was jailed, I think, four times. And was threatened to be expelled from Sudan. I had nowhere to go.

I have always loved watching the news, and I saw a news story about some people from Darfur who had had a similar experience as me, and they left Sudan for Egypt and crossed the border into the state of Israel. So I told the guys that I was living with that I was going to go to Israel, and they said that it was unsafe, and they questioned how I would be able to do it.

But I decided to take a risk, and I left Sudan for Egypt. I met other people from other African countries who were on the same journey. There were forty-three of us. But only thirteen of us made it. Everyone else was killed by the Egyptian border control. I made it to Israel.

Psychologically, it was and is very difficult. But if you focus on everything that happened to you all the time, it is hard to move forward.

Imagine having lived through all of this but wanting to have a better future, a decent future? I knew that I could not let myself get distracted for my future. I would tell myself, *success is the only way. Failure is not an option for me.* I still say to myself all the time, *Success is the only way.* That is how I convinced myself to keep going.

After my time in Israel, I came to the US. After coming here, I was able to enroll in Harvard, and now I am at Georgetown. Because of my background, I thought it would be good to study human rights law.

In life, we learn through things that happen to us. Sometimes, when you go through horrible things in life, that journey becomes the main force that gets you to remain focused and determined to progress. What I went through made me want to do everything possible to get to where I am today.

DAN

MY BROTHER JOHN WAS MY TWIN, AND HE lost his life on September 11th. He was a police officer and had been for nineteen years. At 10:28, when the North Tower fell, I got a tremendous amount of anxiety, and I said to my boss, "My brother just got killed. I got to get out of here." I knew.

You wanna know how you get through the pain? I got my strength from other people in the same situation. And I already knew how to play guitar, but after my brother died, playing my guitar and learning to play mandolin helped. Playing an instrument takes an intense amount of focus, and that helped me to get to another feeling. And you gotta remember the sun's gotta come up tomorrow.

OZZIE

MY FATHER'S DEATH WAS UNEXPECTED. Happened in a week. He had the same type of pneumonia that Jim Henson had. If you don't treat it within twenty-four hours, it's fatal. I was twenty-four at the time. All of a sudden, I had to take care of my mom and pay a mortgage. I wasn't sure if I was capable of that. But somehow I persevered. Playing music helped. A lot. It was good for my soul and my heart. The day he died I had a show that night, and I was going to postpone, and my mother looked at me and said, "That's not what we do." And the day we buried him, I played a show too. It took a couple years to get out of the fog and the hurt of that. But thanks to some close friends and music, I survived. And here I am. Thirty-seven years later. And still playing music.

THAO

PRIORITIZE IDEA EXECUTION OVER IDEA GENERATION.

MICHELLE

I HAD REACHED A LEVEL IN MY CAREER WHERE people knew who I was. People might not know me by my real name, but they knew my character's name. I had gotten connected with a show—*Orange Is the New Black*—that blew up. Nobody expected it to, but out of nowhere it blew up. And out of nowhere I also got dropped from that show. I thought that was the most devastating thing in my whole life because I didn't understand why it had happened.

Pretty soon after that, my father passed away at ninety-three. I flew down to North Carolina to go to his funeral, and my sister picked me up at the airport to take me to the hotel I was staying at. The next thing I remember was over a month later when I woke up in the hospital after a horrific car crash. My sister had been driving, and we got T-boned by another car. I don't remember anything about it; I only know what I've been told. They had to airlift me from one hospital to another. My sister was fine—bruised and shaken, but untouched comparatively. I had fractured fingers, fractured wrists, torn ligaments. I had a tracheotomy. I was being fed through a tube in my stomach. I wound up being there for over two months.

Part of what kept me going was being an actor. At one point—after I'd woken up, obviously—I started reciting monologues from plays I had done in college. I remember doing *Medea* and some others too. Doing these monologues and knowing that when I got better I could still be an actor, I thought, *I'm gonna be fine!* My body was still broken, sure, but my brain was OK, and that's what got me

through—focusing on what I had going for me instead of what was going wrong.

Since then, I've gone to trauma conferences as a speaker. And I tell people about my experience. And I meet other trauma victims there—people who suffered from accidents like mine. And the ones who focus on what they've still got going for them, they're happier, they can still thrive! People think if they're not totally perfect, they're not worthy. But that's just not true.

OLLIE

I'M A FILMMAKER, AND MY FIANCÉE AND I decided to make a documentary about polyamory and about going into an open relationship.

Just to back up a little . . . I had met her at a party, and I thought she was interesting. I read a book of her poetry and fell in love with her brain through her words. And that was the beginning of our relationship.

It was the first relationship I'd had where my partner was my creative collaborator. She was a poet and a good writer. She would help me with words, and I would help her with visuals. We did a series where we made collages of her poems and my imagery. Having someone who gets you and understands you as an artist was new to me at the time. My parents aren't in the arts, and they don't really get art necessarily. It was new and it was special and it felt like we pushed each other creatively.

On the day we got engaged, I brought up the idea to do a documentary about polyamory. The idea was to show the world how well polyamory could work. We are both class clowns—we are both jesters and don't mind making fun of ourselves—so it seemed like this idea would work.

At first, we were all giddy to make this film together, but it slowly shifted, and she became less and less interested in the documentary

I basically wrote myself back together.

aspect and more and more interested in having her adventures. It got to a point where if she wanted to hook up with someone and knew I might have objections, she would take out her camera and film us because she knew I would be more likely to say yes if I was being filmed. It became pretty unhealthy.

What wound up happening is that she fell in love with another guy and broke up with me. Breakups are always hard for everyone. But what I think made it extra difficult for me is that I was filming her fall head over heels in love with this other person. More in love than I'd ever seen her before.

I thought that both the film and the relationship were dead. She was my fiancée and I loved her, but she was also my creative partner. And the film became quite important to me. So I felt like I had nothing. I wasn't suicidal, but I wasn't in a good place.

The first week after the breakup, I was quite determined to go and convince her to take me back. She was in Australia, and I was in New Zealand, and I was planning to do this dance routine—I wanted to dance my heart out for her—and dancing is the thing I hate the most. I practiced the routine and booked my flight. And then my friends talked me out of it. They told me not to go after her. They said it was over.

It was the hardest time in my life. Complete heartbreak! I had had an idea of what the next few years of my life would be and then suddenly all of that went away.

About two weeks later, I came up with an idea of how to keep the film going—I could cast an actress to play my ex-fiancée. Luckily, my ex was OK with me still making the film without her. I'm so driven by my work, so having something to focus all of my grief and anger and energy and pain into, it saved me. It took me five years to finish the film. But I managed to get it made. And I no longer feel that heartbreak.

Whenever I was depressed in life—anytime—it was because I didn't have purpose. I didn't know what I was meant to do. And once I reframed the breakup as an opportunity to create something that was helpful for me and hopefully others, it shifted the whole narrative. It went from something tragic and sad to something good and positive and something to put my all into. I basically wrote myself back together.

GREGGY

I'M A SHY PERSON BY NATURE. WHEN I WAS A kid, we would go places, and if my mom had a long dress on, I would hide under her dress. But I always talked a lot. They used to call me Motor Mouth Jones. So I talked a lot, but I was also very shy—two things that don't make sense together.

When I got to high school, there was this teacher, and if you joined the forensics team, you got an A in her class. It was a ploy to get more people to join the forensics team. So I did.

My first tournament I got a trophy. I was an athlete too—I was playing basketball—but I wasn't getting any trophies. I was like, *Public speaking is more fun, and it's producing fruit.* Literally every competition I went to, I won something. It produced for me not just trophies but confidence.

I grew up in East Orange, New Jersey. And at the time, East Orange was not, like, the friendliest place necessarily. There were good

people there, but you know how poverty works in this country—there wasn't the best education system, and when you don't have money and you don't have education, then you have more crime. So in order to give me the best opportunity for success, my parents decided to send me to a private school.

I wasn't from the neighborhood that the wealthy kids were from. Knowing that can make you feel small. Well, public speech and debate were things that allowed me to grow. And grow past a lot of the stereotypes, so that people could see me in places that I don't think people would have seen me. I was able to show that I had value. I was able to feel that I had value. And that confidence leads to a lot. It's helped me grow and grow and grow.

Now, when I do it—public speaking—people say, "Oh, you're just so good at it." And I have a little bit of resentment about that because I'm like, *Yeah, I'm good because I worked really, really hard at this!*

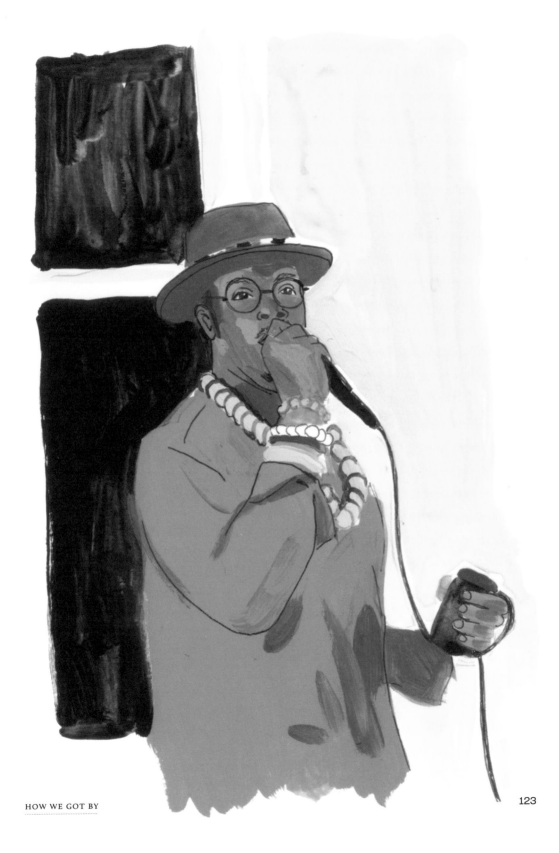

ISAAC

IN 2018, I LEFT A JOB THAT WAS PAYING ME more money than I'd ever made before. Not wild beaucoup bucks, but way more money than my parents had ever made. I had been working tirelessly for the seven years that I had lived in New York. And before that, in San Francisco, I had been working at a breakneck speed. Basically since I was twenty-four or twenty-five, I had been working for—for lack of a better way to say it—the internet. So my entire world was on my laptop. I used to sleep with my laptop. It was the first thing I opened when I woke up. I loved my work. But it meant that I was just dedicating my entire life to it.

In 2018, I step away from my job, and for the first time in a very long time, I don't really know what to do with myself. But what I do know is that I'm burnt out. And I was lucky enough to take that time. It wasn't even like I wanted to figure out what to do next, it was just how do I figure out how to not do anything for a while? I was addicted to doing. I was constantly trying to fill my time doing my work and not much else.

When I first moved to New York City, my friend told me I could live in his garden apartment for one year. That was nine years ago now, and I'm still here. He keeps my rent low. But when I first moved in, I got to know the three blocks around the apartment. Then I'd take the subway to my office in Union Square, and I got to know the three blocks around my office really well. I loved Old Town—it's one of the older bars in Manhattan. They have urinals the size of statues. It's one of those old, classic, dark wood New York bars. It's falling apart but feels elegant. You get a martini in a perfect small glass. I went there a lot. Anyway, if I wasn't working, I was at Old Town, and if I wasn't at Old Town, I was at my apartment.

Which is to say that I was living in one of the best cities on the entire planet, and I wasn't exploring it at all.

When I first moved to New York, I had all of these grandiose ideas about the things I would do. But I hadn't done any of it. And because of my work, I hadn't been physical in a very long time.

I'd also gone through a pretty major breakup. I'd been engaged, and that relationship fell apart. Which meant I had even more time on my hands.

I realized what I wanted to do was explore New York. So I just started walking.

I used to make this joke about how New York is like a vending machine, and you have to put a fifty-dollar bill in it just to leave your apartment. But I realized there's so much free stuff to do in this city. So sometimes I would leave my apartment with no cash on me. I'd have my phone—but really just to count my steps. I made a rule to not look at my phone. I couldn't be on any of the social media apps or read the news. So the phone would stay in the pocket. I wanted to be present.

I started with exploring Prospect Park, then walking deeper into Brooklyn, then going over the Manhattan Bridge and going to Queens. Going to the Bronx. Then I took the Staten Island Ferry. I explored all of these different parts of New York City. I was like, *Look at all of these spaces that exist for us!*

I started walking twenty-thousand steps a day. Walking became a huge part of my life. It changed my body. It changed the way that I view the world. I realized that I have a much calmer sense of self when I am in the space I am in. I live on a much smaller budget now. Now, I will go to a place and just sit down and talk to someone. I feel like I'm actually using the city the way it's supposed to be used!

JOSEPHINE

MY DAUGHTER HAS BEEN SICK FOR SIX YEARS. Sick is the right word, I just don't like using it. She's just been having a really hard time. She just turned eighteen. She had mental health issues and one crisis after another. There were times when she would call, and I would be so grateful she called because I'd have to scrape her off the sidewalk and figure out what we should do next: whether it's going to the ER or just going home and hugging for hours. Her troubles started pretty soon after her dad moved out.

This went on for a really long time. She was in and out of the hospital. She's gotten all kinds of treatment, and now she's on the up-and-up. I'm blown away by her resilience, and to be honest, I'm a little blown away by my own. It was so frightening on a regular basis that it became a permanent state for both of us. For our whole family. But especially for her and for me. We were in the bunker together.

I almost don't remember what I was feeling at the time during the hardest parts. It might have been a choice to not feel it. Maybe it's like a mom thing. Or maybe it was being out of my mind. It was a permanent state of crisis. But I was so desperate for things to get better. So I would come home, and I wouldn't even take off my shoes; my keys would still be in my hand, and I would just fall asleep on the living room floor. I was giving all of my energy to taking care of my family.

Every so often, to feel better, I would pretend to be my future self. I would pretend to be the kick-ass version of what my future self would be. That Josephine is all the things that I am but fully realized, fully formed. I would spend hours getting dressed up. I would try so hard to inhabit this person. This would happen when I wasn't so completely shattered. I would dress to the nines and go for a drink with a friend. I don't want to say I was being my best self because that feels very generic. What I was doing felt really real. I felt like a fully formed, bad-ass woman with wide-open potential. In the moment, I felt freer, I felt freed from my crisis mode. I couldn't just do it anytime I wanted, but if I had a free day and everyone was doing OK, then I could do it. I would walk out my lobby like a boss. I would feel good and happy. No drama. No edge. It was sort of like a vacation into my future self.

Even if it's just one tiny moment or a glimmer of something different. Just some little glimmer in the midst of whatever it is—crisis or something else—those moments are really important.

NORAH

I HAVE A SPEECH IMPEDIMENT. WHEN I WAS IN middle school, it was hard because sometimes the other kids would make fun of me. They would correct me or imitate me. Sometimes it would be hard to make friends. I would try to ignore them and think positive. I would tell myself that there are other people out there like me and don't give up.

Now, I found someone who understands me, and we communicate well. I met a wonderful guy in community college. His name is Jason. He understands where I'm coming from and tries to help me to get my point across to other people. At first, he and I were just friends for many years, and then we started to go out.

When I first met him, I was worried about being able to talk to him. When I get excited or anxious or angry and I try to speak, sometimes it's like gibberish. No one can understand me. So I would tell myself to just breathe. I would do breathing exercises—not in front of Jason— but I would do it before I would see him, and then I would calm down, and it was easier to speak to him.

Also, sometimes I dress up in cosplay—like I wear a costume like a raccoon tail or dragon cuff earrings. Some flair. It makes me feel more comfortable. It makes me feel more normal. It's my way of expressing myself. Jason does it too. Not as often as I do, but it's something we do together.

It's still hard for me to speak clearly sometimes. I have anxiety about speaking. But if I am relaxed, it is easier for me. And dressing in a way that makes me feel good helps.

ALEX

I GREW UP IN CHINA, AND I CAME TO THE United States—to Atlanta, Georgia—when I was fifteen by myself. I moved to a different household every year because I was living with different host families. I came to study what I wanted to study. Because back home everybody studies the same thing. Everybody goes through the same tests. What I wanted to do is art and sports. And here there is more freedom, so I can pursue the career I want to pursue.

Moving here and moving around a lot was hard. Every host family was different. So it's like you're starting from zero every time. I'm an only child. I was born during the one-child policy in China. So my family wasn't allowed to have another child. In these host homes, I would have a roommate. And it gave me the opportunity to experience what it was like to have a brother. I had to learn about patience, sharing, sharing emotions. When you're an only child, you don't have to learn that stuff.

A lot of kids, especially from Asian cultures, go through this. You have to be able to blend into different environments. It's like a different culture every year. What I learned is it's best to just be you, just be you. Don't be afraid of sharing yourself, exploring, and making friends. But also learn to protect yourself and be careful of the friends you hang out with. The big thing is don't regret. Don't regret stuff you said or things you did from the past because people say and do stupid shit all the time. Just don't regret those things. Just keep going. Don't be afraid to express yourself, it's a free country!

Being away from family is hard, but you learn a lot when you do it.

CASANOVA

I GREW UP WITH MY MOTHER, AND SHE'S AN immigrant to the United States. She came from the Dominican Republic. I grew up in Section 8 housing. Sometimes we didn't have a lot of food. We never went hungry, but sometimes we'd have to eat the same thing for a month.

In school, I got bullied a lot. People made fun of me for the clothes I wore because I was poor. Which I don't understand because we all lived in a similar environment. But I guess because my mom couldn't afford to buy fancy stuff, like Jordans and Nikes, we had to shop secondhand. So people would laugh at me because of that.

I played baseball when I was younger, and this one time I had to make a choice between getting baseball cleats and regular sneakers. We went to Target and found these baseball cleats, but they were rubber; it wasn't like the metal ones. So I was happy because it was like I was getting new sneakers AND baseball cleats. Well, I wore them to school, and everybody laughed at me. I was heartbroken.

I also didn't grow up with my dad. I always wanted to have a relationship with my dad, but I had no idea where my dad was. I kept thinking, *Everything in my life sucks. If I meet my dad, my life will get better.* Then when I was twelve, I met my dad. My life didn't get better. Everything I thought it was going to be, it wasn't that. We didn't have a good relationship.

I didn't really have any good relationships. I had this bad relationship with my dad, and I didn't have friends. But I was decently smart, and I always read. And instead of watching TV, my mom would always take me to the library. When I was ten years old, I was like, *I'm gonna learn French.* I got a book from the library with CDs.

I never developed close relationships. Even when I went to university, even when I moved overseas. I was never really able to form good relationships with people. When I sat down to think about it, I realized that, obviously, it had to do with my childhood. The reason why I can't develop close relationships is because of my childhood.

What you lived in your childhood, it's always going to be part of who you are. It's part of the foundation, but you have to recognize that you can change, you can do things that make you happy.

I had to become introspective and believe in myself. I had to change things I didn't like. You can succumb to negative reinforcement. But I decided to tell myself positive things. I would talk to myself and build myself up. If people made fun of me for how I dressed, I would study people who dressed well, and I would go buy myself those clothes. People would say, *You're not going to do anything with your life.* So I told myself I could, and I got work overseas. I traveled and learned languages. And all of that makes me happy.

Don't be fake positive. When people say "positive vibes only," that's not real. Sometimes it's good to embrace a bad day. Sometimes you have to sit in your situation and see what you're dealing with in order to fix it.

I didn't vanquish all of my demons permanently, but I overcame them. And I'm working on my relationships now. I'm building them up now.

MICHAEL

ONE OF THE HARDEST THINGS IS HAVING TO live with AIDS as a Black American. When I first got AIDS, I hid my disease. It was not until 2000 that I finally came out. I came out because I needed to take medication.

I grew up in Steubenville, Ohio. Very conservative. That's the culture I grew up in. That's the culture my parents came out of. I had to deal with that culture. And as a Black American, I felt I could never let them know I had the virus because of the stigma. If we had told a family member that we had AIDS, we had to eat with plastic forks and plates. If we shook people's hands, they would quickly wipe their hands off. That's what we had to deal with.

Before both of my parents died, I told them I had AIDS. When I told my dad, he said, "Michael, come home." My mother, on the other hand, said, "Don't come home." She said, "People back here, Michael, will be judgmental." And, of course, that was hard.

And as a Christian, I cannot tell you the tears I shed watching as the church denied families a Christian burial. The church would not allow people to bury their children who had died of AIDS. That loss of community destroyed us. It created such darkness.

But I try not think about what I'm limited by or the negative in my life. Every one of us has something negative about us or about our lives. Instead, I look at myself as a work in progress. What I think is important is to recognize that we are all a work in progress and to be alright with that.

YINFAN

I GREW UP IN CHINA AND WENT TO COLLEGE there. I was living with roommates for the first time in a very small dorm with three other people. I became good friends with one of them, but then our friendship turned sour. And the other ones started belittling me. We were young—seventeen or eighteen—and I didn't know how to deal with conflicts or emotions. It was a vocational school (equals a community college here in the US). I wasn't sure of what my purpose in life was and felt like my whole life was ruined. I think I was pretty depressed but didn't realize it, and I started to have acid reflux because of it. And I was having nightmares about my roommates. Everything was difficult. So I remember I asked my mom what to do. And she said, "Imagine you were suffering and had no choices. Imagine you were living in a really difficult place where you were worried about not having food." Also she said, "This is just temporary. You will get through this." And it put my life in good perspective.

CAVEH

I HAD A FRIENDSHIP BREAK UP, AND I WAS obsessing about the breakup. It was becoming unhealthy. My revenge fantasies were taking up too much of my mental space. So I was like, *I need help.* I read this book that changed my whole way of thinking about everything—*A Course in Miracles.* And it said that forgiveness is what we're here to learn. And that forgiveness isn't thinking that someone did something bad and forgiving them anyway. It's seeing how what they did wasn't so bad. That's the key difference between true forgiveness and fake forgiveness.

Before I read that book, I was self-righteous and arrogant. I thought I knew how things should be, and if people weren't the way I thought they should be, I was very judgmental about them.

The philosopher Kant says that the moral thing is to do something that you want everyone else to do. So if you wouldn't want everyone to do it, then it's not ethical. If you want everyone to do it, then it's ethical. But everyone's different. And I think a lot of people are judgmental. At least I was. I would say things like, "I would never do that."

There are several things that changed how I thought. One was this girlfriend I had who could see the beauty in people where I just saw what was wrong with them. Two was astrology because in astrology everyone is totally unique. You can say, *Oh, this person didn't respond to my email because she's a Cancer and she has a Gemini moon, that's why!* Instead of everybody being the same exact model that we all have to conform to. It's a way of thinking that everything is complex and different. Even something that you could say seems obviously wrong, like stealing. Stealing could be a really good thing for someone to do at a certain point in their trajectory. Even if it's just to learn that they shouldn't steal. So to say something is wrong is stupid.

The main reason not to judge other people is that I don't think you can judge anyone and not be judging yourself. Because you're separating a part of yourself and saying, this is bad. You're splitting yourself. I think the whole idea of healing the self is forgiving other people. I think they are the same thing.

Whenever someone is mad at me and won't forgive me, I think, *God, I feel bad for you. You must be having a hard time with yourself.* They shouldn't forgive me for me, they should forgive me for themselves.

That book—*A Course in Miracles*—made me realize it wasn't healthy for me to be this way, to be so judgmental. And astrology gave me another model for thinking about it.

MARINA

MY FATHER USED TO MISTREAT MY MOTHER. SO when I was born, when I was one week old, my mother had to escape from the home. The closest place was the house of a neighbor. The neighbors were a very humble family. They didn't have much money. At that time, the family had a daughter living with them and a newborn baby. They hid us for three months. We couldn't go out at all because my father was next door. We had to be really silent. Even though the family didn't have much money, they paid for everything for my mother and me—diapers, everything.

Unfortunately, my mother decided to go back to my father at some point. So we went back. And they stayed together for the next ten years. He never beat me physically, but psychologically it was really bad. He was never diagnosed, and he was very smart, so when he would go to a psychologist, he was able to pretend that he was completely healthy.

For a long time, I was telling myself he was sick and that's why he did what he did.

After my parents split, after ten years, I would still see my father. They shared custody.

And I was suffering a lot because my father was a really difficult person—very violent and manipulative, very obsessive and dark. And every time I had to see him, I was shaking and sweating. And this one day, when I was with a professor of mine—I was fourteen or fifteen—and this professor of mine told me, "Marina, today is going to be the last day you will have to see your father."

It was so important for me to hear. Because society was always telling me to forgive my father. And no one in Spain—where I grew up—nobody would understand not speaking to your father. But when my professor said that to me, I realized, *Wow, I can break up with my father!*

So I stopped seeing him. And I realized that the trauma that I had, that had come from my father, would lessen if I stopped seeing him. And it did.

And that helped me in my whole life. I don't run away from situations, I try to face them. But if I can't face one, if I try and try and it doesn't work, then I don't force myself.

CHRIS K.

MY EX-WIFE AND I MET RIGHT WHEN I WAS starting to make music full-time. So our relationship coincided with me being away a lot. It was exciting, but it was also hard. I think I left for tour three days after getting married.

She also traveled for work, so I'd come home from tour, and she'd go away. We had a kid together, so when I'd come home and she'd leave, I'd be in full-on dad mode. So I was parenting alone a lot. For weeks at a time.

Having my daughter was the best thing that ever happened in my life. But having a kid brings up a lot of problems in your relationship that you had no idea about. I mean, you've never parented before, so that's one thing. And you didn't know this other person as a parent. And you don't know how to do it together. It's almost like you should have a kid with someone and then decide if you want to date them. Obviously there's reasons why you can't do that.

These things are hard to navigate, but I think we did a pretty good job for a while.

You know with some couples, there's a deep well of resentment or complacency that happens. And I really think that's the wrong way to go about this. I just didn't want to have that kind of relationship. And because I didn't

want that, I realized, you know, *I don't think this is working.* So we separated.

I run through it in my head constantly and think, *Could I have stuck this out? Could I have made this work?* I see some people who are more miserable in their relationships than I was in mine. I wouldn't even say I was miserable. I just wasn't comfortable feeling this mediocrity. So we split. And it was horrible. And I think the best thing that a friend told me was, "You have to fight fire with marshmallows." Any anger that is directed your way, you can't retaliate with anger. You're going to have a long-term relationship with this person because you share a child. It's not like a normal breakup where you never see them again.

You have try to channel your inner Gandhi. You have to be very peaceful. If someone is accusing you of things, you have to say, "I'm sorry you feel that way." You have to stay supernaturally calm.

I grew up with divorced parents. They could never get out of their own way. They hated each other. They were never in the same room. At my high school graduation and college graduation, they were in the same room. Neither of them was willing to budge. And I think, for your own sanity, and for your child, you have to put aside any animosity or bitterness to have a nice life.

BECCA WILLOW

ONE OF THE THINGS I LOVE DOING IS BEING A surrogate granddaughter for elderly people. I go to elderly people's homes or have visits with them online. I do this to provide comfort and company for people but also because I enjoy it myself. What I do most with the elderly is I sing to them. And I sing at a lot of funerals.

So I was asked to sing at a funeral for a loved one who had passed away. When I say loved one, what I mean is this is someone I had been a companion to for years. Her name was Rose, and we had great banter. She was very quirky. We would sing together. Before her cognition deteriorated, she would join in and sing with me. We'd sing very festive songs together. And long before she died, she had requested, as a joke, that I sing this specific song at her funeral.

When she died, her family—knowing that I was important to her—asked me to attend the funeral and sing. But they asked me to sing a hymn at the funeral. I told them that Rose had wanted me to sing this other song—she wanted me to sing "Broadway Baby." The song really spoke to her spirit. But her family said no.

I was in this position of wanting to honor Rose but also to honor the family's wishes. It was a real conundrum for me. I thought about it a lot, and I am still not sure if what I did was correct.

When the time came, I didn't do the song Rose had requested at the funeral. What I did was I waited for everyone to leave. I walked around the cemetery, and then I came back and sang the song just for her. And I think there was a groundskeeper nearby, but that was it. I sang it quietly for Rose.

Sometimes I worry that I didn't honor her wishes well. But I just try to not worry about that. What keeps me going is that I try to keep finding Roses to sing to and be a companion to.

MID

PEOPLE ARE MORE THAN JUST THE SIMPLE label we put on them. They are a multiplicity of different intersections. I grew up hood-adjacent. Not the hood. But hood-adjacent. So I have certain tendencies. Like when I meet someone, I look them up and down. They ask me who I am, and I'm like, *Why you wanna know? What's the angle?* If someone bumps into me, my first reaction is to check my pockets. But I've also traveled the world a lot. I've been to twelve different countries and have lived abroad. And I'm at a prestigious university as an academic.

Sometimes people see me and pull their bags close to them. They act suspicious of me. Some people, when they first see me, they treat me one way, and then once they find out I'm an academic, they change completely and treat me nicely. I see it every day. All the time. It gives me stress. It can be hurtful. And sometimes people will be like, *You know, you're kinda cool for a Black.* That happens a lot.

And on the other hand, sometimes people from my old neighborhood will be like, *Oh, you're not* real *real.*

How do I deal with it? I try to understand people from where they're coming from and not try to judge them. But viscerally, that's not how I'm feeling. Viscerally, I do feel judgmental. But I try to think, *Well, they are navigating their experiences the best they can.*

So I am always trying to create better spaces so that people like me who come after me can have better experiences. I'm constantly thinking, *What can I do to help those behind me so that they have to deal with this less?* It feels like a way of contributing. And that feels good.

DAVID P.

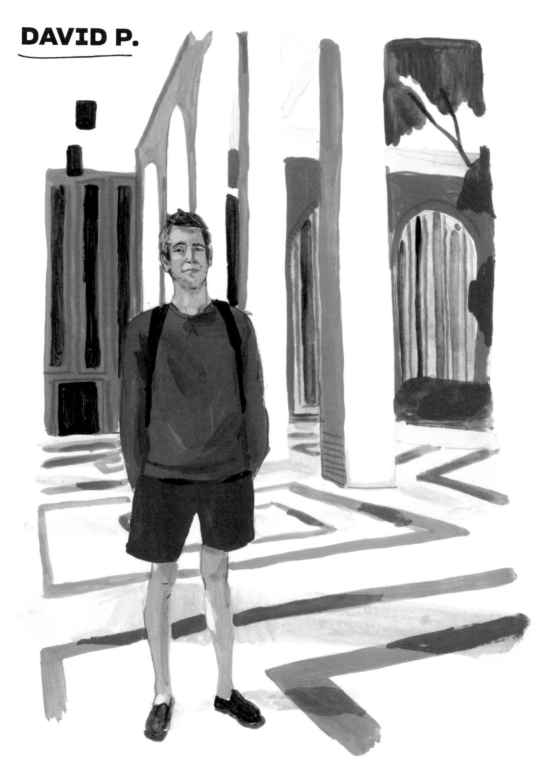

I WENT THROUGH A PRETTY BIG TRANSITION starting in 2013. I had moved back to LA from the Bay Area with my then-wife. We were having a very hard time, and we'd figured out that we were going to go our separate ways. That became a big inflection point for all kinds of new and different things. I was trying to figure out a lot of things following that decision. It was intense. It broke apart a lot of stuff for me.

I had never gotten an undergraduate degree. So I decided to go back to school—and that decision feels like the tail end of this transition I went through.

Now I'm a year and change from being forty, and I'm in undergrad. I'm having a lot of feelings about that.

I was born in Mexico. My mom is from New Jersey, and my dad is from Mexico City. They met because my mom was a free spirit, and in the winters, she would go down to Mexico. And I grew up in LA. I grew up during some really interesting times. There was all kinds of crazy stuff happening in the city back then—Rodney King, earthquakes, O. J. Simpson. There was a ton of tumultuousness.

When I was around ten, my sister was born, and my family moved to Santa Barbara. It's a sleepy beach town where retirees and college students go. It's very small. I had a kind of a latchkey existence there.

I was expelled from high school in Santa Barbara when I was sixteen. I was smoking weed on campus and it was like, "You're gone!" I was super depressed, and this mentor I had had left the school. There was a lot of heaviness. I was getting high every day. I was a shell.

Then I tested out of high school. I went to community college here and there, but I never really expected to go back to get my degree. I

somehow got a career going—through a lot of luck—so I didn't really think it was important to go to school.

Now that I'm back in school, people keep asking me, "What are you doing here if you already had a career?" And I don't really have a great answer for that.

Being an undergrad at this age is weird. I want to be really engaged and focused, and there's certainly a lot of young people here who have no sense of that yet. And I don't spend as much time on campus as the students who live on campus. I feel fairly comfortable with myself, but then you get around other people who are awkward, and it's made me find new layers of my own awkwardness.

There's this need to justify why I'm here. Why I'm spending an insane amount of money to go to school. I end up questioning what I'm doing a lot.

I do have a lot of moments where I'm like, *Yeah, this feels right. I'm in the right place.* When I can bring my attention to those moments, it becomes a lot easier. And blinding myself with crazy amounts of work helps. In a weird way, I've been finding it an oasis. It's a little place for me to be without the constraints and requirements of normal adult life.

I think that the younger me would have been thrilled with where I am now. I am super excited to be thinking about things and having the space to explore and build and learn. On the other hand, it's a bit of an odd look!

My mind just works in this way—I'm constantly trying to map everything out. What are the possibilities, and how will this go well, and how will this go awry? I want it to be a rebirth, I guess. And maybe it is. But we'll have to see . . .

JONAH

I LIVED IN WASHINGTON, DC, FOR A LONG time and went through a breakup while I was living there. I was self-employed and could work from anywhere, so I thought I would use that as an excuse to live more freely. Since then, I haven't had a lease, and I've been living out of a suitcase. At a certain point, it started to feel very disconnected. I would say it was a really unmoored feeling.

For a while, my stuff was spread through-out four states: I had stuff in a storage unit in Washington, DC, stuff in Chicago, stuff in Vermont, and stuff in New York. I never knew where anything was. I'd be like, *I know I have this thing, but where is it?* It made my brain feel very scattered. It didn't make me feel good.

So during that time, I discovered this app that no one was using. It was this app where you and other people who had it could take turns playing songs. It looked like something from the '90s. At first, it was just me playing music for no one. I would play ninety minutes of music from 7:30 until 9 o'clock every night. Sometimes strangers would come and go.

Eventually, these three friends of mine would tune in every night—without fail, one, two, or all three of them would tune in. It kind of evolved, and there was a different theme every night. It could be songs about color or songs about Saturdays, breakup songs. And there was some chatting in the weird sidebar.

For 365 nights we did this—we played at least ninety minutes of music.

It was very grounding. It didn't matter what was happening in the periphery of my screen—that was always changing (different people, different noises, different smells), but this was always consistent.

There would be nights when I wasn't actively participating. I'd be on a long drive, like a fourteen-hour drive. And my friends would be live programming music for me to listen to. It would keep me company on these mindless drives.

You know when you're a kid you have a blankie or a velveteen rabbit or something? It's this familiar object, it's always there with you, something to check in with. It was like that.

I have a weird relationship with stuff. For a long time, I felt totally trapped by my stuff. I would anthropomorphize things—anything that had a face was difficult for me to throw out. I felt like, *What do I do with all of these things?*

Now, having spent the better part of four years not being able to accumulate stuff like I used to be able to, in some ways "stuff" has been replaced by rituals and whatever I can do to maintain consistency.

After 365 days, we stopped playing the music. Now, we do a weekly thing that's aired on this internet radio station. To this day, it's a very grounding thing for me.

BENTON

I GREW UP IN A REALLY SMALL TOWN IN Tennessee. Like really small. Look, little towns get a bad rap. There's nothing wrong with them. They're quaint. But as a kid, it felt like I was going to be stuck there forever.

We were one of those towns where people were big on calling you Big Fella or Big Guy. It's a very Southern thing to call someone a big boy instead of fat.

All the time growing up, people would ask if I was gonna play football. They separated boys and girls, and the boys *had* to play football. And I would hide. I would crawl under this outdoor gazebo. Football was not my personality. I was the opposite of football. I basically thought I was in the movie *The Craft*. I was gothic. I was everything but wanting to play football.

When I was growing up, I remember being like, *Something is so off.* I was like, *I don't understand why I don't feel like all of these other people. Why don't I fit into this little town?* I remember being six years old and thinking something is different about me from everybody else. And it felt like everybody else could see it, but I just haven't caught on yet. I used to want to play house with the other kids in school, but I'd want to be the mom. And I'd get in trouble with my teacher. She'd call my parents and say, "There's something wrong, Benton wants to play the mom." My mom would be like, "It's fine, just let him."

To give some context, this town one time called my parents because they thought I was a witch. They made my parents come to a town hall meeting about it where the town got to come and discuss whether I was a witch, and I had to sit in the truck.

They ended up deciding that I was not a witch. But because I wore a lot of *The Osbournes* T-shirts, they made me eat lunch with a youth pastor a few times. My family believes in God,

we're religious, but we thought it was strange that I had to do this. My mom was like, "Just eat lunch with him and be nice to him." The pastor would tell me that *The Osbournes* was not "of Jesus." I thought, *If they think that's bad, I can definitely never come out.* That was my thought process. I was like, *If TV is bad or playing make-believe is bad, then I am really in for it.*

But I was just one of those people—I just couldn't fit in. I was the kind of kid who would tell the teacher, "I love your shoes!" My flame was a little too big and a little too bright. I would get bullied so much. People would say, "You're gay, you're gay." And I was like, *I've never even kissed anyone; what are we talking about?*

But it was so much beyond being gay, really. I never felt like I was in the right gender space. We didn't have words like nonbinary, but I was just like, *None of this feels correct to me.*

I was very creative but I didn't know what to do with it. Where I was from, being creative wasn't a talent or a skill. Only playing sports was a talent or a skill. We didn't really have any way to express ourselves. And you definitely couldn't be like, *I wonder what it would it be like to kiss the same gender?* It would be unfathomable.

To survive, I was like, *Let me figure out all the ways I can water down my interests until they may be something a boy could like and wouldn't draw a lot of attention.* Instead of being like, *I love makeup.* I would be like, *Let me do YOUR makeup.* I got those ideas from watching TV shows, like *Queer Eye for the Straight Guy*. The gay men would help heterosexual men. So I thought, *Oh, as long as you're helping someone, people think you're beneficial. As long as you're an accessory to straight people's lives, you're okay.*

I realized I could numb down the sex part and really amp up the silly part, the part that

has a bunch of female friends. People will let it slide then. They're not really concerned about the gay part until it comes to intimacy.

So that was the armor I wore throughout school. It's really sad when I think about it now, but at the time, it made the most sense.

Eventually, I decided I wanted to be in entertainment, but I had this idea in my head that I couldn't be the main character. You have to be the sidekick. We have Dan Levy now to look up to. And Ellen. But you don't have a lot of people who are the star of something to look up to. We definitely have more now, but we didn't have a lot then.

I decided I'd do comedy, but there was no real path to get to where I wanted to be. So I was like, *I'm not gonna worry about what everybody thinks, and I'm just gonna push through.* I got better at comedy. I got shows at a big venue in Nashville. And I was doing really well, and I met Whitney Cummings and went on the road with her. It was a huge deal for me when it happened. That was a great achievement.

I feel like I've gotten to do everything I've ever done because I pushed through. Even though I didn't see people like me as the lead or doing what I wanted, I just pushed through and kept going.

Then I hit this whole new layer where I started thinking about my gender, and I felt super-scared all over again. We're at this place right now in comedy where gender is a big joke. It's the butt of all of these jokes. I feel like, *Oh, if I want to wear makeup or nails on stage it's going to hinder my career.* Comedy clubs are a club. It's hard to get into that club. I started worrying that exploring gender was going to hurt me all over again and make me feel like a teenager again. I've had a lot of personal growth, but I've had to learn how to retell jokes as someone who's exploring gender.

Sometimes in comedy, it can still feel like I'm out there alone, searching for someone like me. But I do think comedy is changing, slowly but surely. We have comedians like Phoebe Robinson creating opportunities for everyone. We have more representation now. But we can always have more, which is what I'm excited about—being a part of that change.

> Sometimes in comedy, it can still feel like I'm out there alone, searching for someone like me.

On the plus side, I get to be that for someone else. When I do these bigger shows now, all of these gay and trans kids and their parents come up and say, "Thank you so much for doing this!" Now *that* is making it! Things like that give me a lot of hope for the future. I see people in the audience feel braver and happier hearing my jokes, and that makes me feel braver.

I think the important thing for people to know is this—you're right. You're right about your dreams and your interests. God gave you your desires for a reason. There's a reason for anything you feel. You should go with it. Go for it. Don't water it down.

I wish I had never watered it down. It will never make you happy living through someone else. You have to do what you think is right because you know. You know already.

JESSIE

I DIDN'T COME OUT UNTIL I WAS IN MY LATE twenties. I had dated guys, but I had an inkling that I was queer.

So I was working at a small newspaper in my twenties, and I met this woman. She was the obit writer, and I was a photographer. We got to know each other, and we fell in love. She wasn't out either, but her parents must have known we were together. We weren't affectionate in front of them, but I would spend weekends with them. They were really nice to me. I used to smoke at the time, and they said to me, "Oh, you eat so many carrots, I think it's going to counteract the cigarettes."

I came out to my mother, and it was hard for her. Her response was, "That woman is going to suck the blood out of you." Then I came out to my older sister who I had thought was so cool and so hip, and she said, "Are you purple?" I guess people associate purple with being queer. And I said, "What are you talking about?"

I eventually came out to my dad, who was a somewhat conservative banker. He would come out and visit me on business trips. And he was hard of hearing. He always wanted me to meet somebody, and he would say, "Go on a cruise." And I would say, "Dad, who am I going to meet on a cruise?" We were in a small restaurant, and I said, "I'm with a woman." And, like I said, his hearing wasn't great, so he said in a real loud voice, "So you like women?" And I said, "Uh, yeah." And he said, "Why

didn't you tell me before?" And I said, "I was afraid. I was worried you'd be disappointed." And he said, "So I'm the ogre?" And I said, "No, I was a coward." And he said to me, "I think that's just the way you were born." And then he asked if I wanted children, and I said, "Yeah, but you can't have everything." And that was the end of it.

Eventually, my mom and my siblings came around. And when I got married to my partner, Carol, all of my siblings sent us gifts.

For me, it helped to listen to myself and to listen to what made me happy and be honest with myself and others.

ALICE J.

If there's something you're curious about, find some folks who are curious too. Set boundaries for yourself and do what feels good in that moment.

I'M MULTIRACIAL. MY MOTHER WAS WHITE. MY father is Black. I was born and raised in Park Slope, Brooklyn. My father would take me for a lot of hikes in Prospect Park, and he taught me how to use a compass. Having grown up in Brooklyn and having had a father who is Black teach me some basic outdoor skills, I was unaware of the lack of diversity in outdoor recreation and environmental activism.

When I was nineteen, my mom moved back to Michigan to be closer to family. That prompted me to look into colleges up here, and I ended up going to school at Northern Michigan University, which is in the Upper Peninsula in Michigan and very, very rural. Very beautiful, but not diverse at all.

I lived up there for about six years. Even as somebody who is lighter-complected and who

has spent a lot of time in white spaces, I still felt very isolated there. Had I not been able to benefit from skin privilege, it would have been even more isolating.

I've always loved being in nature. But when I was in the Upper Peninsula, I was around all of these people who spent most of their lives without any discomfort in the outdoors. When I would try to learn more about the outdoors, it felt like I needed to do it in a certain way, and I didn't know how to do that.

My father is an eighty-nine-year-old Black man. He's seen a lot of racism in this country over his lifetime. And like many Black people, I internalized some fear of being out in the woods in rural spaces. Like, if you go out in the woods and you're Black, you might not come back. That trans-generational trauma is very common.

I moved to Grand Rapids, and since 2015, a lot of my work has been around environmental and social justice advocacy. I noticed that the environmental space was primarily white. And the social justice space was primarily people of color. Noticing all of this prompted me to delve into my own relationship with nature.

I started to dig into the reasons why we see disparity. I looked into the history of environmental conservation and looked into John Muir and the work that he did. His writings very overtly took autonomy away from Indigenous people and Black people, and a lot of the things he worked on perpetuated exclusion.

I want to help shed the definition of what outdoorsy is supposed to look like. I've been leading a bunch of trips and experiences for BIPOC folks—trying to remove the barriers to accessibility and inclusion in being outside in nature and having joyful experiences outdoors.

There's no one right way to be outdoorsy. You can forage or rollerblade or garden or just sit in a park. Start wherever feels safest for you. If there's something you're curious about, find some folks who are curious too. Set boundaries for yourself and do what feels good in that moment.

I think I felt shame before. And I don't feel that anymore, and now I feel like I can extend that to other people. Helping people feel like this is something they can do feels good. I find that being in nature is beneficial to my health in every regard—mental, spiritual, physical. I've more recently realized that it's not humans AND nature. Humans ARE nature, and I think it's important for all of us to get back to that mentality.

NEGIN

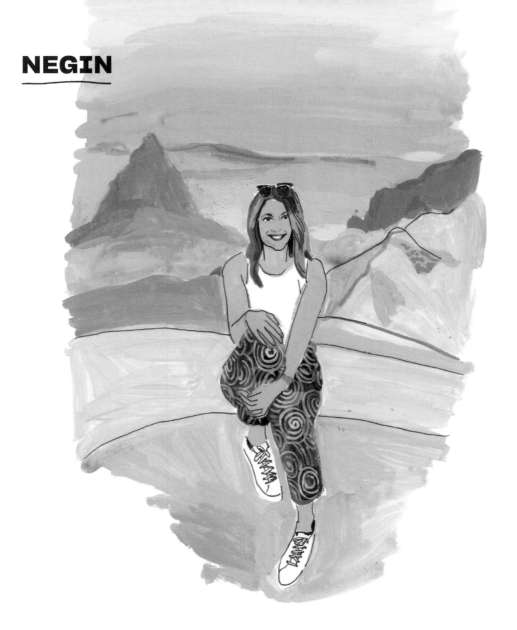

I HAVE NO BIRTH CERTIFICATE. MY PARENTS don't really know the actual date of my birth. I was born in Afghanistan. At that time, my father was a communist. He was a general for the communist party in Afghanistan. The country was split into two. There were two parties. One supported the democrats, who were supported by the US government, and then the communists, who were supported by the Soviet Union. We were in the midst of battle when the communist regime was taken over—they were killing people left and right. I was born in that period. I was born in a basement in a house that was built over a graveyard.

After I was born, my family and I were running away from Afghanistan because my

father was a target to be killed. In fact, he was in prison. He was in line to be executed, but one of his prior soldiers—the soldiers were mingling from all of the parties because no one was keeping records of who was in what party—saw my dad and released him, and our family fled.

I believe I wasn't even one year old when we were on a train to Azerbaijan. My parents were under the impression that if we went through the United Nations in Azerbaijan we would come to the US much more quickly. But it actually took us nine years. We were living in refugee camps. We lived a really, really hard life in Azerbaijan. But there were still moments of happiness—you know what they say: less money, less stress. We lived a very simple life.

I grew up speaking four languages. We spoke the native language—Azeri—which is close to Turkish. At school and with the government officials, you had to speak Russian because it was run by the Soviet Union. I spoke my own native language, Dari, and I also learned to speak English there.

We moved from the refugee camp to an abandoned dormitory, and we lived there for a while. I grew up using public bathrooms and public showers. One of my favorite desserts was milk with a little bit of sugar that you mixed together. It was a very poor, frugal lifestyle.

How we got to America was amazing—it was pure luck. My parents were smart enough to focus on one of their children. They focused on my brother, who was five years older than me. When my older brother was in elementary school, my parents used all of their money to hire a tutor to teach him English fluently.

I don't know how, but my mom got him to go onto this radio show and tell people about our lives. He talked about us being an Afghan family who had come to Azerbaijan with ten or twenty thousand dollars in cash, but it had all gotten stolen. He talked about how we are now in this foreign country, and we don't know the language, the culture, the people.

We got a lot of attention from that radio appearance and people started calling the United Nations, saying, "There's this family, and they need help. And we want to help them." This Presbyterian church in California heard about us, and they said they would sponsor our family to come to the United States. And it went through! Some churches want people to convert, but this church didn't want that. They were amazing.

We got to the United States a few months before 9/11. And we have been here since. It was really the best time to come because we have friends who are still in Azerbaijan waiting to leave. Because after 9/11, seeing "Afghan" on an application is not well received.

It was a struggle being here too. Our parents didn't understand the system and worked night and day to provide for us. We didn't get government support for many years.

I grew up in this conservative, religious household that was still very much Afghan. Yet I was going to a public school where everyone else is from all kinds of backgrounds, and I'm

super American in school. I basically have to be two different people because the two cultures don't mesh. At one point, I decided to be more honest with my family and myself, and I started to mesh them together. I know I am not the only person who has felt this way.

My mom got married when she was sixteen years old. There's a mindset that your only role as a woman is to be a wife and a mother. I had a lot of suitors when I was young. Some of them were twenty years older than me! There was a lot of pressure to get married as soon as possible. And I had to dress a certain way. You had to cover your cleavage, I couldn't wear skinny jeans. I couldn't do anything about my facial hair. There are all of these rules. I felt I had to pray five times a day and fast and be this "good girl." And what's a good girl? A good girl is someone who listens to the male authorities in their family—their brothers, their father, uncles, grandfathers. As long as you're abiding by their rules, you're a "good girl."

As I was growing older, I saw some of my girlfriends dating. That was tough to see— I was a teenager, I had feelings, I wanted to date too.

Here I was, this girl who had grown up my entire life hearing, "We don't have money." We had never gone on a family trip. When we used to go to dinner, we would only order water. And we would only go out every once in a while. So money became my focus. I thought, *What can I do to make sure I never have this conversation with my family, with my kids, with my spouse?* I saw education as an opportunity. So I started pushing for my own education. For example, when we got here, I was in third grade, and I was in ESL (English as a Second Language). But by sixth grade, I was in honors classes. I always felt, even then, that education was freedom. Especially in certain countries, you

don't have access to education unless you're rich. Education is wealth. So I worked really hard during school.

But then I had this realization that I'm smart, but I'm still abiding by these principles, like, I can't be out past 7 o'clock at night, I can't hug a guy, I'm told when to speak when a man is speaking to me, when to look up, when to have eye contact! So all of these rules were weighing on me. At home, I'm weighed down by rules, but out in the world I am this talkative girl.

It was right after college when I became a teller at a bank. I started working a lot and noticing my financial independence. I was paying for my own education and paying for all of my bills but living at my father's house. I was questioning everything. It took me all the way to law school to finally move out and become the individual that I am today. I finally said, "That's enough." I just couldn't continue to act like an independent woman outside of my house, and then go back home and say, "Yes daddy, yes mommy."

I grew up thinking my parents were always right and that in order to be happy I had to abide by what they were telling me. I'm redefining that now. I realize now that you have to prioritize your own happiness, and you have to figure out what your happiness is. If that causes relationships to deteriorate, that's not your fault.

I am very close with my mom. I think my mom lives vicariously through me. She's my champion. She was always in the back being my cheerleader. I could tell she was like, *She's right. I agree!*

I still identify as Muslim, although I am not practicing. I still respect where I come from. But I feel a freedom now where I can just be me and no one is watching over me.

NAOMI

I'M EIGHT-AND-A-HALF NOW, AND EVERY TIME I go to school, there's drama and I can't stop it. It's like I'm caught between two friends. There's this friend that I like, but then she has a best friend who is jealous of our friendship. And it's really hard. It's like this one girl is my enemy.

She tries to humiliate me by playing these very inappropriate games. Too inappropriate to talk about. She always excludes me and tries to make me feel like the worst one. Whenever I play with her and our other friends, she always gives the other girls special powers. I have to have the least powerful power. We'll play a game where we're all witches, and she will have *all* of the powers, and then she lets the other

friends choose their powers, and they choose shapeshifting and teleporting. And then she gives me two options. She'll be like, "Do you want flying or cloud power?" And both of those powers are weak and weird. When that happens, I just leave the game and play with someone else.

Sometimes, bullies are mean and you just have to deal with it the best you can. Try to not take it too personally because it's really just that the bully feels bad about themselves. They don't feel secure about themselves. They have to be mean to other people to make themselves feel better. It's helpful to know that at the end of the day I can talk about it with my parents.

TANTELY

I LIVE IN ANTANANARIVO, THE CAPITAL OF Madagascar. I'm married. No kids. My wife, we were friends a long time ago. She was one of my best friends, and then we started to flirt, and we wound up together.

Me and my wife, we really started from zero. We didn't have rich parents. We built our small house together, and then I started to work in 2008. I worked as a flight attendant. We started to save money because we wanted to have our own business one day. I studied tourism, hospitality, and environmental conservation. And we both worked in events in Madagascar for a couple years, so we wanted to have a business that combined all of that.

For about four years, we tried to save as much as we could. It felt good. We'd work and get money. You could really feel the emotion of saving the money. We had a simple life and made sacrifices because we had a target to hit. We both worked very hard.

But then we were taken advantage of by someone, and we lost all of our money. A man came to us and proposed an investment, then he disappeared with the money. We were disappointed. At first, I did not have a good attitude because I'm human.

But we never gave up. A couple days after it happened, we tried to stand up and try again. I said to my wife, "This is not a problem; let's save again." So we did; we saved again. And we created our own business. We created an event logistics company. But then we tried to invest again with someone and again we lost our savings. We had to deal with it. We tried to survive with the small amount we had left.

What I learned is that you have to choose your partner, your friend, the person you're going to work with. You have to make the right choice. It's difficult, but you have to try. And also, never give up in your life. Work hard and never give up. You might meet difficult things in your life. You might lose, but you will also learn.

Recently, someone called us and asked if we are interested in working with them. They said they didn't need any money, but they wanted our experience. I said, "OK, perfect. I have no money. But I have experience." They said we would be a partner with them. It felt like a blessing for me and my wife. Now we live much better than even just a couple of months ago. Our life is better than before.

CARLA

I FOUND MYSELF PREGNANT, AND I WAS NOT in a position to have a baby. There was an organization at the time called the Clergyman's Consultation Service, which was started by the Rev. Howard Moody at Judson Memorial Church. It was before abortion was legal in New York and before *Roe v. Wade*. Rev. Moody had set up this committee to help women get safe abortions.

I lived in the West Village at the time, so I went to the church and sat with Rev. Moody, and he helped me figure it out. They had a couple places where you could go and get a safe abortion. It was still illegal, but it was safe. One of the places was in Pittsburgh. What you did was you flew to Pittsburgh. It was done by a doctor. From what I heard, he was the head of gynecology at the local university hospital. You took a bus in from the airport and got off at the last stop, which was across the street from a hotel. So you'd go to the hotel.

I went by myself. I can't remember if you had to go by yourself or if I didn't want to put anyone else into any danger. I wanted to take full responsibility for it myself.

So I went up to the hotel room. I was wearing a skirt, and I removed my panties. He did it on a table in the hotel room without any anesthesia. Basically, you needed to be able to get up and walk out if you had to. You didn't know what would happen. You make it through those things.

I was very fortunate because my gynecologist at home knew about it and was prepared to help me when I got back. Back then, you depended a lot on your gynecologist to provide you with support. And a lot of them wouldn't because they were too afraid, but by that point, there were some people who were stepping up and offering support.

My abortion was so fast that I took the same bus back to the airport that I had taken to the hotel. The bus driver said to me when I got on the bus, "Oh, quick trip, huh?" Clearly he had an idea of what was going on.

I was about to get on the plane, and my body just started shaking and feeling crazy. It's a big shock to the body. You're not supposed to just jump up and jump on a plane. But I got on the plane because I figured I might need someone to help me, and I figured that way the airline would have to help me. It's a crazy thought. I just wanted to get back. During the flight, I was shaking, and the airline gave me blankets. By the time I got off, I was much better, and a friend was there to help me.

I think now when people will have to come to places like New York for abortions, they will

be well cared for. I hope. But at that time, you were basically on your own.

Now that abortion rights are being debated again, I am heartsick about it. I am very angry. I am worried that people aren't angry enough. Our government promised us that we would be able to make decisions for our bodies. It's going to be very painful for people, and people are going to die. If abortion is illegal, then everyone has failed. It's horrible for anyone who has to go through it, and there's a stigma. But on top of that, people wouldn't have the luxury to heal. It's criminal.

At the time, when I got my abortion, I felt that I didn't have a choice. And when you don't feel like you have a choice, you just have to do what you have to do.

I have gone to abortion rallies since the late '60s. Now I go to abortion rallies, and I wear a sign that says, "Tell me about your abortion. Ask me about mine."

And I'm somebody who, my whole life, I wanted to have kids. And when I finally had my daughter, I was in a position to have her; it was the best thing I ever did. I have a close relationship with my daughter. That wouldn't have been possible if I had had to have a child when I was totally unprepared to be a mother.

VICTOR

I GREW UP IN A VERY IMPOVERISHED NEIGH-borhood. There was a lot of violence and drug dealing around me. It was very hard to keep away from it.

I was very into basketball. During high school, I played basketball a lot. But before high school, I was homeschooled. And it made it harder for me to not be in those surroundings. I would get done with homeschooling at around 1 or 2 o'clock, and then I would go outside, and I would play basketball and not come back home until the streetlights came on outside.

There were a lot of things I saw then. There was this dude—I used to go and cut his grass—he was a drug dealer. He had a girlfriend, and they had a son together, and pretty much every Friday—which is when the paychecks hit—they would get a lot of alcohol and go out on the street and drink while I was playing basketball. And a lot of times, she would get on his nerves, and he would abuse her in some way. I remember this one time, I heard them shouting at each other. And he grabbed her hair and threw her down this concrete hill and started stomping on her.

When you're young, and you're surrounded by that, you just think, *Oh, this is normal.* And being homeschooled, I wasn't exposed to much else.

I saw people at church interact. But I didn't know that they would go back home and have different lives than what I saw. My family would drive thirty to forty minutes to go to a better church in a better neighborhood. Some of those kids at the church got exposed to the same things that I was exposed to in different ways. But some of them didn't. For me, it was a lot about survival.

My family was just working to make ends meet, and so it was hard for me to break out of the mental bondage that what I saw in my neighborhood was normal.

It took all of these steps to get me to change my mindset. My parents signed me up for an intramural basketball league, and I saw my coach there, and he got me playing summer basketball. At the time, my family was having trouble with our car, so we would rent cars or walk or bike to places. So my coach would pick me up and take me to basketball practice and take me to games. His name was Jimmy Horton, and he was a very good influence on me. He would pick me up, and we'd drive all over to go to practice. I was around him so often that it influenced me. I saw someone outside of just my family who was living differently than the people in my neighborhood. I could see this type of life that was good to live.

Then I started walking a mile to a community center right after school and wouldn't get home until 9 o'clock at night. And that took away from all of the bad influences when I was just going to play basketball down the street.

Then in my junior year of high school, we moved. I started going to public school, and that opened my eyes. You might see bad things happen, but there were also good things. You could see what life could be like.

It was a combination of all of those things that helped me break out of that mindset that things had to be bad.

REGGIE

MY FATHER WAS THE PASTOR OF THE WAYSIDE Baptist Church in Brooklyn for twenty-nine years. I have one younger brother, Barry, and our father was our hero. We were very close to our dad.

Any free time I had, I spent it with my parents. In 2007, I started to notice that my dad was taking a lot of naps. Sometimes I'd be there a few hours, and he'd take two naps. I thought, *That's not like him.* But I didn't really pay it no mind.

It was Memorial Day weekend, and on that Friday, the drummer at the church came up to me and said, "Hey man, what's wrong with your dad?" I said, "He looks fine to me." And he said, "Nah man, something's off."

The next day, I get a call from my mom, and she tells me my dad's in the hospital. So I went to the hospital, and my brother was there. We saw our dad, and he didn't seem like himself. Our mother took us into another room to speak.

I'll never forget it, it was like I got a Mike Tyson uppercut. With my eyes closed! I didn't see it coming. My mom said, "Your father has prostate cancer. He's had it for a year and made me swear not to tell you guys." I was like, *Well I'm not going to blame my mother for not telling me.* My mom was going through hell trying to keep a secret for a whole year while he was getting treated. It was a tough pill to

swallow, but we didn't think the worst would happen.

We went back in to see our dad and didn't tell him we knew. He told us he was going to get out of the hospital and keep preaching. People were telling him he'd have to cancel, but he was stubborn. And he was devoted to his church.

They let him out of the hospital, but things didn't get better, they got worse. He was sleeping all day, not eating. We went back and forth to the doctors, and they said those words, "It's just a matter of time." They told me that my dad, my hero, only had a few months to live.

We took him to Memorial Sloan Kettering. I had to pick him up and lift him into the truck at this point of his illness. That was a very difficult moment for me, having to carry my dad like that.

He stayed in the hospital for a while, and there was nothing they could do. His skin color was changing. He looked like death was coming. He had this look in his eyes. He wasn't really there. It had spread to his kidney and his lungs.

At Memorial Sloan Kettering, there's a floor there, and they tell you, "Every patient you see on this floor is dying." When you pass by the rooms, you see the family members sitting with patients; it'll break your heart. It's like it reaches into your chest and pulls your heart out because it's so sad. I was looking at them and feeling sad, but that was me too!

Eventually we took him out of the hospital. He made his last appearance at the church. A lot of crying. Grown men crying. Grown men just messed up.

We took him back home, and on a Sunday, on July 29th, it rained all day. My wife and my kids and I were there with him. I started crying, and the last words my dad said were, "Don't cry." He struggled to say it. It's tough to see your dad like that.

My wife and kids and I left, and about fifteen minutes later, we got a call. He was gone. I watched them take him out in the body bag.

I'm a musician, and I wrote a song called "Heaven." Part of the words are, "We all have lost someone dear to us. No one ever told us that death would be easy. But somehow we gotta keep going on, with the hope that we will see them again." It's about my dad. And it starts with me talking about how I wish there was a plane that could take me up to heaven so I could spend some time with him.

Sometimes life just hits you right in the face. And you have to take it. When that happened, my cousin who is older than me said, "You have a family to raise, you got to keep going. You have to get over this and keep going." I thought that was a harsh thing to say, but it was real.

JULIA

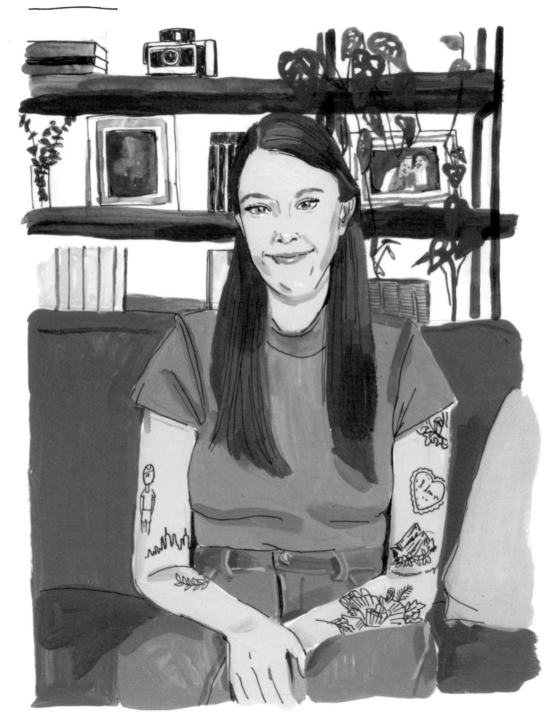

I MET THIS GUY THROUGH MY BEST FRIEND. She feels really bad about that now! They were friends, and I trusted her judgment. She told me she thought we'd be a good match, and we started texting.

He lived five hours away, so it was a long-distance relationship. He had plans of moving back when he finished school.

He was the nicest person I had ever met. He asked me so many questions about myself. No guy had ever been as intrigued by me as he was. He wanted to know every aspect of my life. When I tried to get him to tell me anything about him, he just turned the focus back on me. At the time, I was twenty-one years old, so it seemed cool. But now I know that's a red flag.

When we finally met in person, I thought he was an uggo. He was not cute at all. I was really let down. But I was like, *Don't be shallow, this is the nicest dude ever.* But I should have trusted my gut.

Things moved really fast. Things were perfect. He had the exact same interests as me. He was so doting and nice. I hate saying he was nice because it was all fake. But he was perfect for the first three months. I know now after researching sociopaths and narcissists that he was love bombing. He was mirroring my personality because we actually have nothing in common.

So I get pregnant after three months, and I decided to keep it. That was when everything changed for the worse, and he started showing his true colors. He started doing weird shit that I wouldn't have put up with normally, but I was pregnant and felt like I couldn't just break up with him.

For instance, one day I came home, and he told me he had read all of my diaries that I'd ever had. He said, "You had them on the nightstand, and you were begging me to read them." I was like, "No, I wasn't, I had them in a drawer."

We were still long-distance, so we didn't see each other too often. But I started getting clues that he was a terrible person. He started getting more aggressive sexually and not taking no for an answer. He came to visit one weekend, and I didn't want to have sex because I was eight months pregnant. He wouldn't let up. So I said, "If you just want to have sex with a body as if I'm a sex toy, go ahead." I expected him to be like, "No, it's fine," but he was like, "OK." My body froze and I was in shock, and I just let it happen. I started crying. He saw me crying. We made eye contact even. But he just kept going. I should have broken up with him then, but I didn't.

When my daughter was born, things got even worse. He's from a typical Southern family, and he thought the woman would do everything.

When my daughter was ten months old, we moved in together. By the time my daughter was one, I realized I had to break up with him. When we were long-distance, he was able to keep up the charade of being a good person, but once I was around him all the time, I realized he was a fucking terrible person. I lost my entire identity. I couldn't go to the bathroom without him picking the lock. If I had to pee, he needed to see me naked. If I didn't have clothes on, he needed to see me. I came home from work one time, and he told me he'd sniffed my underwear while I was gone. He was relentless in begging me for sex. He would do all of these really invasive things and I was like, *I cannot live like this.*

I started having daily panic attacks. I was the most stressed I had ever been. I told him I couldn't have sex. I said, "I need a break, and I promise I will tell you when I'm ready." That night, I woke up to him molesting me, and he was like, "I have needs." That happened every day for a month. I would wake up and tell him to stop, or I'd wake up crying. He thought he had access to my body whenever he wanted. He was raping me.

I broke up with him. But I was in my last semester of college, and I was working a minimum-wage job at a daycare because it allowed my daughter to go for free. We still lived together because I couldn't afford to live alone at that time. He would torture me: He would wake me up in the middle of the night and withhold sleep from me. He would play porn in my ears. He planted condom wrappers in the house to pretend he was fucking other people.

Then he bought a shotgun. It was the first gun I'd ever seen. I was raised by a hippie and am very anti-gun. I'm afraid of guns. He put the gun on my side of the bed. I was like, "You need to put that away, we have a child in the house." And then he would explain to me how hard it would be for my daughter to operate the gun. He was like, "This is not a threat, you're just scared."

There was a time when I heard him cock the gun. And I called to him and he didn't say anything. I went into the bedroom, and he was on the bed, and the gun was just leaning against the wall. And he was like, "What's up?" And I said, "I thought I heard your gun." He said, "No, why would you hear my gun?" I thought I was going crazy. I had been gaslit for so long, I felt like I was losing my mind. That happened the next night and the next. But on the third night, I didn't call to him. I just tiptoed back to the bedroom, and he was there, sitting on the bed, cocking his gun to scare me. I started crying, and he started laughing. He was like, "Gotcha!" He was evil. I had no idea that this kind of evil existed in the world.

Soon after that, he moved out and left me with the lease. It was rough on me because I was really, really poor.

It took me getting out of the relationship to realize it had been abusive. I started listening to podcasts about abusive relationships and reading stories online about other women who have been through them. The parallels were insane. It made me realize I'm not crazy and I'm not alone. That really helped—hearing other women's stories. I started sharing with my family and friends, and talking about it helped.

I still feel ashamed I let so many things happen, but I know it's not me and it's not my fault.

After talking it out with a lot of people and after meeting my husband, I confronted him. I told him about all of the things he had put me through and that it was an abusive relationship. He said, "I'm sorry you feel that way, and I often ask myself why I felt so entitled to your body." Confronting him helped a lot.

I still have contact with him because he's my daughter's dad. On social media, he acts like he's dad of the year.

I started posting about this on Instagram and TikTok, and that helped. Because people like him, they want you to be quiet. They want you to think no one will believe you. And if my stories about this can help someone else, that would be awesome.

The one good thing from this is that I am going to teach my kids about consent. That's not something I would have done. And I'm going to teach my daughter about what an abusive relationship is. Hopefully she will never find herself in this kind of situation.

TENILLE

I ALWAYS SANG IN THE CHURCH. I WAS BORN and raised in Little Rock, Arkansas. And I grew up going to church, singing in the choir. My aunt was the organist in our church. She was the first woman I saw playing keys and making it look cool. She was always sharply dressed too. It was like, *Man, I wanna do that.*

And back then, Whitney Houston was my idol. I remember watching her and thinking I would like to do that but not taking it seriously that I would ever get to.

When I moved to New York, I had been teaching myself how to play keyboard, so I would go to Guitar Center every day. I would stay in there to practice until they would kick me out.

You know how you feel like you expect something to happen, but you don't know if it's gonna happen? That's how I felt about playing music and being a musician. I kept wanting it to happen, but for a long time, it didn't quite take off. And when you're an artist, it sucks *just* to have a day job. It makes you feel very insig-

nificant. If you just go to work and come home and that's it, you feel bad. And that was what my life was for a little bit, and it didn't feel good.

Society tells us that you need to be a certain age to achieve something, and if you don't do it by that specific age, it's over. But that's just not the case. I say, do what makes you happy and keep going because nobody's journey and timetable looks the same. The artists that I've studied before me, it took them years, and they got what they wanted because they never stopped. There's a passage in the Bible that says something like, *The prize is not to the swift, it's not to the smart, it's to the one that endures.* It's not that you're smart or better than anybody, it's just that you never quit. And because you never quit, you're gonna have what you always wanted. That sticks with me and encourages me to keep going.

Now things are happening for me as a musician! And I have a lot of hope right now that things are going to work out the way I always wanted them to.

MIKE

I WAS WORKING TOO MUCH AT A RESTAURANT, and I was really stressed. I was drinking a lot and doing drugs. The thing is, part of the restaurant industry is to drink and do drugs. It was like a status symbol. You're cool if you can drink heavily and still make it to work the next day.

We'd drink so much because it's such a stressful environment. And it's stressful because there's a lot of high-end clientele. You don't want to make any mistakes or disappoint your tip pool because you share tips. It's not healthy for your mentality. And there's not enough support in the industry. It just got to me. I broke down.

I knew I had a meeting with my manager at the restaurant on a Monday morning, so on Sunday night I went out and got messed up on Molly. After going out, I partied in my room by myself and tried to do the rest of the Molly. I hit my limit on intake, and by the time I was supposed to go to the meeting, I was still too high to function around sober people.

I got in the shower, and I was getting ready to go to work to have the meeting, and I was like, *I can't do this anymore.* I turned off my phone and started playing video games for three days straight. My friends and roommate were checking on me, knocking on the door and asking if I was alright. I was like, "I'm alright." But I didn't want to face anybody. I tried to sleep, but when I woke up, I was still high. It was Molly, so it took a long time to run its course.

So I decided to run. I only had a hundred dollars in my account, so I spent eighty dollars to buy a ticket to anywhere that Greyhound would take me. It happened to be Richmond, Virginia.

I got to Richmond at two in the morning, and I just started walking. It's suburban there. It's a red state—Trump people. I was walking around in the middle of the night in these rich neighborhoods. Then it started to get lighter out, and I'm walking around, and people

started to say hello to me. I walked around this college campus because it felt safer.

I hadn't brought anything with me—no phone. All I had was a bag of books—my favorite books. I walked and walked. I walked for maybe eight hours. I walked off the high.

Then I walked to this hill. Over the hill was a Greyhound station, and I managed to scrounge up enough money on my credit cards and with the cash I had to get a ticket back.

I remember coming into Port Authority, and it felt like everything was regular again. But when I got back to my house, my roommate was like, "Dude, we thought you were dead!"

My feet hurt because I had walked so much. But I had to go right back to work because I had to pay rent. It was a lot.

Eventually, I quit that job and I moved to Las Vegas—because my parents live in Vegas, so I have some family support here.

When I first moved, I was still drinking a lot, and I was like, *I can't keep doing this*. I decided I had to build myself up in other ways, not build myself up with drinking. I decided I had to build my confidence.

Only now do I realize how much hatred I had inside me, and I feel like the only way to move forward is to let it go. It's hard to let go. It's a process.

So I stopped drinking, and I started reading more books and playing music. I'm a guitarist, but when I was drinking and doing drugs, I was barely a guitarist anymore. But once I got back into it, it took me about a year to get my chops back up. Now I'm thinking about music all the time. It feels like it's what I was born to do.

Now, sometimes I can see other people at work who are stressed or overwhelmed and I tell them, "Hey, it's cool, I got you." I want to offer that to them because I've been there, I know how it feels, and I know how it can make you feel good to hear that someone's got your back.

KRYSTAL

IN 2003, I MET A GUY ON MYSPACE. AND WE became friends. First, just on Myspace. He was a good friend too. Eventually, we got together because we were both single at the right time. We dated a couple of months, and then he was like, "I'm ready to be serious." And I was like, "Let's go." He and I had both had previous relationships where we had been cheated on, so when we got together with each other, we did it very purposefully.

Then he cheated on me. But instead of telling me, he projected it on me. He lied to me and kept saying that I was cheating on him! He did that for two weeks, and then he finally told me the truth. When he told me, it felt like my wheels had fallen off my wheelchair. I was just stuck.

He had been a friend of mine long before we got together; we'd known each other almost twenty years! And all of a sudden, we were completely finished—no romantic relationship, no longer friends. And I'd lost this whole life I was preparing for.

When we were together, my focus was to build a life with him—apply for positions where he lived in Atlanta, get ready to move there, prepare to be a wife. But once we broke up, everything changed. Just like that, I had to reinvent my life.

I'm smiling now, though, because the breakup wound up being a catalyst for me. All of these good things happened for me back-to-back. These other seeds I had planted on my own started to bloom. Right after our relationship ended, I got all of these opportunities: I got asked to model for an adaptive athletic line, I got to do a fashion show, I got a new apartment. Then I started hating my job, so I applied for different positions, and I got a promotion at a whole new organization. It's mind-blowing how life works.

Here's what I think: The first step is to feel the feelings; don't try to hide them or suppress them. At first, I suppressed my feelings, and then my girls were like, "That's enough drinking and sleeping, you got shit to do, Krystal." I have amazing friends. I have a great tribe.

The thing is, you can forget your feelings for a little bit, but then you have to feel them. I like to journal, but I have really bad carpal tunnel, so I do voice journaling on my phone. I'm also a Buddhist, so I do chanting. And I meditate. A clear headspace is my best friend.

For me, once I felt the feelings and understood them, I was like, *OK, let's start thinking of the next step.* I didn't feel stuck in the situation anymore, and I could attempt to merge back onto the highway.

Sure, my life isn't perfect, but it's good. I'm feeling surprisingly good. And I'm thriving.

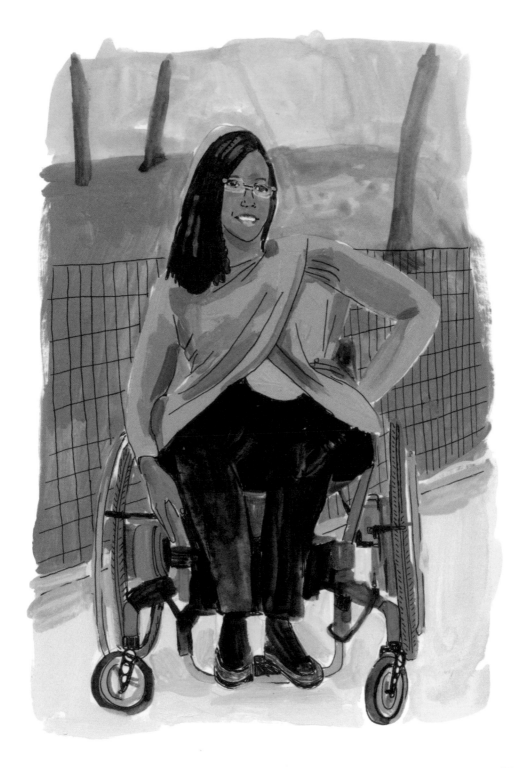

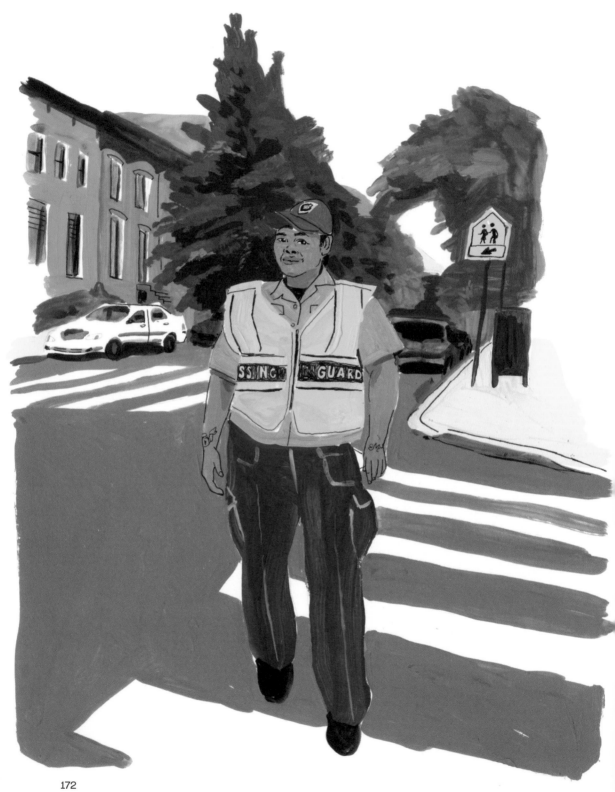

MONIQUE

MY GRANDMOTHER ADOPTED ME. THEY called her when I was in the hospital, and she came and got me out of the hospital, and she raised me.

The neighborhood I grew up in, everyone knew my grandmother. She was everyone's grandma. They all called her grandma. She knew literally everyone. She didn't have the luxury to go to school when she was growing up, so she would always tell everyone, "Go to school! It's free to learn and read."

My grandmother, she always told you the truth, whether it was hard to hear or not. You always knew it was coming from a place of love. She would be the voice of reason. She never judged you, she never put you down. That's why I am the way I am. I got her personality. She was sassy. She walked with a certain dignity. She was about her business, and when people see me, they think, *Oh, Monique is about her business.* Like, we keep ourselves nice.

And my grandmother was big on how you treat people. That's why when I come to work I say hi to everyone. I'm a crossing guard at a school, and I say hi to everyone whether I know you or not. My grandmother always told me that saying "good morning" to somebody could change their life. She would tell me not to call anyone "girl" or "her" or "him." If they have a name, you should know their name. I say hi to 250 people every day, and I know all their names—I have a list of names in my phone. I'm in the business of making people feel like they're people.

So when I was twenty-five, my grandmother died. If someone had told me ten years earlier that she was gonna die, I would have laughed and said, "You're a liar!" She was in perfect health! But we found her dead from a massive heart attack. She died on the spot. The medical examiner said we couldn't have saved her unless she was in the hospital and hooked up to machines. It was sudden. Here today, gone the next day.

After she died, I took it one day at a time. She was a good Christian, so I would listen to gospel or think about things she used to say. I'm not fully over it, but I'm learning how to cope every day. Now, as I get older, I do things to keep her memory alive. Like saying hi to all those people all day long.

SEENA

WHEN I WAS RIGHT OUT OF COLLEGE, I watched my friend get hit by a car on Fifty-Seventh Street between Eighth and Ninth avenues in Manhattan. I was the first one to get to him. I took his pulse, and he was dead on the scene. We rushed to the hospital. I carried his bloody clothing to the hospital. But it was too late.

My friend, his name was Ben, he had been crossing the street, and a car sped up to zoom past another car. The guy driving had had a few drinks. I saw it all happen. I could hear the revving of the engine as it sped by. I'll never forget that sound.

He was such a good friend. He was so sweet. I was a transfer student, and making friends as a transfer student is hard, so making friends with him was a big deal for me. When we were out that night, I had said to him, "You're a friend forever." We had so many of the same visions for our lives.

I had lived a really charmed life before that, and seeing that rocked me. Seeing an entire future wiped out . . . it's wild.

What was so difficult to deal with afterward was the fear. Living in New York City, you're crossing multiple streets every day. It became a real fear to a certain extent. When I would hear a car floor it, I would get very tense. If I was with my ex-girlfriend or, later on, with my wife, and I would hear a car revving, I would grab their arm and be like, "Wait, be careful!"

To deal with it, I drank a lot and smoked. I went to shrinks. All I was trying to do was *get over it.* I was trying to *get over* his death and *get over* this fear. I finally realized you can never get over them, they become part of you. I had to gain a sense of acceptance about that. When I would get scared of the car zooming by, I would externalize Ben and hear him saying in my head, "It's OK, don't be a wuss, you can cross the street." And I've applied that to other parts of my life now. Creating that other voice and personifying it in a way; being able to almost have a conversation with him in my mind has helped me grow. And it feels like he's still with me in a way. It's helped me deal with the trauma of his death. And the fear.

I'm a father now, and I want to convey this all to my son. I want him to know that acceptance can help you get over any challenge, any trauma, any tragedy. Because we will all have that in our lives—no matter how much you're protected or cared for, this world is a wild place, and you will be confronted with something that causes you pain at some point.

This acceptance—it's an acceptance of self in a way. And if you can accept yourself, everything else becomes a lot easier. I think we fight against ourselves for so long. We fight against some image of who we should be and what we should be doing. But really just being *is* what we should be doing. It's OK to just be. I'm still working on that. But it's the key to how I've grown since he died fifteen years ago.

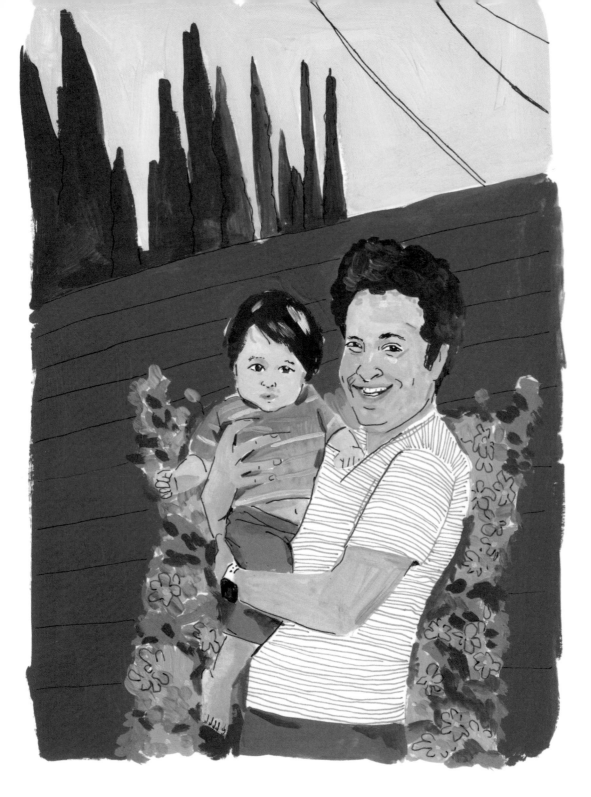

ULI

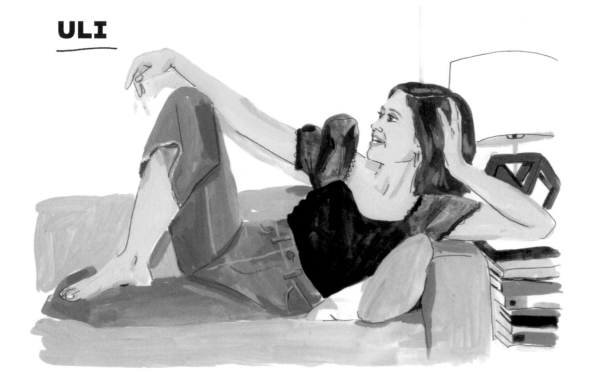

THE THING THAT I'M REALIZING IS THAT WE are overcoming something every hour, every minute. Currently, I am overcoming myself. I have been spending a lot of time, especially as I was turning forty, thinking about this. There's a little bit of an ego death that's going on right now. What I mean by that is that I had a lot of expectations that I had set for myself that I co-created with societal expectations. And a lot of assumed expectations from family members and friends, that I would be a certain way by the time I turned forty.

It first started to express as what I would call a midlife crisis. I was like, *Why am I feeling so out of place and so out of touch with what I thought my life was going to be?*

Probably like so many women or female-identifying people, regardless of whether you're leading your life in that direc-

tion or not, you come to a point in time where you are thinking about the question: "Should I be a woman that gives birth to someone?" That question will come up voluntarily or involuntarily. It will come up whether you have thought about it your whole life, whether you can conceive or not conceive, whether you were a person who thought for a big chunk of your life you never wanted children. When you are child-free and you find yourself turning forty, you are faced with it in a finite way. You realize that, biologically speaking, you are "running out of time" to biologically have a child.

That question came to me when I wasn't birthing a person, I was birthing a book. I was faced with the realization that I was leading a life that was very different from anybody else that I knew. My girlfriends were having their first kid or their second kid. They were

looking into buying houses or had bought houses. They had these settled lives. They had nine-to-five jobs, like their partners. I came up to this fork in the road and looked at the directions that were potentially options for me. I had to evaluate if I wanted to make a drastic lifestyle change. My husband and I are both artists. We often don't have steady jobs. We live in a two-bedroom rental apartment that I think is very beautiful, but we don't own it. We pay a shitload of money to a landlord every month. It's not our investment. It's money we won't ever see again. We are both living a life that is lived in the moment.

I have always been so proud to live a life in the moment. It is rare and hard to do. It takes a lot of dedication and commitment. It takes a lot of practice to be able to do it. Many times, we think of living in the moment as meditation or something that a Zen monk might do in the Himalayas. But when you're surrounded by a Western capitalist culture, living in the moment is really, really hard. When you go against societal norms, you have to overcome the societal norms, and you have to overcome yourself.

My mom always thought she was going to be a grandmother. And we're coming to terms with the fact that she will probably not be one. Because my life is just not set up that way.

I'm standing at the fork in the road and looking in the direction of continuing to live as the artist in the moment. And for me, personally speaking, I don't think I can also choose motherhood and continue that practice. Other people can do it, and I have so much respect for that, and I have no idea how they do that.

It's an idea that you have to overcome, that you can be a valuable member of society without having these achievements that are "standard."

There's this idea that our bodies owe something to the world, and I want to overcome that idea. I want to say, "My body doesn't owe anybody anything." It's my place to inhabit until I transition into another form. And it's OK for me to have total ownership and total authority over it.

How I'm overcoming all kinds of things, including the choice to be child-free, is that I am practicing saying no. I am realizing that saying no is the most powerful tool available to me. As a woman, I have been conditioned to say yes. I have been taught that I have to accommodate other people. I am getting really into saying no, and that doesn't make me less of an optimist or an empath or a super-feeler. It makes me actually more available to the things I want to give my time to.

When we think about the word "overcome," you're making it over something. You're making it over the hump. You're crossing the threshold. There's a fault line in the earth in front of you, and you found a way to surmount it. And anyone who has overcome anything is a person who has found a new perspective. You found a new way. You built a bridge where there was none. You are walking the pathless path. Finding your own way into something is the most beautiful experience you can give yourself.

Being strong in your own person is the hardest thing to do in life. And there are so many ways to find your way into your personhood. But I think the number one thing you have to practice is decision-making. But decision-making that is individualized to your own personal truth. And you can't make decisions if you don't know yourself. And how do you get to know yourself? By making decisions. So you just have to start someplace.

CHAD B.

I WAS CREATIVE DIRECTOR AT ABRAMS KIDS and ComicArts, where I spent thirteen years overseeing the design of 250 books a year. I was behind the aesthetic for over forty of the *New York Times* bestselling and award-winning books. My "youth"—as they would call it—was spent there. I started at Abrams when I was twenty-six. I began as an art director, but six months into me being there, I was basically the boss. It scared the hell out of me, but I found my way. At that time, Abrams had a children's imprint that had only been around for about five years, and we had the opportunity to really grow it and be more risk-taking.

Abrams became part of who I was; or who I thought was. When I left, it was identity-rocking. I had been okay with giving the company so much of my time—giving it my soul, in a way—because I loved the work. But when I was on the outside, looking in, I quickly realized that it was somewhat of a mirage. My identity there was an illusion, and I had to start building my life back.

At first, I was trying to get back what I felt like I had lost. I was basically working from scratch. I was at that first company so long, that I got a real sense of comfort and ego because I had a place to be. After I left, I found myself scrambling and lost.

Then one night, an agent friend of mine texted me and said I would make a great agent. He was a literary agent. At that point, anyone telling me I would be great at anything was like, *OK, great, yes!* So I started trying to figure out if I could be a literary agent. I interviewed for a few different jobs, but they didn't work out.

During this time, I posted on Instagram and offered to look at artists' portfolios. I would look at their work for thirty minutes to an hour, and then we would talk about how each artist could get one step higher in their creative process and how they could better communicate what they are interested in and place that enthusiasm into their work. The idea was to help them to work on their portfolios so that they could get the kind of job they were looking for. It was a lot like being an agent! After doing that for a little while, I started reviewing portfolios of possible future illustrators for The CAT Agency, helping them find new talent, which led to the agency president offering me a job as an agent. I work with the most brilliant, cool, accommodating person *in the world* now, and she is a beacon of light and fun who pushes me to be my best self and a better agent. Which is how I ended up where I am right now. And I'm doing really well! The trick is figuring out how much I can handle.

I don't think I'll ever feel like everything will be OK. But I feel good. I still operated with the mentality that if I take the foot off the gas, I'll start sinking. I don't think I'll ever feel as comfortable as I had at that old job, but I also think that level of comfort was a detriment. How do you walk away from something that's working? That seems insane. But being comfortable can be dangerous to growth.

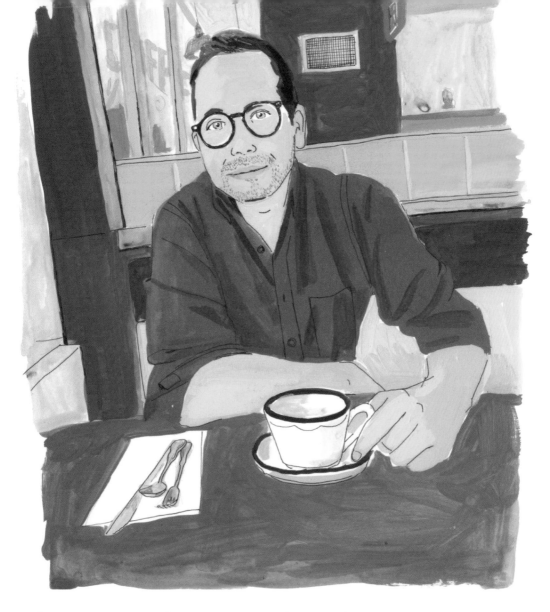

If I was going to give advice to someone going through this—someone having just left a job or looking for a job—I would tell them to be as proactive as possible and always say yes. Just say yes to things. Try things out see what fits, no matter how big or small. I was ready for something new to happen, and saying no to anything meant that I was just staying still—and being still was the most horrifying thing I could imagine because I didn't like where I was.

Now, I almost feel like I'm not working because I don't have the same stress levels I had at that other job; no more toxic office politics to navigate. With this new job, I help others navigate the terrain of publishing. The amount of success is based on how far I can dive in. It's up to me.

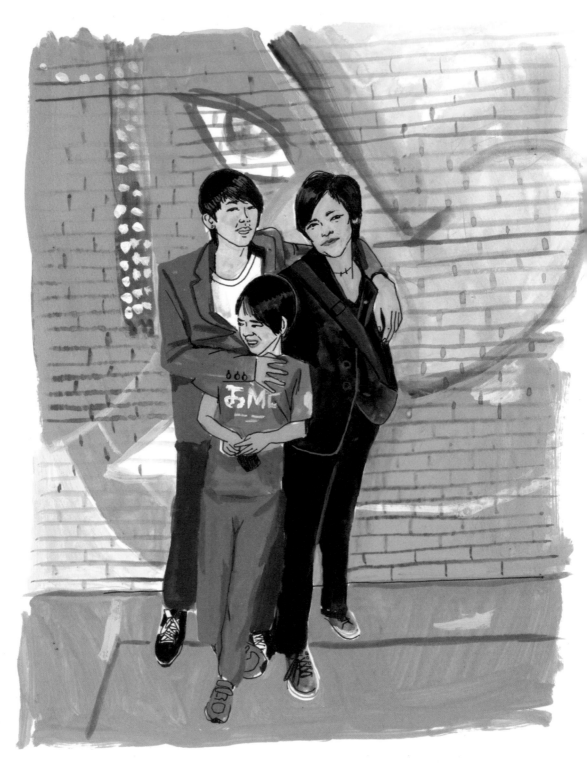

AYA

WHEN WE WERE PREGNANT, IT WAS RIGHT around the time when everyone was talking about Ricki Lake's documentary *The Business of Being Born*. It was all about the industrialization of childbirth, especially at hospitals and especially at New York hospitals. Everything was monetized. Everyone's time was monetized. Everyone's space was monetized, and that led to a cascading of events that would inevitably lead to a C-section. That was the point of the movie: it was basically saying women should know their options.

So we watched the documentary, and we were like, "Oh my god, what the fuck are we going to do?" At that point, I was planning to have my baby with a midwife who had a birthing center as part of Beth Israel Hospital because that's where my insurance was. But after we watched that documentary, Irwin, my husband, was like, "Oh my god, we've gotta have a home birth." Which is a really funny thing for someone who's not pregnant to be saying. But I agreed, especially if that was what the hospital experience was going to be like. And so many people I knew had these traumatic birth stories.

We decided to figure out how to make a home birth happen. So we transferred our care to a midwife. And I was already seven months pregnant, so it was kind of late in the game. But we managed to do it.

Through most of the pregnancy, I would go to the midwife's office in Harlem every three weeks or so. But then toward the end, she would come to my home. But she didn't have all of the equipment she needed. And maybe it was some kind of legal thing, but every week I had to go to a hospital to get monitored. They would monitor the heartbeat of the child to make sure everything was OK.

I was already pretty late. Pregnancies are supposed to last forty weeks, but I think anything between thirty-seven and forty is normal. So at forty weeks, I went in, and they monitored the heartbeat, and they were like, "We're not done with you. You have to stay here, and we have to continue monitoring you because we're hearing something irregular." At the same time, they wouldn't let me eat anything. So I was super-hungry and super-thirsty. This went on for a couple of hours.

Eventually, a doctor came in and yelled at me. He said, "What are you doing? You have to have this baby right now." He told me he would have to admit me, induce me, and I would have to have the baby immediately. He told me there was something irregular they were getting from the monitor and because I was already forty weeks, I had to be induced.

Meanwhile, I was talking with my midwife on the phone and asking what this all meant. And she was like, "I don't know! I don't use

those measures in my practice." She thought I was fine and told me to get out of the hospital. She thought they were pressuring me to get into their system and start this process of induction.

Irwin was with me the whole time, and we talked it over with the nurse there. I said, "What would happen if I were to admit myself right now?" And the nurse was like, "Wellllllll, it's Friday, so no one's around for the weekend. We would start you on the pill that softens the cervix, and maybe by Monday we would start you on the Pitocin." Basically, she was telling me that I would admit myself and for two days nothing would happen. It wasn't like they would bring me in and cut me open right away. So it indicated to me that it wasn't an emergency.

I was like, *Well, if I have those two days, there are things I can do on my own.* There were things I was already doing. My midwife was giving me enemas. I was giving my husband blowjobs and swallowing the sperm— supposedly the hormones in sperm are supposed to help induce contractions. I was taking walks. And you can do acupuncture too.

Irwin and I decided to go home and spend the weekend trying to go into labor on our own. The hospital wouldn't release us until we signed a waiver that said if our baby dies, it's not their fault. That was horrifying. That was really the first horrifying thing we had to face. But looking at the facts, it didn't feel like we were risking our child's life. We signed the papers and left the hospital.

I had this incredible acupuncture session with this woman who came to my house, and as she was treating me, she was also encouraging me to cry a lot and release a lot of fear I was holding in my body. That was at 3 o'clock in the afternoon and she was like, "I think you're going to go into labor in about twelve hours." I was like, "Really?" Then at 3 a.m., I started having contractions.

My doula was like, "This is awesome, but you need to conserve your energy." But I was so excited about the contractions, and I had read that you need to keep active to keep them going. So we walked across the Brooklyn Bridge. It was very silly.

All of this is to say that the literature that's out there for pregnant people leading up to the moment of childbirth is of a weird mystical genre that doesn't actually help you understand what's happening.

Anyway, labor was happening and it was taking a really long time. My doula comes over. My midwife comes over. They were with me for hours and hours and hours and hours. I had already vomited, so there was nothing in me, and I was getting really exhausted. My midwife was telling me to push on the contractions, but I just didn't feel like I could get behind it. I couldn't put my weight behind pushing. Things weren't progressing. At a certain point in the late afternoon, I started to freak out. I was like, "I don't think I can do this." Not only did I think I couldn't do it, I thought I was going to die. I felt so horrible and so weak. And also at that point, I couldn't talk anymore. Everyone around me was asking me questions, and I couldn't answer them anymore. My brain was starting to blank out.

It was a pure kind of fear. It was like an animal fear. It wasn't a logical thing. It wasn't like, *I'm afraid I can't get this baby out.* It was just a pure state of fear that the logical part of my brain couldn't grapple with.

The next part of that was just succumbing to that fear. I was like, *Oh well, I guess I might die and this baby might die. I can't do anything about it, and I'm going to give up and give in.*

I can't control this. I know at that point, my midwife and my husband were talking about what hospital to go to and who was going to get a car. And then my body started to push. And my midwife was like, "Are you going to have the baby here? Now?" I couldn't answer her, my body just started going through this. In between the contractions, they made me dance. Not dance, but they were forcibly moving and shaking my pelvis back and forth to help the baby come down. Eventually the baby came out.

Later, we found out that the reason that he was taking so long was that he had a compound presentation, which meant his hand was on his ear, so as he was coming out, his arm was also coming out. Which meant that his shoulder was stuck in a certain position and his shoulder and elbow were in the way. There had to be a lot of twisting around to get him out.

He finally came. And my midwife was like, "See, you did it! You should feel so victorious. Now you can do anything in life." Which was so ironic to me because I felt so defeated and humiliated by this whole process. I'm such a controlling person and an exacting person and a mind-forward person, that the process of having my mind break, basically, in order for my body to take over to do what it had to do to get the baby out was completely humiliating.

Signing those papers at the hospital was one level of fear, but to reach that moment in my mind where I was feeling like I might not make it through this experience—that kind of fear is really unique and isolating. It was very lonely, which compounded the fear.

I wish the defeat was something that had just fallen away. But it really stayed with me and sank into me like a layer of sediment.

Also the recovery from the childbirth took a long time. I was in so much pain. I couldn't sit up for weeks. Every time my body would experience a new kind of pain, I was reminded of this humiliation. It really affected how I thought about my own identity as a mother. I felt really broken and fractured. I have spent the years since I gave birth piecing myself back together.

I wish the defeat was something that had just fallen away. But it really stayed with me and sank into me like a layer of sediment.

What did help was having a second baby. The labor was so easy. I had mentally prepared for twenty hours of labor. I had prepared for a marathon. And then I almost gave birth to him on the toilet because I felt like I had to poop. I went to the bathroom, and my doula was like, "Wait, let me look at what's happening." She was like, "Wait, wait, wait, you're not pooping. You're having a baby. Get in the tub."

The midwife wasn't even there yet. The doula turned to my husband and was like, "Wash your hands, you're going to catch your baby!" And then *boop*, the baby came out in the bathtub. That birth was so easy and simple and painless that actually going through it again with so much more ease was healing. I feel like that second birth closed the chapter on that feeling of defeat and humiliation from the first one.

JAMIE

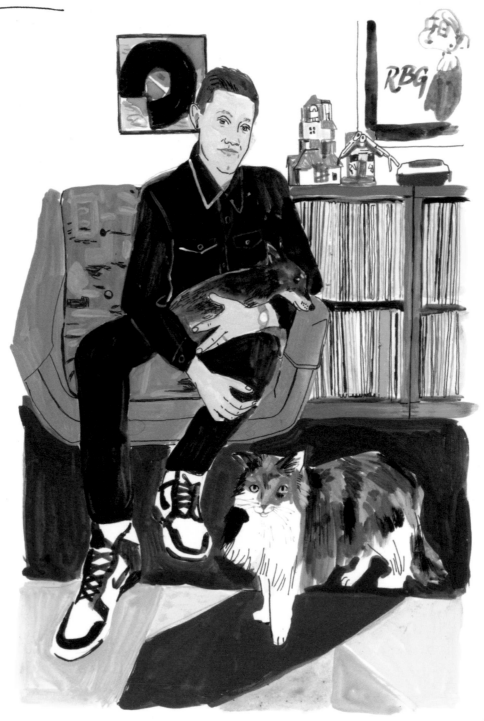

I GREW UP IN SOUTH FLORIDA. I HAVE AN OLDER gay brother. My father's side is very Jewish. My mother's side is very southern Baptist. It was like, "Nice to meet you, now go fuck yourself" with their families.

My dad always wanted a sports player. He's not a super-masculine guy, but he always wanted that. And he never got that with my older brother. My brother is super-smart, really cerebral, and preferred to spend his time rescuing animals and making art. I was the jock in the family. I also liked fashion and arts. And growing up, I was always being thrown into a box—you're the piano player, you're the basketball player. But I never felt like I fit into any sort of box.

As a kid, even with long hair, people were like, "Are you a boy or a girl?" At five years old, I just leaned into it, and I wore a tie. I did feel uncomfortable in my own skin sometimes because I didn't know how I was supposed to be. I was a butchier kind of girl, but I still liked pink.

The first woman I was attracted to was a man in drag at the gay bar. That was the most beautiful woman I had ever seen. I found out later it was the most popular drag queen in the South Florida scene. That was how I grew up in South Florida in the '90s.

And I grew up in the music industry. When I was growing up, I wanted to be a music engineer. My mom ran recording studios. I was really good at tech. I would go into these studios with all of these men and be better than them. I had a better ear, I was more focused, I had the ability to problem-solve faster. And the guys would be like, "You're just the boss's daughter, 'cause girls don't do this."

This is what I dealt with from the age of twelve through my early twenties. At a certain point, I was like, *I'm so fucking sick of these men telling me I'm not good enough.* I decided to quit being an engineer. I quit doing what I loved because I got badgered so much.

Eventually, I cut my hair. And suddenly I looked like a man to men, so the conversation changed. Instead of saying girls can't do that, they would talk to me in a different way. They'd talk about women in a disgusting way to me. It happens to me to this day.

Anyway, so now I'm a producer, and I do have great business partners that are men, but I often get treated differently than male producers and colleagues. I'll be on a call with a bunch of dudes, and no one will speak to me, and if I start talking, I get cut off.

Other times, I'll be on a call speaking about an LGBTQ project, and everyone else is speaking. I'll be the only LGBTQ person on the call, and I'll be like, "You do realize I'm the only lesbian on the call, right? Do you want my opinion?"

Sometimes I'm facing sexism. Sometimes it's homophobia. Occasionally it's gender bias. I never know what I'm going to walk into. So I have this self-deprecating humor because I want to make everyone else comfortable.

I've come to a sort of peace with it. It used to rile me up more.

Therapy helped. Also, I stepped outside of myself, and I looked at all of these things that were happening to me. I realized that I had to stop focusing on the sexism and homophobia. The reality is sometimes people are sexist. But all of that is noise. When I started focusing on myself and my confidence, then things changed for me, and they started to take off for me.

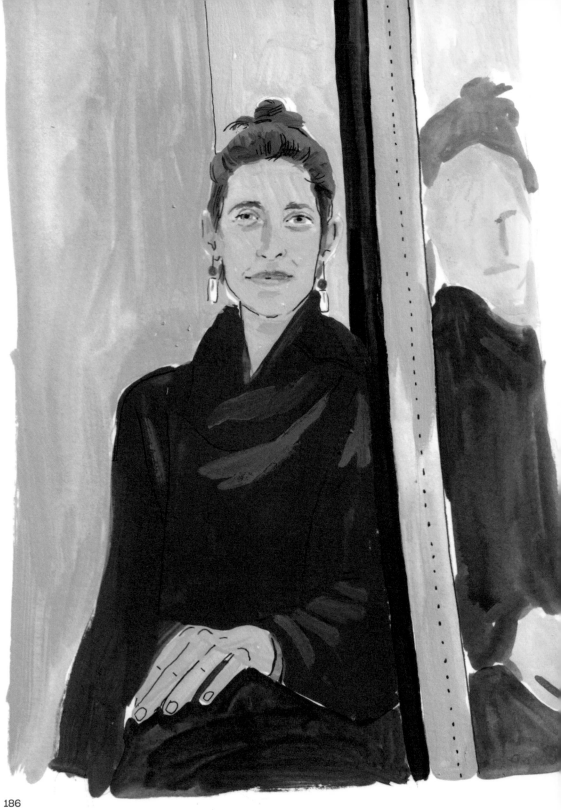

JULIA M.

MY DAD'S BEEN HIV-POSITIVE AND LIVING with AIDS since 1993, and I, very surprisingly, served as his primary caregiver for a time starting in 1998 when he was very, very sick.

In 1993, when my dad was diagnosed, he was diagnosed in secret. Not officially in secret, but he decided to keep it a secret. Including from me, my brother, and my mom, who was his ex-wife. At the time, my father was living very openly as a gay man. He had partners. His gayness was a very easy fact in our lives. It wasn't a surprise when he came out. But his illness—he never raised it with us for years.

At that time, I was thirteen and my brother was nine, and we were living with my mom in western New York, and my dad lived in New York City, and was a singing teacher.

It wasn't until 1997 that my father's diagnosis became apparent to me.

I finished high school early and hightailed it out of my town on graduation day with my father on a Greyhound bus on Pride Weekend. We went to the Pride parade, and we had a ball.

My dad parented us in his way, but he wasn't a daily part of our lives from a very early age. My parents split when I was five and my brother was one. When we saw him, he was always doing wacky things. There was a time when I was obsessed with Pippi Longstocking, so he let us strap sponges to our feet and wash the floors of his apartment by dumping buckets of water everywhere.

When I left my hometown in 1997, it was like adventure all the time. I had gotten into a prestigious acting program and had an agent— all of this fancy stuff. And my dad was teaching

at the time. A few months into me living with him, things got a little weird. He had offered to pay for things that I would receive bills for, and when I'd raise it with him he would say that he just hadn't gotten to it yet. He would take the bill, and he would call the school or whomever and angrily tell them not to contact me because I was a child.

He also had a cough that he couldn't shake. And I was diagnosed with mono—though I had been kissing no one. During Hanukkah/ Christmas time, I became very ill. And my mother, whom I had a complicated relationship with at the time, wound up driving to New York and coming to get me. My fever had spiked so high that I was vomiting the medication I was taking, and my dad just didn't take me to the doctor or to the emergency room. At the time, I didn't question it. It just wasn't what he did. It was what my mom did. So my mom came, and my mom did it.

A couple months later, we left our apartment—it was a loft on Bleecker Street. It turns out he had been kicked out. We wound up moving deep into Brooklyn. I had deferred college and was pursuing acting and working at a restaurant and babysitting. And I moved out of his place that spring. I got a room share with a weird dude.

At the end of June, it was very hot, and I asked to go to his place because he had air conditioning. Initially, he declined. But then he came around and said I could come over. He told me he was under the weather, and I just assumed he had a cold. So I arrived, and things had just gone horribly wrong. There was

rotting food all over the house. There were soiled clothes everywhere. He had disintegrated. He was very thin. He couldn't breathe.

He had told me the year before that he was not HIV-positive, so I had no reason to believe he hadn't told me the truth. I just assumed he had a very bad flu. At the end of that weekend, I convinced him to go to a doctor, and it was only when he couldn't walk down the stairs to the taxi that he let me come with him.

We went to a clinic, and the doctor called me into the room, and she told me that not only was my dad HIV-positive but he now had AIDS, and it was very serious, and he should be taken to the hospital immediately. My dad cried and walked away from me, and I think he said, "I'm sorry." I put him in a cab, which we could not afford. And we went the four blocks to the hospital, and he was admitted into the intensive care unit.

He was sent into the ICU without me, and after a little while, I was allowed to go join him. But emergency rooms—with all of their curtains—are kind of labyrinthian. So I was walking around looking for him. I was walking around in circles, and I kept walking by this window of a man in isolation. All I could see was the bones of his back. I kept thinking over and over again, *Poor guy, poor guy.* And I couldn't find my dad. But it turns out, that poor guy was my guy. That's when I clocked how sick he was.

He spent the next six weeks there. The summer was one disaster after another. My dad—at his peak—spoke seven languages; he was a brilliant guy, a beautiful visual artist in addition to a singer and teacher and director. And he lost the ability to do all of those things.

I was told to say what I had to say to him. A pulmonary specialist said they had never seen a person recover at this point in his illness.

They told me to call his family. I fought with him for several days about calling his sister and his brother. He didn't want to let anybody in. It was like us against the world. It was just me and him.

It took a while to convince him to let other people know. But eventually, everybody came and said goodbye. They spoke of him in the past tense to his face while he was lying there. Which was very strange. But what was even stranger is that he didn't die. He slowly started to get better.

In the midst of all of this, as I became the keeper of my father's life, I discovered that he had racked up tens of thousands of dollars of debt everywhere. He hadn't paid taxes since 1986, he had been evicted with a large debt against him, he hadn't paid his Con Edison bill. He had lost his social security card. Where a person should be, there was just a trail of nothing.

I spent a lot of time trying to prove that he existed in the eyes of the government so that he could receive Medicaid. I very quickly became the grownup. I decided what we could and couldn't afford, where we could and couldn't go, what could and couldn't happen, who could and couldn't see him.

At the end of that summer, when he was not dead, he was transferred to a nursing home. He lived there for nine months. He learned to walk and speak and write again. He went through a period of mental distress where he thought he was Jesus and wrote a death threat to my roommate. He started to believe that there was a grand reason why he had been spared.

I took up even further the mantle of adulthood. I continued to defer college. I moved in with a much-older boyfriend. I made structure and routine and tried to understand the landscape of my life.

When a parent is doing a beautiful job in early childhood, they are offering a kid a mirror so that they can see themselves. That's what I try to do as a parent; I hold these different containers for my kid so they can bounce around and figure out who they are. But in a situation like mine, the mirror was warped, and the container wasn't real. And so as I progressed through the journey of being with my dad, I had to start to figure out what was true and what was not about the world around me and myself. So much of who I was had been tied to who my dad had showed me I was, but so much of who he was had been a lie to me. So I started to have a hard time believing what was truth.

His survival was remarkable. But it was coupled with my falling apart.

When he got well enough to start to take care of his own life, my own life became a sinking ship. It was like there was water everywhere. I went through a period of self-sabotage. I started not to pay bills, even though I could. My phone was constantly being turned off. I broke a lease that I didn't need to break in the middle of the night. I think in a sense I was trying to understand myself in relation to this person.

I had to find the ground beneath my feet in a way that belonged to me. Not me as a caretaker or daughter. Just me. And that was hard for me.

When I look back on that time—at my behavior—it was like I was slapping myself to feel alive. I didn't know how to feel what was happening without violence, largely emotional violence.

When I got to my early twenties, I felt like I couldn't continue. I needed to break away in order to survive.

And when I was twenty-five, all of these little weird pieces of magic happened for

me. I got a job at a Shakespeare festival in San Francisco. I was given a car. My newly minted stepdad drove me halfway across the country, and then I drove the rest of the way on my own.

As I was driving across the country, I had to drive through the Salt Lake Desert to get to Nevada and then to the Bay Area. There had been a massive storm, and the result was that the Salt Lake Desert had flooded. And there were these little tiny snaking pathways surrounded by crystalline water and everything was reflected in the water—there were mountains in the distance reflected in this water. And I wandered through in my little car, alone. In the mountains, there was a hailstorm, and peeking out from the mountains was a rainbow. It was a remarkable image. And I was driving into it. It was absolutely beautiful, and I was so satisfied in my aloneness for the first time. I felt so peaceful and quiet and like I had finally been allowed to leave. It marked a transition.

That trip—leaving New York—it was the first time I had really left. And I was leaving for something, not running away. I spent the summer where no one knew anything about my dad or about my past. Before that, there had been a very long time where no matter who you were, the first thing you learned was, "Hi, my name is Julia. My dad has AIDS. I take care of him. I would like a glass of red wine." It was like, before the drink order, you have all of this information.

And it started becoming a deliberately kept thing so that I could be something else. In giving myself permission to sort of lie by omission, I wound up getting to be something else. And from there, I started to make my own choices and have agency over my own life.

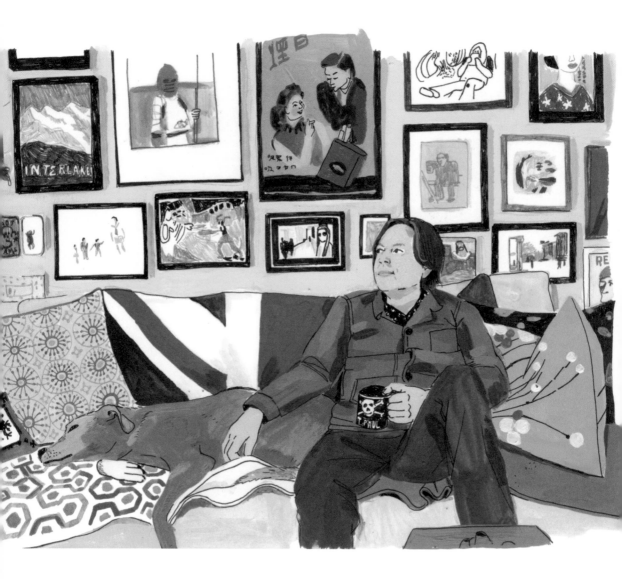

DAVE

I THINK IN RETROSPECT I'D HAD ANXIETY most of my life, but I didn't realize it. It wasn't until the depression kicked in that I was able to look at my life and see that the anxiety had been going on for a long time.

I had this irrational fear of drugs as a kid. I had this made-up, after-school special notion of drugs. Totally manufactured—my parents never said anything about drugs. I thought people were going to inject me with heroin or shove acid down my throat. In grade school, we had mimeographs, and we got one that said something like, "Watch out, there's LSD going around, and it has Mickey Mouse on it. It's going to tempt you." It made me so upset.

Then, when I got into high school, I was on the varsity hockey team—it was all seniors and juniors, except for me and a couple other freshmen. It was a big stoner sport; the locker room smelled like weed every day. They were hazing me so bad, and it felt like if I showed them that I was worried about weed, they'd make me smoke it. I literally got over the fear like that. All of a sudden, that fear was just gone.

Looking back on it, there was always something I would get fixated on and be so upset about for weeks, and it would ruin long stretches of time.

When I was in my early twenties, the anxiety and depression had gotten so bad that I had stopped eating and I wasn't functioning. It became really apparent to my roommates. I was also drinking constantly, and I don't think that helped.

I would get fixated and think I had different diseases. I was obsessed with the idea that I had HIV. I started having these episodes where I would really think I had HIV, and I would get tested and be like, *Something is wrong with the results. It's wrong. I have it.* I would call hotlines to talk to people about it, and I talked to this one guy and he was like, "Everything you're telling me . . . you're just not in the risk group. You're a young, straight guy who is fooling around with young, straight women." He was like, "I think you're depressed. I think you need to talk to a therapist." That was the first person that was like, *You have mental problems.*

After that, I talked to my sisters, and they were like, "Yeah, you're depressed. We've had horrible depression." I was coming from this family that didn't really talk about it. It was considered something you didn't talk about. You should just pray the Rosary. But hearing they had it, I was like, *Oh, this is a thing.*

Right after college, I went home for a weekend, but I just never came back. I went home, and the first thing I did was make an appointment with a doctor to see if I had HIV, and the doctor referred me to a therapist.

I had OCD too. It wasn't like I was touching things. It was more like I would make up these brain exercises. I would type out Led Zeppelin lyrics in my head. I would be hanging out

with people, and in my head, I would be typing lyrics the whole time. It would stop me from thinking about whatever I was obsessed with that week.

I started going to therapy in Cleveland. And that therapist helped me realize that the anxiety and the OCD were so exhausting that it made me depressed. Depression is this mind-fuck. Like, people would ask me why I was sad, and I didn't know.

Looking back on it, there was always something I would get fixated on and be so upset about for weeks, and it would ruin long stretches of time.

The therapist would ask me about my cancer history, and basically any relative I've ever had has died of cancer. And he would be like, "Are you worried about that?" I would say, "No, why would I worry about that?" And he would say, "Isn't it weird that you're obsessed with something that there's no evidence of but not worried about something there is evidence of?" He would point that stuff out to me.

That therapist taught me about this thing called "worry periods." Where you take twenty minutes twice a day and just convince yourself of the worst possible thing. So whatever it is you're worried about, you offer yourself no consolation. If you think you have cancer, you tell yourself you're gonna die. You set aside

time in the day to do it. You tell yourself, *OK, I'm going to think about this at 6 o'clock.* Anytime you want to think about it that's not 6 o'clock, you tell yourself you're going to think about it at that time, and your brain is like, *Oh, cool, we're gonna think about that later.* And your brain kind of goes with it.

Then when you do the worry periods, you can't possibly think of only the bad. It's like someone saying, *Don't think of pink elephants.* Then you think of pink elephants. And if someone says, *Only think of pink elephants,* you can't help but think of other things. Your brain just wants to think of other things. You can't only think of the thing you're worried about.

When I initially started doing it, I would throw up. I would be sitting in a room, crying, running to throw up. Because I was really good at worrying. But then eventually, it starts to work and the physical makeup of your brain changes.

That was super helpful for me—doing worry periods.

Another thing that was super helpful was that one day my therapist was like, "You know, we don't obsess about real things. We worry about real things, but we only obsess about illusions. So if you're obsessing about something, that's your bullshit detector." I was like, *Oh, wow!* He even wrote it down for me on a piece of paper, and I put it in my wallet. I was able to shift my way of thinking with that.

It's still an ongoing thing, but it's really improved. It always felt like my thoughts were so connected to me. You always hear people say, *You are not your thoughts.* But only recently has it felt like my thoughts have broken away from me. Now they are just something I can have and I can just watch them like a film strip playing out and then move on.

GOLDIE

A LOT OF THINGS HAVE BEEN HARD FOR ME TO do. Like learning to read. And doing math. Math is the hardest. And learning to ride a bike was hard. But my mom and dad told me that falling is good for you. That falling will help you learn. That mistakes will help you learn. I fell off the bike fourteen hundred times. And now I know how to ride.

There's one more thing that's very hard. I was sucking my thumb for my whole life. My mom and my dad told me to stop sucking my thumb. They had to have me put on nail polish that when I put it in my mouth it was very yucky. It felt sad to stop, but then I noticed it is not good for you to suck your thumb. So that made me feel like I'm growing up into a big girl.

RAELEN

What I learned doing it was this: as long as it's safe, then go for it.

I'VE ALWAYS WANTED TO BE A PERFORMER. That's always been my go-to thing—being an actor. And if I can't be an actor, I'll be a singer. Ever since I was a little kid, I've wanted that.

My family is full of performers, so I grew up with it. When I was in my mom's uterus, she was in the musical *The Wiz*. So I was technically in it too.

Now I perform in school. I did the musical *All Together Now!* with my high school, and I had a solo song in it. And then I got cast in my high school's production of *Clue*. I got cast as the Cook.

When I found out I got cast, I was excited but also surprised because some of the sophomores and juniors didn't get into the show. I'm a freshman, and I got in!

But then I got really nervous because I learned I would have to die and fall out of a fridge onto a person. I had to die on stage! It was scary! I had never died on stage before, and I'm not very good at falling. Luckily, the person who I was falling onto knew how to fall, so when we practiced the scene, I didn't get hurt.

We didn't have an actual fridge for me to fall out of, so for the show I was offstage, and I would fall from offstage to onstage. Dead! When we did it opening night, it went fine. But after I fell, my chef hat fell off, so we put it back on. And then I got moved to a couch, and the chef hat fell off again. Then I had to be on the couch—dead!—for the rest of the show. Which I hadn't known until earlier that week—that I would be onstage the whole entire show, dead! I was like, *Oh no! I can't go to the bathroom the whole time!* But it was fine. It was actually fun.

After the show, I told my friends, "My hat fell off! It wasn't supposed to fall off!" But everyone said it was funny. So that was good.

What I learned doing it was this: as long as it's safe, then go for it. I think if you can trust the people around you, then try it. I also think it's important to trust yourself to be able to do things. I didn't trust myself until I actually did it, but once I did it, I was like *Oh yeah! I can do this! I am actually able to do this!* It's a good feeling.

GABE

We were just getting through it. It was something we were getting through all the time.

FOR A LONG TIME, THE BIG STORY OF MY FAMILY was that my husband, Aaron, got hit by a speedboat and had to have his leg amputated. Aaron had been in a canoe, reading a book, and a teenager was driving a speedboat, looking backward. The speedboat hit the canoe, and then the canoe hit Aaron's leg. For a long time, *that* was the big thing we had overcome. It was a good story. It's dramatic. And it had a mostly happy ending.

Let me go back a little. So before Aaron's amputation, we had tried for years to get pregnant, and we did IVF, and it finally worked, and we had twins. When the twins were seven months old, we took a trip from New York to Indiana so my extended family could meet them. Getting the babies was a big deal and took a long time. So this was the celebration.

But then Aaron got hit by this speedboat. And the local hospital was small, and they were like, *We can handle a paperclip injury.* They were just like, *Go someplace else.* And so they cut off his shorts and put in a catheter and sent us to Kalamazoo to a bigger hospital. Eventually he got transferred to a hospital in Grand Rapids, Michigan. That hospital was ready for this type of excitement. They had a whole team of orthopedic surgeons.

Aaron ended up getting what they call a guillotine amputation. When we were released and we came back home, managing Aaron's pain was the scariest thing for me because he was so out of it; he was on a ton of different

types of really intense pain medicines—opioids and things. And his dad is a recovering alcoholic. So Aaron was really, really nervous about being on opioids and getting addicted. So he wanted to get off them as soon as possible.

I was managing all of his pain meds, and then we had these twins who are seven months old. It was a lot. It was all very traumatic. But we felt so much love and support from everybody. We were just getting through it. It was something we were getting through all the time.

So then, like, ten years later, during the pandemic, Aaron was out skateboarding, and he broke his leg—his amputated leg. Again. After the canoe accident, his leg had been amputated from the mid-calf down. Which is a good place to be amputated because the pros-

thesis has room to be attached. You just don't want to be amputated above the knee because the knee is so important.

Anyway, for Aaron, skating was his release. We lived really close to Bard College, and it's this gorgeous campus, and there's lots of little paths winding through it that you can skate or walk on and be away from everything. Skating was how he was getting through the pandemic.

This one day, he was skating, and he was going too fast, and he ended up getting thrown off the skateboard. And, of course, he didn't have his phone on him because he's a dingdong. He had left it in the car, thinking, *What do I need my phone for?*

So Aaron flags down a student to be like, "I hurt myself. Can I call my wife?" But because it

was still very early in the pandemic, and no one really knew what was going on with COVID, the student didn't want to get too close. So the kid calls me instead of letting Aaron call. And he says, "Do you have a husband?" And I was like, "Well, yeah." He tells me what happened, and it's like, *What do we do?* We only have one car, which Aaron had taken to go skating. And there aren't really any cabs up where we live. At the time, I knew two people up here—we were new to the area—so I called one of them.

I also didn't know what to do with my kids. Do I leave my kids at home? How long am I going to be gone? I don't know! So I decide to bring them with me. And then we didn't know where to find Aaron because the kid that called me had been very vague and said something like, "It's past the dean's house." I didn't know where the dean's house was!

Luckily, a security guard had seen Aaron skating in the weeks before and noticed that he was on the ground, not the board. The security guard was an old dude and had found Aaron and brought him out to where the car was and was showing him pictures of his tiny poodle or Chihuahua while Aaron waited for us to get there. At the time, Aaron thought he had just dislocated his knee and was planning to knock it back into place himself.

We drove down to the hospital, and I knew we wouldn't be able to stay with Aaron because of COVID. I knew I'd have to leave him there, which just felt awful. It felt like I was just opening up the door and throwing him out. Like we were on the run, and I was leaving the one who was slowing us down.

I was scared to have him stay at the hospital because of COVID . . . but I was also scared to have him come home. I just remembered how when he came home right after he'd had his leg amputated he was in

so much pain, and managing the pain was really, really, really overwhelming. It ended up that his leg was broken, and he stayed in the hospital overnight.

And it was just a broken leg! Which is not really that big of a deal, but it brought back all this stuff from the first time he had had his leg amputated. It was bringing up a lot of things that I thought I had already gotten over.

But I hadn't. And I didn't realize that until months later. My kids' school was gearing up to do a Moth Night—a storytelling night—where parents or staff members would share a story, and it was a fundraiser. I was writing something about bad haircuts. But eventually I decided to do it about Aaron breaking his leg.

I would sit at my laptop and just bawl. I was just sobbing about all this stuff that I was having all of these feelings about and didn't know how to solve. Somehow, shaping all that trauma into a five-minute talk was just so cathartic for me.

We had a dress rehearsal with the other people telling stories that night. And as I was saying my piece, I kind of blacked out. I had a weird out-of-body experience. I've never had anything like this happen before. I was performing my little five-minute thing, and I just left my body. And I think it was at that moment that I realized, like, *Oh, my God, I have post-traumatic stress!*

I had never allowed myself to use that terminology before. And that felt like a huge, huge breakthrough because before that, it had been something that happened *to* Aaron, and it felt like it was *his* sadness and grief. But the truth is it also happened to me. And recognizing that really worked for me. It feels corny to say, but naming it and allowing myself those feelings just worked for me.

MONTE

I HAVE ONE ELLIOT WHO IS MY FRIEND AND one Elliot who is my arch-enemy. The one who is my arch-enemy, he has a water gun, and he sprayed me at the park and told these older kids to spray me too. I didn't want to be sprayed.

I had to be brave. I told myself, *Monte: Be brave*. But I only said that in my mind, not aloud. And then I told him, "Elliot, I don't want you to spray me." But also, it's just a water gun, so it doesn't hurt. But the kids who had the water guns were acting like real people who had real guns, and guns are not good.

Being brave feels good because you're standing up to the part of yourself that doesn't want to be brave and saying, *Just be brave*. But it also feels good to stand up for yourself to others. You just have to take a big breath and say, *Be brave*. But only say it in your mind. That's it!

After I stood up to Elliot, he said he didn't want to spray me with his water gun anymore. And now he is my friend.

CARISSA

IN 2019, I GOT THE JOYOUS NEWS THAT I WAS pregnant after trying for a long time. We really wanted a baby, and I had told myself throughout the beginning of our relationship that we were genetically well-matched. There's this theory that kissing is a way to "genetic" test your partner. Like, if your partner's saliva tastes good, and they smell good to you, then you're diverse enough. I was a big fan of that theory.

My partner and I are from different ethnicities, and I thought, *Our genes are diverse enough, we will have healthy offspring.* It was delusional, but I feel like your mind has to create some kind of hope or certainty to do something like wanting to have a baby.

During the pregnancy, I felt like nothing bad could happen to us. But once she came, almost instantaneously, I felt like something was wrong. The baby didn't cry. The nurses at the time were like, "She's tired, she needs a break, just like you do." It felt like everything was going to be OK, and it also felt like something was wrong. I was holding both the hope and the terror at the same time. It wound up that she had cystic fibrosis.

I've been an atheist all my life. I wasn't brought up with a particular tradition of faith. But I found myself starting to have this stereotypical version of what prayer would be like. I would lay in bed at night and just hope that the baby would be OK. I would do this sort of, like, confessional. I would be like, *If there is a higher power, if there was one thing they could do in my life, it would be to help me believe that my baby will be OK.* And I do think she is going to be OK. I hope she's going to be OK. But what does that even mean? I think I'm still holding out for a cure, to be honest.

I really wanted my daughter to have a sibling. And I think I also really wanted to have a healthy baby. I wanted to know what that experience would be like. So we wound up getting pregnant again, really fast. And I was filled with this same certainty that this baby would be healthy and she would be fine. But eleven weeks in, we got the tests results that she also had cystic fibrosis, and we had to make the decision to terminate the pregnancy.

It was a hard call. On the one hand, I was already in love with this baby. I'm still in love with this baby. I think if I could, I would go back and make a different decision. I think I always thought more information was better. Like the more I know, the better decision I can make. But now I don't think that's true. I didn't realize how painful it would be to lose this potential.

But having to bring somebody into the world who is already really troubled, knowing that they will have a harder life . . . it's a difficult decision to be faced with.

I'm having trouble these days with the idea of getting through something. It's a mantra I tell myself all the time, *Oh, you just have to get through this.* But in reality, would it be more helpful for me to accept that I'm never going to be through it or over it? And to just carry it with me?

MARIKE

MY HUSBAND AND I WERE TOGETHER ELEVEN years. His name was Edwin Aguilar. He was an amazing human being. He was from El Salvador. He fled the civil war in the '80s and came to LA. He was an ex-gang member and had been shot and stabbed. He had this teacher who got him into animation, and he ended up working on *The Simpsons* for, like, twenty-three years.

He grew up very poor, so he always gave back to kids. If any teacher asked him to help, he always said yes. So, I was a teacher—at the time, my whole identity was being an educator—and I was teaching social studies in LA, and we were doing an animation project with the kids. Edwin came to help with the project. That's how we met and we wound up together.

Edwin had health issues—he had diabetes—and my fertility was low, so we decided to do IVF to get pregnant. And it worked, which was amazing. I was working a really high-stress job at that time. I was working full-time as an assistant principal in one of the poorest neighborhoods in LA. I was worried about losing the baby from stress.

When I was six months pregnant, Edwin went down to El Salvador for a Comic Con. While Edwin was down there, my brother reached out to me. My brother was a doctor. And he tells me Edwin had reached out to him because he was having some symptoms, and my brother is like, "He needs to see a doctor." I kind of sat on that. And the next day, I say to my brother, "How bad is it?" And my brother tells me they probably need to admit him.

When Edwin gets back, he's diagnosed with heart and kidney failure. His kidneys weren't functioning, so he wasn't filtering fluid, and his heart wasn't working, so it wasn't pumping stuff through the system. So if he tried to lay down, he would get fluid in his lungs. We never quite knew his real age, but he wasn't old at this time.

They admitted him to the hospital. Fortunately, the hospital had benches with foam on them. So I would sleep there, wake up at 5, go home, and shower and go to work all day, and then go back to the hospital.

They took Edwin off blood thinners to do a kidney biopsy, and he had a stroke. He lost his vision in his right eye. I was seven months pregnant at that point.

Two weeks before our son, Bodhi, was born, Edwin got emergency catheter placement. I didn't want to stop working because Edwin didn't have life insurance, so I was like, *I need to provide!* I was working fifty hours a week still. I worked up until the fortieth week of my pregnancy and then went into labor. I have a picture of Edwin and Bodhi laying together, and Bodhi has his hospital wristband and Edwin has his wristbands from his hospital stays.

It winds up that Bodhi is autistic, which we didn't know at first. I knew Edwin and I were meant to have Bodhi, but it wasn't like all I cared about was being a mom. It didn't come naturally to me. And before we knew Bodhi was autistic, we had all of these people commenting on why he wasn't progressing or

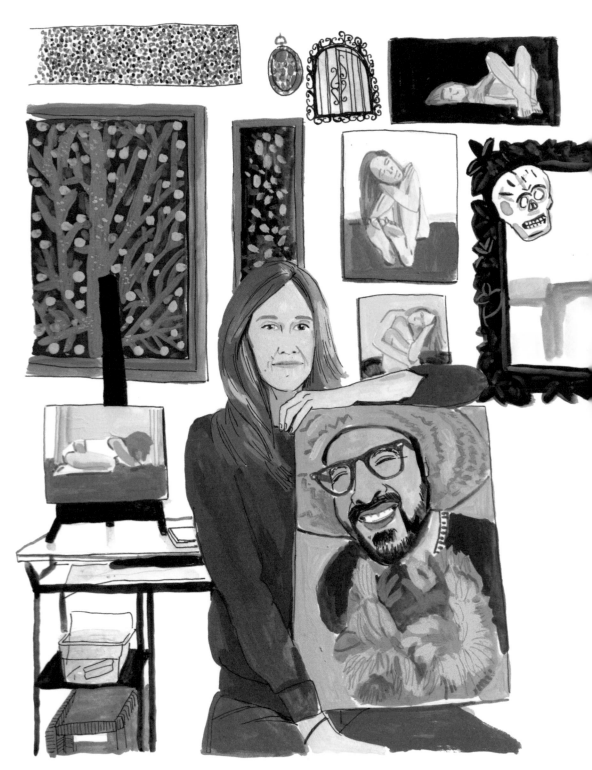

talking. And we're surrounded by New Age-y people in Los Angeles. Everyone thinks you can heal yourself. You make a vision board and everything's going to be fucking fine. But I was going to all of these doctor's appointments with my husband, and every time we went, things were worse. I knew what was happening. He was dying. His body was slowly falling apart. And people are like, "He's gonna be fine." It was maddening. It was utter chaos for me.

Everyone thinks you can heal yourself. You make a vision board and everything's going to be fucking fine.

When Bodhi was two, he was diagnosed with autism. (Now I look at autism, and it doesn't seem like a negative thing, but as a mom, you have this fear that your kid is not going to be OK or won't fit in or won't respond "right" to the cops.) He was diagnosed in August or September. And then in October, I went with Edwin to his doctor's appointment, and his doctor said, "We've done everything we can to help your heart; it's not going to get better. You need a heart and kidney transplant, and your arteries might not be able to handle it."

That day I went to work, and I was sitting outside, and I basically had a panic attack. I'm usually pretty resilient. My friend was like, "You need to go to a doctor." So I went to my doctor. My doctor told me I should get on medication. I had so much pride. I didn't want

to be someone who was on medication, but I did it. It felt like no one would be able to handle this. I needed it to keep going.

Edwin was an artist, clearly. And I did art when I was younger. But I just didn't have the self-esteem to put myself or my art out there. Edwin and I used to do these chalk festivals, where people do chalk art on the sidewalk. For about ten years, we did these portrait pieces together. They were real big—eight feet by ten feet. We'd grid it out and work on it together. At that scale, you're basically just working on blobs of color. And when you step back you see the portrait. We always did kids because it just made people so happy. The last one we did together was of Bodhi; it was so cute.

I was still working constantly because I was afraid Edwin was going to die, and I needed to make as much money as possible, and Edwin was working constantly because that's all he could do. But at a certain point, I had this realization that this was it. That Edwin and I just had this time together. Then we started working from home because of the pandemic. It felt like we were being given the gift of time.

I had this photo that I had screenshot on Instagram, and I was like, *Someday, I'm going to paint this.* During that time, I sat down to paint the photo, and it was really good. I'm not trained in art, and people were like, "What? What is this?" People were offering to buy it and wanted to commission paintings. Edwin was impressed. Then I did a portrait of Bodhi, and it was good. Nobody was more surprised than me, by the way. Because I didn't even know how I was doing it. I decided to do a self-portrait. I was just painting all the time, and Edwin was coaching me.

It became this year of mentorship or apprenticeship. Edwin was like, "Look, you need to do a show, and for that, you need to

do twenty paintings." I just kept painting. People were making fun of me, "Wow, you painted everyone but Edwin." I had the photo I wanted to paint of Edwin. And I finally did it. I sat down and did the painting of him, and it was so him. I felt my identity shifting. By the time I did this portrait of Edwin, I was an artist.

I had this spreadsheet of the paintings that I had done over the year. I would write down when I started them and when I finished them and if I got paid for them. I went to add Edwin's painting to this spreadsheet, and I realized his was the twentieth painting. And it was exactly a year to the day from when I did the first painting.

About a month later, he had a stroke. He was in a critical care center for a few days, and then he died. With his first stroke, he could still draw. But with this stroke, he could no longer draw or speak. He had lost everything that mattered to him. He passed away a month after I painted his portrait.

Being with my partner as he was dying . . . it's fucking awful, but it was also a sacred experience. He was so beloved, and there was a beautiful obituary in the *Los Angeles Times* about him.

I was basically drunk for a month after that. It was all a blur. But then a month after he passed, his friend told me I needed to paint. I said, "What am I going to paint? Myself in a fetal position?" He said, "Yeah, you should definitely paint that."

I started a series of paintings. I did a photo shoot of myself, grieving. And I painted those. All of these feelings started coming up that were super-intense after being numb for a while. I can't believe I lived through all of that.

It was almost like Edwin came into my life so that I could really embrace myself as an art-

ist. I'm from a small town in Illinois. Being an artist is like saying you're going to eat ice cream for a living. It doesn't surprise me that he got me to that point and then left.

My dad was mayor of our town. Our neighbors were this family, and the dad was this Korean War vet named Ray. He would tell you to fuck off in a heartbeat if he felt you deserved it. He was kind of gruff but madly in love with his wife, Mary. She was four-eleven, wore a black beehive wig and platform heels. She was an artist. She had four kids, but she created art twenty-four hours a day. It was wild stuff. She made lamps—all kinds of things. One of the things she became obsessed with was clowns. She made all of these 3-D sculptures of clowns. They're amazing.

Mary passed away, and any time I would go back home, I would visit Ray. I would tell him not to get rid of anything. I told him people would love Mary's art. And I would take it. The last time I went and saw him, he told me he had lung cancer. He passed away a few months later. And when he died, none of the kids wanted Mary's art. One of the sons told me that I had three days to get all of the art out of the house because they were about to put it all in a dumpster. I got as much of the art out as I could, and then I spent three thousand dollars shipping it across the country. Now I have all of Mary's art hung up all around my house.

It was almost like going to get this art gave me a sense of purpose in my grief. It felt like Mary was choosing me to share her art with the world. And it felt like I was shifting my identity to being an artist and doing bold things. It was like, *Why not ship fifty clowns across the country and hang them up in my house? Why not?* Losing my husband who was only forty-seven, it made me realize I didn't need to hold so tightly to security. Life is short.

Beautiful life

EDDIE

I used to sell the sizzle, not the steak. I sold the hype. It was horrible.

I USED TO WORK FOR THIS ELECTRONICS company. I used to sell home theaters. Have you ever been in the street and someone's asked you, "Hey, you want a home theater?" I used to do that. But I used to be real good at it.

When I started, I was twenty-two and I made one hundred and twenty thousand dollars a year. It was an unorthodox job. I was scamming people. I was convincing people to buy things they don't want to buy. I did it for a while.

This one time, I ended up selling two boxes to these guys. They called me up two days later and said, "Meet me at Route 46 at the Wendy's. I wanna buy two more home theaters." I had a gut feeling something was wrong. But I wanted the money. We had a motto back then, "Callbacks are fallbacks." So if someone called you back, it meant something was wrong. But I was greedy. I wish I'd listened to my gut.

I show up and two guys jump out of a truck. And they weren't happy. I was like, "I can give you your money back." But they didn't believe

me. To make a long story short, I'm talking to them, and someone approaches me from behind and jumps me. I got my mouth broken. I had to eat out of a straw for a year. I ended up losing 150 pounds. I would have rather broken an arm or a leg. You don't realize how much you open up your mouth in a day: to yawn, spit, eat, talk. And I had all of this nerve damage from it.

So I was there for a year, eating out of a straw. Let's put it this way: You ever eat a cheeseburger out of a straw? Disgusting. After three weeks of drinking Ensures—strawberry, vanilla, chocolate, strawberry, vanilla, chocolate—I was like, *I need a cheeseburger.*

Anyway, let me backup. So when I was twenty years old I was about to go to the army. I had taken the first test for the army and passed it. I'm about to take another test—once I take the second test, I'm in the army. My dad's like, "Don't go, don't go!"

Meanwhile, I'm living at my mom's house, sleeping on the floor. It was a one-bedroom,

and it's me, my mom, my dad, my sister. And I didn't know what I was going to do with my life. I think the only option is going to the army. But this one day, I'm looking at a newspaper, and I see this ad. It says, "Must like money, music, and having fun." I'm like, "Shit! I like money, I like music, I like having fun." I thought, *Lemme try it out.*

Long story short, next thing you know I'm sitting on a milk crate and watching these guys sell home theaters out of a truck. They sell the whole truck out and make about a thousand dollars each. It's like scam school. So I start doing it. In the first week, I made fifteen hundred. I had never seen that type of money before.

It's called the White Van Scam. You can look it up. There's a whole show you're doing, a whole pitch. We'd call the customer a duck. We'd see someone and go, "Oh man, there's the duck." Then we'd go up to them and say, "I know this sounds nuts, but you want a home theater? I got two extras from work. They're worth like three thousand dollars, but I'm selling them for dirt cheap. You want one for dirt cheap? I gotta do it fast before my boss sees me." If I got anything but a flat-out no, I'd give them my whole spiel. And I'd do that over and over. The stereos were decent, but they weren't great and weren't worth that much.

You ever find something you're really good at? That you didn't know you were good at? It's like *Eureka!* That was me. I'm just banking. Everybody's like, "You got the gift of gab." But my wife—I met her during that time—she's like, "Yo, you're just a liar." I used to sell the sizzle, not the steak. I sold the hype. It was horrible.

I was doing it for a whole bunch of years. The reason why I left was, when I got jumped, the cops are asking my bosses about me. They say, "We see he works for you." And my bosses are like, "No, he doesn't work for us. We're just a distributor." Which is a lie. I was the trainer! I was training people for them. You ever see the movie *Boiler Room*? It's an old-school movie. They'd clap it up and be like, "Who's ready to make some money? If you're not here to make some money, there's the fucking door." It was like that. I was teaching other people.

When they said they were just the distributor, I took offense at that. I had made them so much money. So I left. I started working independently—doing the same thing. But I got lazy. If it was raining or cloudy outside, I'd be like, *Nah, I don't want to work.* I ran out of juice.

When I first started doing it, I didn't feel bad about doing it. Because you get blinded by money. I was a kid. And it had been rough for me. My whole family, we never had money. Nothing. And that's why I was gonna go to the army. It was either sell home theaters or go to the army. It could've been way worse. I wasn't selling anyone a brick of coke. The speakers weren't stolen, and they weren't going to kill anyone. So it could've been worse. I really needed it then.

But after a while, I felt bad. One day, I sold one to a woman, and I felt so bad, I went and found the woman.

Eventually, I left selling because I had a kid. Everything switched after I had him. I listened to my gut. I wanted to be on the books. Now I work maintenance. I like it. I know I'm gonna get the check every week and I'm not doing anything wrong.

I'm not the same person I was back then. I feel better now than when I had more money. I just feel good. I'm married. I got a kid. A job on the books. I got a 401(k). I live in a high-rise with an amazing view. I feel good about myself. I'm loving life.

RIO

I DIDN'T HAVE A WIGGLY TOOTH. BUT THEN when I went to sleep and woke up, I had a wiggly tooth. Then for three days or four days, it was wiggly. It hurt to eat, and I felt worried. I was worried that when it fell out it would hurt. Then I went to school on a Wednesday. After the whole day went by, I went to afterschool. I was playing ball, and I was wiggling my tooth back and forth with my tongue. I pushed it all the way back and then I tried to push it forward and it fell out. A teacher walked by, and she knew I had been having a wiggly tooth, and I told her I lost the tooth. She got me a plastic glove to put my tooth in, and she tied the glove and I put it into my backpack.

Now, I won't be afraid of losing another tooth. And when my little brother has a loose tooth and he is worried, I will say, "Don't worry. When I had a loose tooth and it fell out, it didn't hurt."

ANGELA

WHEN MY BEAUTIFUL SON, LUCA, WAS BORN, he was born with a cleft palate. That meant a lot of surgeries. And a lot of worry for me as his mama. I was also born with a cleft palate. I remember my mom telling me about how hard it was for me in my first year of life to eat because I couldn't suck on my mother's breast. My palate (which is the roof of the mouth) was completely open. I had a hard time gaining weight, and it caused trouble with my ears too.

When I was pregnant with Luca, they hadn't determined that he had a cleft palate, and I was so happy. But then three days after his birth, he wasn't latching; it wound up that he did indeed have a cleft. I was devastated. It hit me hard. It was a moment of trauma for me. But my husband, Jeff, was amazing about

it. He said, "This is something we're going to repair through surgery. He's going to be okay." I really saw Jeff become a parent during that time. He really threw himself into the world of fatherhood.

We had to wait a little over a year for Luca to get the first surgery—they have to wait for the jaw to mature. So there was this whole year of knowing there was this big surgery coming where they would bring the two sides of the cleft together.

From six months on, Jeff would take Luca out every day—Luca was obsessed with trucks—so every morning he would take our baby out to construction sites. He would take him to fire stations and concrete plants too. He was doing this immersive study of trucks with

Luca. It wasn't so much a distraction; it was more that Jeff was doing what he knows how to do—which is to get himself really involved in something. He saw this interest in Luca, so he ran with it!

We had the surgery, and everything went well. But it was a big deal. For three weeks, Luca couldn't have his hands in his mouth. Jeff and I would stand watch over him. It was big. But he pulled through beautifully.

As Luca got older, his interest in trucks continued. He knew all of the parts. Together, Jeff and Luca would make diagrams of trucks. They knew all of the truckers in the neighborhood. One day, a trucker let Luca sit in the cab of a truck, and Luca blew the airhorn and yelled out the window, "Papa, me truck!" Jeff realized that Luca was saying that he wanted a truck.

Jeff started looking on Craigslist—scouring Craigslist for trucks. What he wouldn't do for Luca! He found a cab, which is the front-end of an eighteen-wheeler. It was an old 1981 cab. They went to visit it in New Jersey. We sat in the truck. It was owned by an older war vet. The truck was this man's pride and joy, and he looked at us like we were nuts. He looked at me and was like, "Is this for real?" I was like, "Listen, I have no idea what we will do with this truck, but this is for real. This is my husband, he's a risk taker!" I just knew I wouldn't be able to talk him out of this. We barely had enough money for the deposit for the truck, but we went for it.

We got the cab the following week and had no idea where we were going to put it. We found a guy who let us park the cab on his property for a hundred dollars a month.

We would go out on the weekends and visit the truck. Luca named the truck Big Mama. He would literally hug the truck when we would visit it.

After a while, Jeff was like, "You know, I see this truck in a field, with kids running in and out of it, like a camp!" I'm an educator, and at first, I wasn't into the idea—who needs another art truck? But then I started to think of how to make it work. I decided we could anchor it in curriculum. We got hooked up with a little funky school. We created a children's play space. For a whole summer, Jeff, Luca (who was five by then), and I slept in the cab! And the program grew and grew!

All the while, Luca was undergoing surgery after surgery. Speech was an issue for a while with him. His breathing wasn't right. Simultaneously, we were growing this educational program and dealing with medical issues with our child. Our careers were mingling with our life. At times, it really felt like too much.

We would tell Luca, "You know, everyone is working on something. Never give up!" And out of that came our motto for the educational program, *Keep on Truckin'*. But that was really the motto for our family too.

Luca's speech isn't perfect now, but he has come so far! He is eleven now, and he's a hardcore skateboarder, on track to being pro. And I truly think he has this grit and this tenacity because he just kept trucking. Getting back up and going again is just part of who he is.

When you stay in something and work through it, you come out the other side. You come out stronger for it. That's what happened for Luca. And for us. We kept at it. And what a journey it has been!

EDAFE

IN MAY OF 2021, I GOT A TEXT MESSAGE FROM my sister in Nigeria, and she said, "Daddy's dead." I was confused. How could he be dead? Because when my father was sick, I got engaged to be married, and my family said, "Don't tell daddy, he's just coming to accept you, and that might kill him."

My father did not accept homosexuality. But he was coming to accept me. But now he's dead? And it wasn't my fault. And he didn't get to know that I'm about to get married. It devastated me. I had five days to complete my semester, but I almost dropped out. It was the most difficult time of my life.

I came out as gay when I was nineteen in Nigeria. I suffered rejection, shame, abuse. My father was not happy with me and wanted me to get married to a woman. I said I didn't want to do that. So I left my family when I was twenty-two. I didn't see my father for eleven years.

My father lied to me when I was in college. He said he was breaking up with my mother because she was supporting me as a gay man. But that was not true. Because later on, he had another wife and two children. It was just an excuse. But I forgave him, and I moved on. I wound up leaving my country because of my sexual orientation.

When my father was very sick, we started to have some sort of relationship. We talked on the phone. I told him I was going back to school and I had a job in America, and my father was excited about

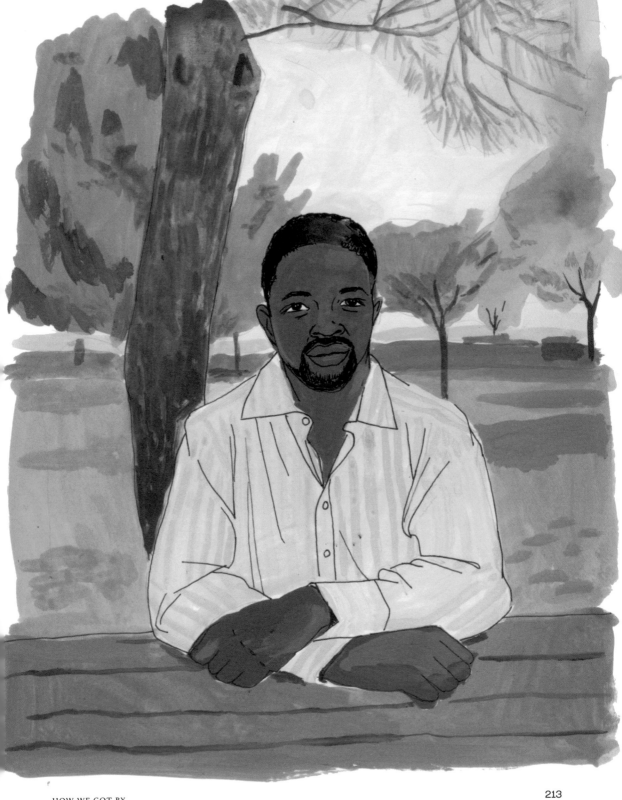

everything. But I still did not tell him about the engagement because my family had told me not to. After he died, I felt remorseful about that.

I did wind up finishing the semester, and on the 11th of May, I went to testify in DC to the US Congress on asylum. While I was in DC to do this testimony, I started speaking about my experience as a refugee, and someone on the committee questioned me and accused me of lying about why I left Nigeria. I just burst into tears. Who would want to leave their family and everything they knew? I said, "I just lost my father a few days ago, and as a refugee, I can't go back to my country to see my father being buried. Why would I give up everything just to be here and lie?" It was heartbreaking.

In America, people do not know about the struggles that refugees go through. They think that life is great for refugees here. But we are still struggling with what everybody struggles with—grief, loss—plus we are dealing with being refugees!

I don't feel at home in America. After my trip to DC, I felt misunderstood. I had a big identity crisis. I felt I like don't fit in here. I don't fit in at home. What do I do? That led to me having a depression.

That summer I was having a pain around my waist. So every day I am complaining to my partner about my waist. I went to the doctor, and he said I had increased weight around my waist, and it's unhealthy, and I have fatty liver. She referred me to a psychologist. Three months into therapy, the psychologist told me I have severe depression. They said I had to go back to doing things I did before—exercising, seeing friends.

Through the process of doing therapy, I discovered that holding on to the grief was my way of holding on to my father. I felt like I betrayed my father and family. I used to see people when I was young who traveled abroad, and then their parents died and they wouldn't come home for the funeral, and I would think, *Those people don't love their parents.* Now,

In America, people do not know about the struggles that refugees go through. They think that life is great for refugees here.

I was the person who wasn't coming home. I would tell myself, *I can't go back to my father's funeral because I am a refugee.* But the reason why I couldn't see my father was because of death. Death is a door you can't go through. It separates us from the people we love. If I were to go to Nigeria, I won't see my father. Whether I am a refugee or not, death separates us. It's not my fault that I am a refugee. It's not my fault my father died. I had to let go of the pain that I felt that I hadn't done enough for him.

I am still letting go of it. Every day, little by little. Week by week.

I had developed an eating disorder, my sleep pattern was distorted, my attention

span was destroyed. I couldn't sit and read or anything like that. So I bought a journal. When I wake up in the morning, I write in it. The process of writing helps me to feel my feelings. I say, *How is my body feeling? Is this sensation internal?* It has helped me to see a pattern of things that I do. Before I journaled, I would just have a feeling and then watch TV or go to Uber Eats. But now I ask myself what my feelings are. I learned how to embrace the feelings.

One of the feelings I embraced was crying. I used to think that men don't cry. But sometimes I just want to cry. I lost my innocence of being a child to homophobia. I lost my innocence of building a life to being a refugee. And now just as I am becoming an adult of my own, I lost my father. Every moment of my life has been riddled by tragedy. How can I not allow tragedy to be the only narrative I talk about? I want to also talk about joy.

I left so many things I knew as my coping mechanisms behind. Instead of ordering delivery, I buy a lot of vegetables, and I eat those foods. I keep my shoes in the living room at night, so that I can go to the gym in the morning instead of watching TV.

I was listening to a TED Talk one day, and a lady was talking about how she lost three of her partners. She said, "You can't move on when someone dies, but you have to move forward." And moving forward for me is telling the story of my father. I never saw my father to be a nice person, but now I believe my father was a good person. The emotional intelligence he had or the knowledge he had, he used that in parenting.

He was a survivor of war. When he was very young, he lost eight of his siblings to famine. They didn't have food to eat. Three years after Nigeria gained independence, there was a civil war. My father had to fight as a soldier at eleven years old. He thought that being a gay person would mean that I couldn't take care of myself. It was his fear that made him over-protective.

When I was six years old, the Olympics were in Atlanta. People didn't have television in Nigeria in '96. But my father had a black-and-white television. So he brought the TV outside and put it on some empty crates of alcohol. And he used a wire from a car to connect to the television. He turned on the ignition, and that's how seventy people watched the soccer game at the Olympics. And Nigeria beat Argentina in the soccer final. People were praising my father for having done this. And now, when I think about myself as a community activist, I realize it's what my father did. What he did is what I do. Trying to give space to people who are marginalized in society, to give them community—I learned that from my father. He would do anything to make sure people in our community were happy.

We are products of our parents. Letting go of the grief and embracing the good things I learned from my father is the only way I could release the pain of losing him.

The only way to move forward is to take the things that we value in the people who've gone and memorialize them in our lives. Tradition is to memorialize their name, but what if we memorialize their values instead? My father was angry that, as a gay person, I wouldn't pass down his last name. He thought our last name would evaporate. But what if the name evaporates? And the values do not?

216

ALESSIO

I WAS BORN HERE—WE LIVED IN SAN FRANCISCO—and we moved back to Italy when I was ten years old. In San Francisco, I was in a Catholic school, and us Italians weren't seen that well back in the 1970s. There was a racial thing going on. There were lots of bullies. And I was a soft, emotional kid.

But when we moved to Italy—to Lucca, which is a small medieval city forty-five minutes west of Florence—it was like a rebirth!

It was 1977, and my grandmother had *just* had the bathroom built in the house. In 1977! Before that, she'd had the bathroom in the stable with the cows.

I remember when I got to Italy and walked into my grandma's house, the first thing I smelled was mold. Like a farm-style, old-house mold. It's a smell that today I miss. Sometimes I catch it, and it triggers positive memories. It was totally different from everything clean in San Francisco that I had known before. And in the house there were no heaters, so in the winter we would surround the fireplace and stay there for hours.

For me, being there—I was free! We would take off on the bicycles and do what today is unthinkable. We would ride kilometers to go fishing in a little pond in the middle of nowhere. As a young kid in the summer, we were allowed to stay outside until late because there was always an old lady spying on you. We were always watched by the community. The parents felt free to send us out.

Later on, I had job opportunities half the planet away—in Tunisia, in Spain. And in my twenties, I started to travel back to San Francisco again. I always had zero cultural shock. I would adapt immediately.

I am lucky to have lived in two worlds. If you are traveled, you have a different view of what the world is about. I feel very comfortable in different cultures. If you have a kid, let him free, let him loose, let him get out of his comfort zone and travel as much as he can!

DIANE

THE NATIVE AMERICAN PEOPLE ARE THE MOST underserved people in the country. Completely ignored. The government intentionally ignored us. And I couldn't see why it had to be that way.

I grew up in a community where everybody is a storyteller. You ask them anything, and they'll tell you a story about it. That's part of how Native people communicate.

What I hated to face when I left the Osage Nation was that people didn't want to know our stories. I knew about America being a racist country; I'm not that naive. But I was not prepared for the lack of interest in who we are, the lack of knowledge. I was not prepared to be summarily dismissed and ignored.

I think everybody's stories are important. Very important. In fact, the two things that people all over the world have held on to from time immemorial are the drum and telling stories.

In school, I studied *The Iliad*—it's one of my favorite stories. It's an indigenous tale, and I didn't understand why if that story was told our stories couldn't also be told. *The Iliad* hadn't been written down for well over a thousand years. They sang it. And that's the same way it's done in indigenous communities around the world. Art and storytelling was how you passed knowledge.

For a long time, we as Native people were not being given an equal opportunity to tell our stories. The dominant culture was telling stories about us. They were white savior stories. They were really stories about themselves. And they would congratulate themselves on their achievements. We, the Native people, would always be asked to be their "advisors." And we'd say, "We don't advise people on who we are." And asking someone to be an advisor is a good way of getting out of being responsible to someone because you don't have to listen.

At a certain point, I said, *We have to tell our own stories.* I wanted to tell a story, so I sat down and wrote one. I decided I wanted to make community-based films, where we came together and overcame all obstacles together. And so, if we don't have money, we find a way to do it without money. Slowly I began to get fellowships and grants as an

individual artist. I saved them up and made my first film.

When we'd go to shoot a film, we'd go into the community and galvanize the support there. People would cook for us. We filled in the gaps together, as a community.

Once the first film was made, people wouldn't distribute it. So we distributed it educationally. We went around and showed it in Native American communities and Native American studies departments and arts institutions and told the story of making the film as well. We kept finding a way to stand up. And we continue to do so. Now I am finishing my second film, and a distributor wants to pick it up!

Native people often feel called to do something. It's not about monetizing things. It's more about achieving something. If you feel called to do something, do it. But be prepared to keep following through. Because it's the people who keep trying who are the ones that get it done. You have to hold on to that. When you feel called to do something—even if it is very lonely and very difficult—you will be able to do it.

TONE

I'VE LEARNED TO STREAMLINE STRESS. HERE'S how: You have to slow down and assess your situation, look at the things you gotta do. Then pick out what you can handle first and do that. Then move on to the next thing. Listen: Life is fast. The slower you take it, the better off you'll be.

NICK

IT'S A LONG TIME MY FAMILY'S BEEN IN THE pizza business. And I've been in my spot for four years now. If the ingredients are working and people like the pizza, leave it the way it is. If it works, don't change it. That's true of all things!

THANKS:

We want to thank everyone who has shared stories with us, whether for this book, our previous one, or for the work we do in the *New York Times*. We are so thankful to be part of the long tradition of storytelling. Thank you to anyone who connected us to anyone else for a story. Thank you to our editor at the *New York Times*, Ashwin Seshagiri (*hey Ashwin!*); to Wendy MacNaughton, who motivates us with her illustrated journalism. Thank you to our previous editor, Nick Summers, who, in addition to editing many stories for us, edited a piece we did in March 2020 for the *New York Times* and came up with the title, "How We Got By." That piece inspired this book, and the title stuck. Thank you to our incredible agent, Kate Woodrow at Present Perfect Lit, who makes all of our work better; to our editors at Andrews McMeel Publishing— Allison Adler, who brought us on, and Melissa Rhodes Zahorsky, who offered thoughtful edits. Thank you to Jenny Volvovski for your wonderful design. Thank you to the reader! We hope you find something to connect to in these pages, and we hope you continue to tell your own stories. Of course, thank you to our families and friends. And lastly, a big, big thank you to our partners, Ollie and Chris, who put up with a lot from us all the time. Thank you, thank you!!!!

Andrews McMeel Publishing
a division of Andrews McMeel Universal
1130 Walnut Street, Kansas City, Missouri 64106

www.andrewsmcmeel.com

23 24 25 26 27 IGO 10 9 8 7 6 5 4 3 2 1

ISBN: 978-1-5248-7231-1

Library of Congress Control Number: 2023931028

Editor: Melissa Rhodes Zahorsky
Art Director: Diane Marsh
Production Editor: Brianna Westervelt
Production Manager: Chadd Keim

ATTENTION: SCHOOLS AND BUSINESSES
Andrews McMeel books are available at quantity
discounts with bulk purchase for educational,
business, or sales promotional use. For information,
please e-mail the Andrews McMeel Publishing
Special Sales Department: sales@amuniversal.com.